The Silbury Treasure

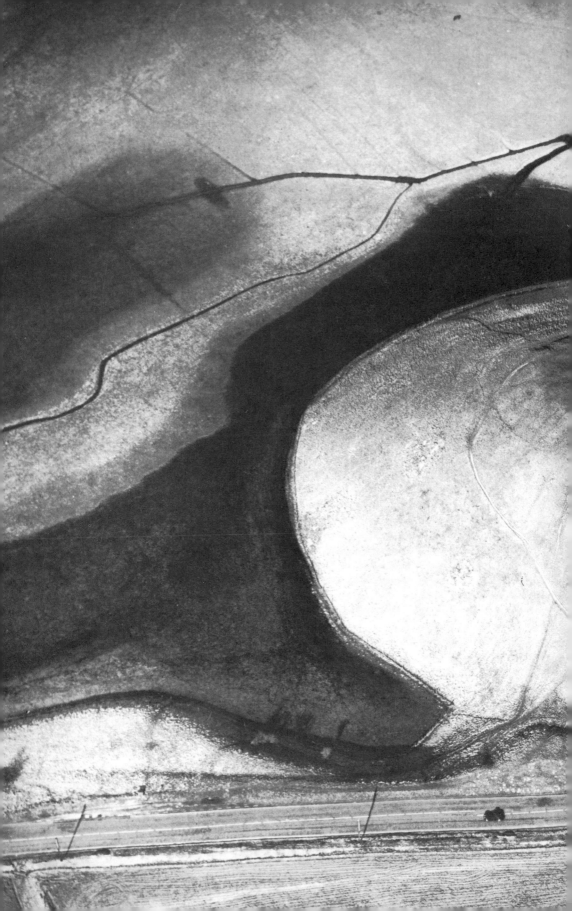

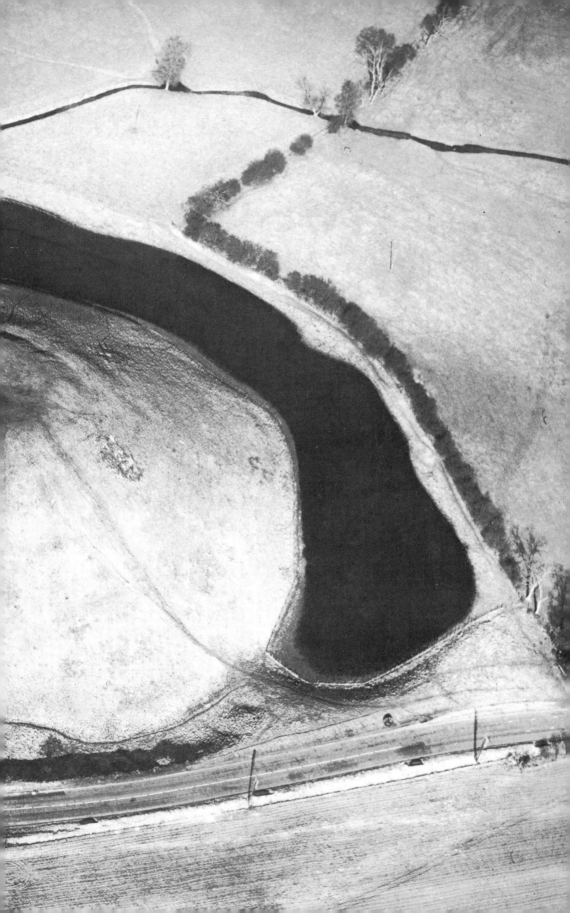

Michael Dames

The Silbury Treasure
The Great Goddess
rediscovered

 THAMES AND HUDSON · LONDON

And the end of all our exploring
Will be to arrive where we started
And know the place for the first time.
Through the unknown, remembered gate
When the last of earth left to discover
Is that which was the beginning;

T. S. Eliot, Little Gidding

Filmset and printed by BAS Printers Limited, Wallop, Hampshire

Contents

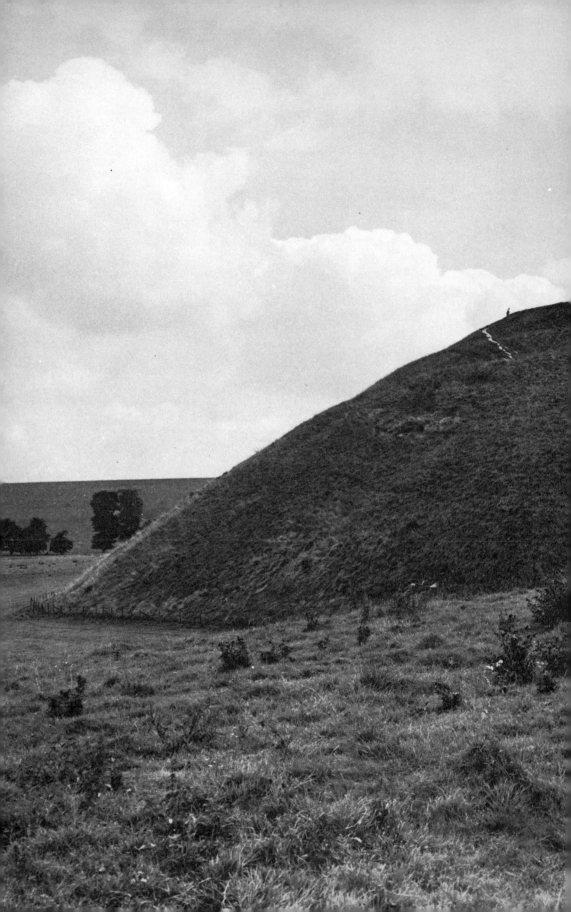

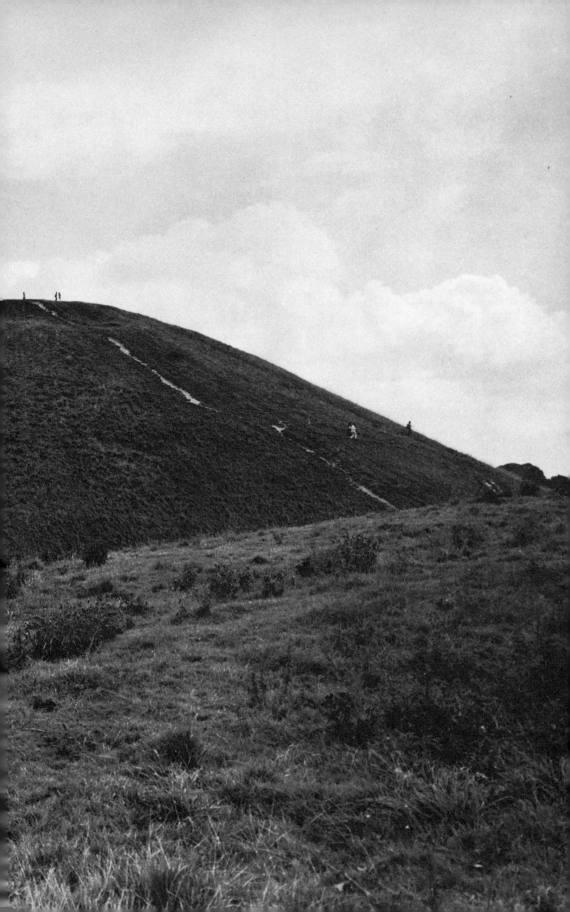

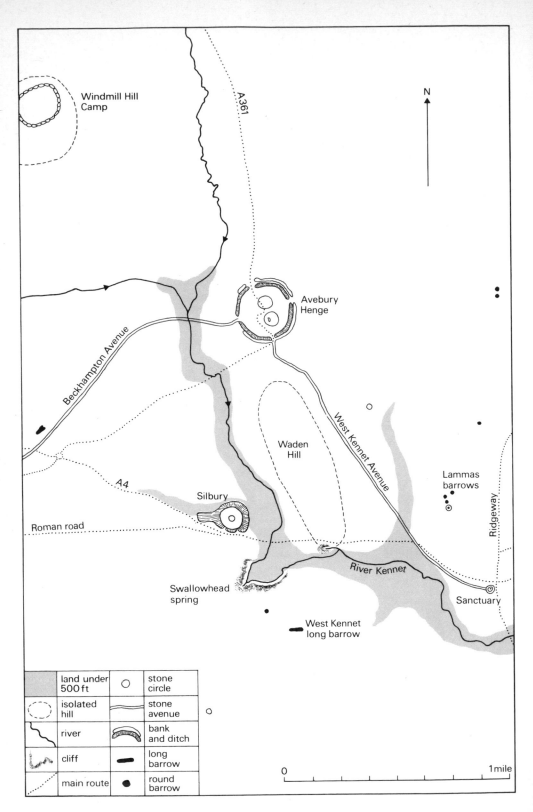

Windmill Hill
Camp

N

A 361

Avebury
Henge

Beckhampton Avenue

West Kennet Avenue

Waden
Hill

Lammas
barrows

Silbury

Ridgeway

A4

Roman road

Swallowhead
spring

River Kennet

Sanctuary

West Kennet
long barrow

	land under 500 ft	○	stone circle
	isolated hill		stone avenue
	river		bank and ditch
	cliff	▬	long barrow
	main route	●	round barrow

0 1 mile

Silbury Hill and the king

What sort of treasure?

The flowing natural profiles of Wessex chalklands are modified in a thousand places by the blurred and broken remains of prehistoric monuments. Of these, the most remarkable group, in size, variety, and state of preservation, is to be found in Avebury parish, north Wiltshire. In this Avebury group stands the tallest prehistoric structure in Europe, Silbury Hill.

Silbury is the subject of this book, which provides the first full-length written portrait of the Hill ever to have been compiled. The account will attempt a faithful description of the monument, inside and out, from close quarters, and from long range. It will seek to answer the questions: why was Silbury built, and what meaning does it hold for us?

The conclusion is reached that the wisdom of the original designers is still accessible to us through the structure which they left behind. Their wisdom is shown to amount to more than a display of immense technical skill with limited resources. Properly read, Silbury conveys a splendid prehistoric philosophy, which is of exceptional relevance to the modern world. The monument can reveal not only the gist of how the prehistoric community behaved at the site, but also what they probably thought and felt.

Unfortunately, in recent centuries, Silbury has been reduced to a stupendous enigma, through the attempt to impress upon it concepts such as kingship, personal property, and individual glory. All these attempts have failed because the builders belonged to a society for which such terms had little importance, or even meaning. On the other hand, since *their* compelling priorities are not entirely absent from our scale of values, we are quite capable of appreciating something of the original Silbury treasure, especially since recent doubt concerning the long-term future of our own civilization may give an urgency and humility to our investigation.

Most people first come across Silbury by chance, for the monument stands beside the busy A4, London–Bath road. Yet even a casual encounter reveals qualities

(Opposite) Map of Silbury and nearby monuments.

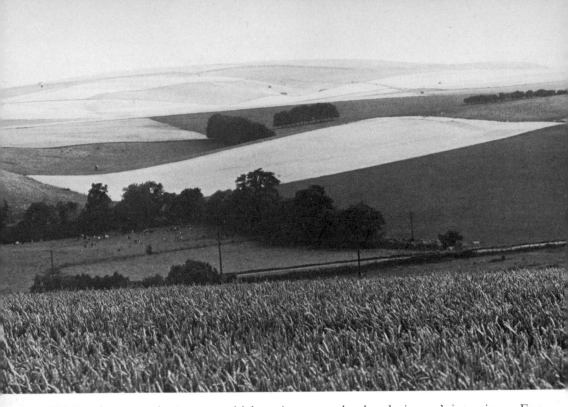

Wiltshire downscape, showing the Kennet valley and the Marlborough downs stretching to the high horizon at St Ann's Hill. Viewed from Waden Hill, looking southwest.

which point towards the designers' intentions. For example, to a driver travelling westwards from Overton Hill, Silbury displays a highly flexible scale. At first smaller than a child's hand, it expands at extraordinary speed, rearing into the sky to fill much of the field of vision and appearing almost to block the way ahead, before subsiding into a corner of the driving mirror, eventually to be extinguished by a bend in the road. Awareness of this physical growing and shrinking touches on the once familiar urge to create a structure capable of being simultaneously perceived as all possible sizes – a speck of dust, an egg, a human belly, a mountain, the world, and the universe. To find, to express, and to benefit from the identity between microcosm and macrocosm was *the* subject of prehistoric life. Silbury, glimpsed through a car window, potentially shows us the way back to this former preoccupation. The Silbury treasure is a vision of lost unity.

If a modern traveller passes the monument more than once, he is likely to be offered a second clue as to its original purpose. He will see that Silbury alters according to the seasons and the time of day. Thus, while the arresting oddness of the truncated cone remains constant, under snow it is opulent and distended, at night it turns sharp-edged and two-dimensional, in early morning it becomes an island in the

mists that hang around the adjoining water meadows of the river Kennet.

As will be shown, the Silbury treasure was concerned with time, and the changes brought by time. The Hill was built to participate in dynamic processes – the fattening of the moon, the transformation of corn from green to gold, and the stirrings of an unborn child. The Hill was made to be an active agent in eternal dramas like these. That is why it was made to last, and why its value remains undiminished.

Who would exchange this value for a single horse and rider, even if cast in solid gold? Yet this is the imaginary substitute which, for two centuries, learned men have searched in vain to find beneath Silbury's massive bulk. Nevertheless, although antiquarians and archaeologists have come to think of Silbury as a place where backs and reputations are damaged, without their efforts it is almost certain that the riches now revealed would have remained hidden indefinitely. Criticisms which we may subsequently make of their approach should be seen in a context of gratitude and respect for their endeavours, which have contributed to the eventual emergence of meaning.

Since much can be learnt about the true meaning of the monument by studying the way it has been mis-understood, the first two chapters of this book will deal with the excavations made there from 1776 onwards, whose purpose was to find a royal tomb, royally furnished.

Silbury from the east, where the A.4 crosses the wooded end of Waden Hill. A terrace near the Silbury summit shows clearly.

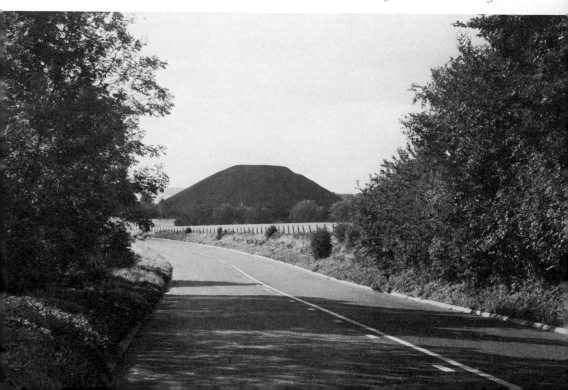

John Aubrey (above), the Royal topographer, made the first drawing (right) of Silbury, c. 1660. (Below) William Stukeley M.D., the eighteenth-century antiquarian, whose patriarchal interpretation of Silbury has been shared by most modern observers.

Silbury and King Sil

In 1663, the writer John Aubrey was showing Charles II the Avebury henge, when 'his Majesty cast his eie on Silsbury-hill about a mile off; which they had the curiosity to see, and walkt up to the top of it with the Duke of Yorke, Dr Charlton and I attending them.'[1] What could the royal topographer tell the king about the amazing 130-feet-high pile?

'No history gives any account of this hill. The tradition only is that King Sil, or Zel, as the country folke pronounce, was buried here on horseback, and that the hill was raysed while a posset of milke was seething.'

Of these two traditions, the King Sil story rose in strength and eventually turned into gold in the following centuries, while the posset or bowl of milk disappeared.

Aubrey himself accepted the tomb idea, as is evident from his statement: 'I return now to the Mausolea of our owne countrey, and will first set down Silbury Hill in Wiltshire.'[2]

The diarist Samuel Pepys passed by, in 1688, and learned from a local man that Silbury was named after 'one King Seall, buried there, as tradition says'.[3] Pepys gave his informant one shilling.

In 1723, the famous antiquarian William Stukeley also gave money (he does not say how much) to a local workman, for Silbury's sake. The man, John Fowler, had been employed 'in the month of March 1723, [when] Mr Halford ordered some trees to be planted on Silbury Hill. The workmen dug up the body of a great king there buried in the centre, very little below the surface, the bones were extremely rotten so that they crumbled to pieces with the fingers. Six weeks after I came luckily to rescue a great curiosity which they took up there; an iron chain, as they called it, which I bought of John Fowler, one of the workmen;

it was the bridle buried along with this monarch, being only a solid body of rust. I immerg'd it in limners drying oil and dried it carefully, keeping it ever since very dry. It is now as fair and entire as when the workmen took it up. There were deers horns, an iron knife with a bone handle too, all excessively rotten, taken up along with it.'[4]

Did the rotten bones represent the mortal remains of King Sil, whose horse had disappeared, leaving only its bridle behind? Stukeley did not think so. But he was convinced that the bridle belonged to the harness of a British chariot, and had 'no scruple to affirm that Silbury is the most magnificent mausoleum in the world ... the most astonishing collection of earth, artificially raised, worthy of the king who was the royal founder of Abury, as we may very plausibly affirm.'[5] Nevertheless, he did not believe that Sil was the monarch's name. Instead, he preferred to call him Kunedha, after the British name of the river which ran nearby – the Kennet.

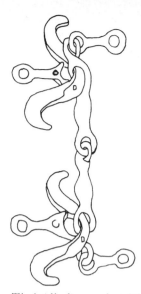

The bridle discovered at Silbury in 1723, drawn by Stukeley.

'It is likely,' he wrote, 'our king Kunedha lived at Marlborough, was buried in Silbury, and was the founder of [the] Abury [henge].'[6]

The bridle survives only in Stukeley's drawing. Some commentators have suggested that it resembles a type common in England in the seventeenth century AD. Others allow that a Viking[7] or even an Iron Age date is possible. However, the use of iron absolutely disqualifies the interment from being contemporary with the Hill, which is now known to belong to a much earlier period.

Long before this discrepancy had been identified, Stukeley's claim to have discovered the primary and original burial was being scornfully dismissed. For example, Douglas, in his *Nenia Britannica*, 1793, retorted: 'The bit of a bridle discovered by Stukeley and his assertion of a monarch being buried there, has only the pleasure of conception to recommend it ... it is not likely the monarch would have been buried *near the surface*, when such an immense mound of earth has been raised for the purpose.'[8]

Despite the doubts surrounding Stukeley's claim, he was certainly correct in his belief that the Hill itself was prehistoric. In the eighteenth century it had been shown that the Roman road between Aquae Sulis (Bath) and Cunetio (Mildenhall), laid out in the first century AD, changed course in an unmistakable manner to steer to the south of the Hill, before carrying on its

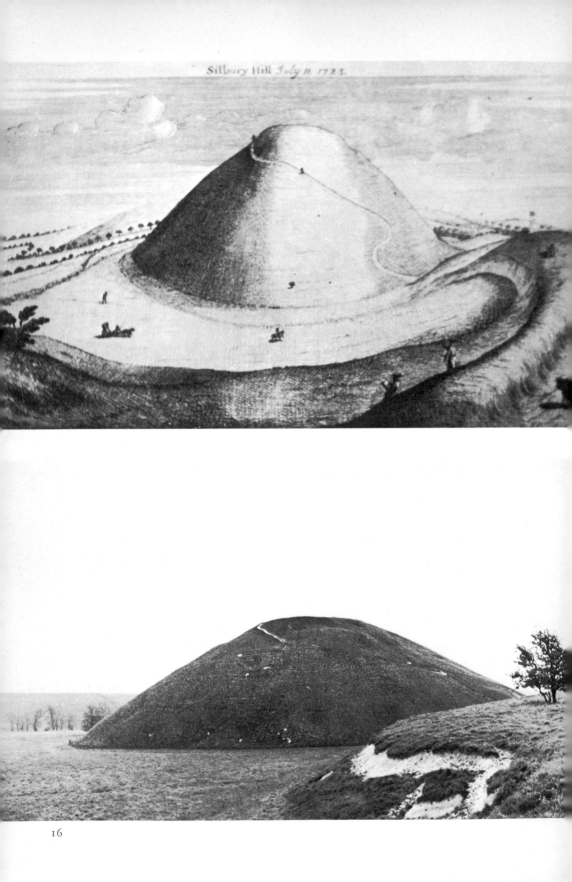

way. Because roads only make detours round pre-existing obstacles, the Hill must predate the road. (The road runs 90 feet to the south of the Hill's base, and is flanked by two ditches, 18 feet apart. It was called the Via Badonica, as a pseudo-scholarly invention.) A. C. Smith established its exact route by cross-sectioning in the nineteenth century, and there has been general agreement that Silbury *is* a prehistoric monument.

Armed with these prehistoric credentials, King Zel wisely retreated from the exposed summit to the concealed base of the Hill, where he achieved remarkable support from later generations of antiquarians, who shared the following assumptions:

1 That Silbury was a mound, built to protect and enhance a tomb.
2 That the tomb was designed for one man.
3 That the man had been the head of a royal house.
4 That he had been buried along with his royal treasure and his horse.
5 That the treasure was likely to match the unique size and importance of the mound.

To keep King Sil on his horse, in the nineteenth century leaders of archaeological opinion in Wessex, such as the rector of Yatesbury, drew attention to the upgraded (or debased) Victorian version of the king's story: 'There is at this day a local tradition that a horse and rider, the size of life *and of solid gold*, yet remains below.'[9]

Moreover, this equestrian statue could be made to carry a heavy weight of scholarship: 'It is a curious circumstance that the tradition embodies a fact, that it *was* the custom of barbarians to bury horses with deceased chieftains.'[10]

Those who believed Silbury to be something other than a tomb-hill or barrow were invited to visit the site: 'The countless barrows which stud the downs in every direction around Silbury, being themselves places of sepulture, proclaim the great hill to be the same. What appearance does Silbury present, but that of a gigantic barrow?'[11]

The final proof awaited only the successful location and excavation of the mighty royal grave. Because the Hill occupied no less than $5\frac{1}{2}$ acres at base, this would be a difficult task. But was not the prospect of an extraordinary prize worth the effort? Perhaps enclosed in a stone chamber somewhere under the chalk mound, the golden rider would spur us on.

(Opposite) Silbury compared. Stukeley's drawing shows the hill rising with exaggerated steepness from the silt-filled ditch. A spur of natural rock, forming the west causeway, is plainly registered.

The Bronze Age barrow

Silbury Hill is a mound, precisely round in plan, 520
feet in diameter, and surrounded by a ditch from which
the material was dug. It is generally regarded as a
round barrow. Since most round barrows in England
are believed to have been constructed during the
Bronze Age, King Sil or Zel, if such *was* his name,
most probably ruled in the Bronze Age, i.e. at some
time between 2000 BC and 1000 BC.

So ran the orthodox view from the nineteenth into
the twentieth century AD. Thus L. V. Grinsell uses a
photograph of Silbury on the cover of his *Ancient
Burial Mounds of England*, and writes inside: 'The best
guess so far is that Silbury is a very large barrow,
probably of the Early Bronze Age, and perhaps of the
chief who was responsible for the building of Avebury
[henge].'[12]

Other respected contributions have been:

'If really a colossal barrow, it is certainly worthy of
its setting in the metropolitan area of Avebury, and
must form the resting place of someone of very
considerable authority and prestige.' (J. F. S. Stone,
1958)[13]

'Silbury Hill, perhaps the outstanding mystery of
Wessex archaeology, but surely only the barrow
idea carried to its logical if enormous conclusion.'
(P. J. Fowler, 1968)[14]

'It must be considered a Bronze Age round barrow,
thought by far the largest in Europe.' (Nicholas
Thomas, 1960)[15]

'Silbury Hill . . . has every appearance of being an
enormous barrow.' (James Dyer, 1971)[16]

Regarding the possibility of treasure, contained
within, Professor R. J. C. Atkinson was able to write,
as recently as 1967: 'Some archaeologists believe that
Silbury Hill is the largest of all Bronze Age barrows,
and is likely to contain a royal burial of exceptional
richness.'[17]

E. S. Wood articulates the widely accepted belief
that 'barrows' generally decline in size throughout the
Bronze Age.[18] This being the case, it was natural to
think in terms of an Early Bronze Age date for the
biggest barrow in Europe. Such a date (*c.*1600 BC,
according to a 1963 chronology[19]) had the added
attraction of possibly representing the continuance of a
tradition of major engineering achievement, flowering

in the Late Neolithic at nearby Avebury, and followed perhaps by the later phases of Stonehenge.

There are five recognized types of Bronze Age round barrow. Of these, only the bowl barrow would appear to resemble the outward shape of Silbury. (The others are characterized by a pronounced ledge between mound and ditch, for which there is no parallel at Silbury.) Bowl barrows were certainly being built in the Early Bronze Age, and they represent the most numerous class. There are nearly 3,700 known examples in Wessex alone.[20] They vary in diameter between 15 feet and 130 feet, although the latter figure is exceptional. None approaches Silbury's 520 feet diameter. As to height, the largest bowl barrows measure 25 feet (*cf.* Silbury's 130 feet), and may be surrounded by a ditch up to 5 feet deep, compared with Silbury's 30 feet.[21]

Doubts and difficulties

The discrepancy in scale is arresting, but Silbury exists, and if it does not conveniently fit into a known category of structures, suspend your disbelief in its credibility as a round barrow at least long enough to examine without prejudice the following statement:

'Barrows are sited on open stretches of country (moors or commons) or on hill tops: if the latter, they may be slightly below the actual top, on what is called the false crest, so that when seen from the settlement lower down the slope, they are on the skyline.'[22]

How does this generalization fit the location of the many Bronze Age bowl barrows in the neighbourhood of Silbury? The answer is that it suits them very well. There are clusters of barrows, or barrow cemeteries, on Overton Hill, Windmill Hill, Waden Hill, and there is a scatter of the same type on the high down to the south of the village of East Kennet. Each of these groupings is within $2\frac{1}{2}$ miles of Silbury Hill, and each lies *above* 550 feet O.D. Beneath these relatively high, and certainly dry, positions runs the valley of the river Kennet, and *in this valley* stands Silbury Hill. From Silbury to Marlborough, a distance of 6 miles, the flat meadows follow the stream in its meandering course. The Ordnance Survey $2\frac{1}{2}$ in. sheet, SU16, marks the boundaries of this strip with contours indicated at 25 feet intervals; not a single round barrow of any sort is drawn on the valley floor. Nor do any occur in the upstream direction towards Avebury and Winterbourne Basset. If Silbury is regarded as a round barrow, its siting must be acknowledged to be exceptional.

The siting of Silbury. The Hill's
location in the Winterbourne–
Kennet valley causes problems
for those who believe it to be a
barrow. Unlike a typical Bronze
Age barrow, Silbury is sited
emphatically on a valley floor.

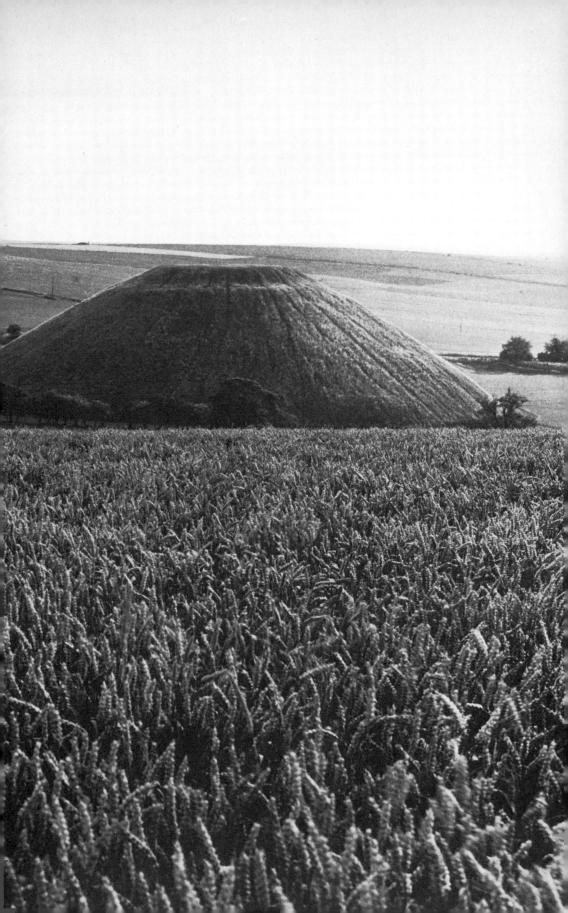

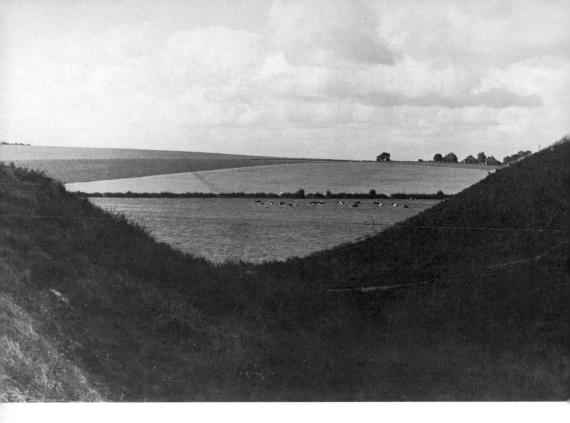

The west causeway, looking northwest. The two causeways create great difficulties for those who try to interpret the Hill as a round barrow.

Another difficulty is presented by the marked step or shelf which breaks the profile of Silbury immediately below the flat summit, for which there is no parallel among the thousands of Wessex bowl barrows. Pondering this anomaly in 1959 Professor Atkinson wrote: 'It suggests that the uppermost section of the mound may have been a later addition,'[23] i.e. an addition to, and an alteration of, a more acceptable barrow shape. In 1970, as a result of his own meticulous work on Silbury, which involved making two cuttings across the terrace, he was able to announce the truth, that the terrace was an original feature of the design.[24] Thus investigation created more problems for the round barrow theory.

If attention is transferred to the ditch surrounding the hill, there are other features which are very difficult to explain. Where in Wessex can one find a round barrow whose ditch is interrupted by causeways of undisturbed chalk, asymmetrically disposed and with the widest more than three times the width of the narrowest? If there is an example which corresponds to Silbury in this respect, it has never been identified. The theory has been advanced that 'the two causeways of solid chalk may be unfinished parts of the work',[25] but can one believe that the designers, who carried their

work upwards to a resolved and symmetrical conclusion, dug downwards in a different spirit, or that a finished mound was made from an unfinished hole?

When all these doubts have been evaluated, there remains the question of scale. How is the discrepancy in size between Silbury and the largest known bowl barrow to be explained? The search for a single bowl barrow to provide a stepping-stone between the two has not succeeded. But there is an important sense in which Silbury has been provided with monumental equivalents. In the immediate vicinity are gigantic and superlative examples of other types of prehistoric monuments; representing the mid-Neolithic, some of the grandest barrows in England lie within sight, as does by far the most impressive British henge monument, constructed towards the end of the Neolithic period, while even nearer at hand are the nearest points on the formerly magnificent Beckhampton and West Kennet stone avenues. It has reasonably been suggested that the daring example of these Neolithic buildings inspired the building of a Bronze Age barrow of unprecedented and never-repeated size, in the same locality.

Perhaps the absence of credible alternatives has contributed as much as anything to the prevailing belief that Silbury is a burial mound of extraordinary size. Another factor has been the attractiveness of the hope that a big burial mound indicates a body of corresponding importance, and therefore wealth; in short, that the largest tomb in Europe might cover the richest prehistoric treasure.

Golden possibilities

Expectations have been based on archaeological realities. Bronze Age grave goods were found under many Wiltshire bowl barrows. Overleaf are some examples of previous finds.

Concerning the disposition of the body in an Early Bronze Age barrow, E. S. Wood says: 'Sometimes the primary burial is in a grave at the centre of the circle, but quite often it is laid on the natural surface, or in a stone cist. Sometimes it is placed on a little conical mound of earth, sometimes under a stone cairn. The body can be tied up, weighted with a stone, or mutilated, and ... the normal rite in the Bronze Age is single burial, as opposed to collective.'[27]

If Silbury Hill was a Bronze Age barrow, 25 times the height of Manton barrow, one might therefore

FINDS FROM BRONZE AGE BOWL BARROWS (WILTSHIRE)

NAME	FINDS
1 *Main Bowl, Circus Group nr Stonehenge*	Beads of amber, faience and stone.
2 *Manton, nr Marlborough* (5 miles from Silbury) (Height 6 ft)	(i) Bronze knife with amber pommel. (ii) Necklace of 150 shale beads, graded in size. (iii) Large shale barrel-shaped bead with gold bands around it. (iv) Bead of gold and bronze, shaped like a halberd. (v) Disc of amber with gold sheet around edge. (vi) 3 bronze awls, 2 incense cups and a collared urn with food offering.
3 *Bush Barrow Normanton Cemetery nr Stonehenge* (Height 11 ft)	(i) Inhumed corpse of what must have been one of the most powerful of Wessex chiefs. The body had been buried clothed. On the chest was sewn:[26] (ii) lozenge-shaped plate of sheet gold. (iii) 3 daggers, one having a handle inlaid with hundreds of tiny gold pins. All in sheaths of wood, leather-lined. (iv) Bronze axe, and remains of shield. (v) Mace; wooden shaft decorated with bone rings and fitted with a honey-coloured stone head.

expect to find a single body, accompanied by grave goods, placed at or near the centre of the mound, and close to the original ground surface.

For at least the last 250 years the advocates of this possibility have demonstrated how an emotional preference can help to overcome uncertainty. Consider the following statements, typical of many, where complete professional uncertainty is immediately followed by allegiance to the barrow theory:

'The date and purpose of Silbury Hill remain a mystery. It should perhaps be regarded as the largest of all round barrows.'[28]

'No satisfactory explanation of its age or purpose has ever been arrived at, but it is certainly pre-Roman, and is probably an enormous tumulus.'[29]

The hero/treasure syndrome

As we have seen, everyone likes treasure, and hopes for treasure to be found under barrows. These hopes were given substance by the finds at Sutton Hoo when, in 1939, a rectangular pit was discovered under a partially eroded tumulus near the river Deben in Suffolk. In the pit were the remains of a Saxon boat, and in the boat lay the Sutton Hoo treasure. Its presence indicated that a truly spectacular hoard may still be found under an easily identified burial mound.

The sustained warmth of public interest in the Sutton Hoo treasure suggests a national identification with the objects, and also with the motives which caused them to be assembled. Those motives are instinctively (and correctly) felt to be very close to our own drives and aspirations. The compulsion to wrest wealth from the pattern of general circulation, and to keep it, to guard it (the Silbury walls are thicker than those of the Bank of England), to cling to it, even after death, and in spite of all attempts by tomb-robbers, is a drama made to enthral an audience of heroic capitalists.

Who put King Sil into Silbury? We did, because we wanted him there – a superman with a super treasure hoard – a man (naturally) so vain, so aggressive, so successfully acquisitive, so preoccupied with eternal fame, that he could provide us with a standard of excellence worthy of respect. In defeating the obscurity of death, he carries our best wishes and gives us hope. Without such men how would we stand vis-à-vis earwigs, elm trees or clods of mud?

So let us dream of the Great Wessex Warrior who

gripped the gold and copper routes from Ireland to the Continent in one clenched hand, and with the other pointed in megalomanic force at a patch of grass on the Wessex downs, and ordered for himself Europe's biggest tomb. To that place trudged the shackled multitudes, to labour under the music of the whips in the manner indicated by film epics.

In view of the history of the last three centuries, when feats of arms and mercantile energy granted England sovereignty over one third of the entire world, it is hardly surprising that our prehistorians have tried to reconstruct Silbury Hill to conform to the patterns and priorities of a patriarchal warrior society, where it did not belong, and could not be made to fit.

The empty tomb

Bones of our wild forefathers, O forgive,
If we now pierce the chambers of your rest,
And open your dark pillows to the eye
Of the irreverent day! Hark, as we move,
Runs no stern whisper down the narrow vault?
Flickers no shape across our torchlight pale,
With backward beckoning arm? No, all is still . . .

Emmeline Fisher
Lines suggested by the opening made in Silbury Hill, 1849.

The Drax shaft, 1776

In 1776 the Duke of Northumberland let it be known that, under his patronage, a Colonel Drax would direct the excavation of Silbury Hill. Cornish tin-miners would be employed to sink a vertical shaft from the middle of its flat top to the original ground surface, 130 feet below. The shaft was to be 8 feet square, tapering to 5 feet by 4 feet 6 inches at the base. The decision to dig vertically from the centre was directed by common sense. It was known that burials were normally placed at the centre of round barrows and, in the case of Silbury, the central axis was emphasized with extraordinary insistence by the strong definition of the flat circular summit and the surrounding terrace. There was nothing furtive about the dig. Indeed its goal was the revelation to the world of the riches of antiquity. His Lordship, in common with many aristocrats of his day, had a passionate interest in the remote past and knew that it could provide him with statuary, artefacts, and ornaments.

Syon House, entirely remodelled for Northumberland during the previous decade by Robert Adam in the 'true antique Roman manner',[1] was intended to be furnished with objects from antiquity. In 1765 Adam wrote to Charles Rogers begging customs clearance for a shipload of works of art commissioned by Lords Northumberland and Shelburne, and collected 'during severall years in Rome'.[2] Collected, not made; and much of it from the ruins of Herculaneum, lately revealed beneath a thick cover of lava.

For Northumberland, Silbury Hill was to be a British Herculaneum. At his instigation and expense,

a new and perhaps glorious facet of antiquity would be revealed to an astonished world – or at least to that part of it permitted to make the pilgrimage to Syon House. The antiquarian community had been alerted, its appetite aroused. Bingley's *London Journal* for 1776 reports: 'They have made a hole in the top. The antiquarians promise themselves wonders from the bowels of this mountain.'[3] Nearly twenty years later, the author of *Nenia Britannica* described how he had visited Colonel Drax to review the results of the excavation:

The great hill of Silbury, generally considered as a barrow, was opened under the direction of the late Duke of Northumberland and Colonel Drax, under the supposition of its having been a place of sepulture. The only relic found at the bottom was a thin slip of oak wood. By burning the end of it in a wax taper, we proved it not to be whale bone, which had been so reported; the smell of vegetable substance soon convinced the Colonel of his mistake. There was no reason for considering it to have been a place of sepulture by the digging into it.[4]

No golden horse, no gold in any shape. No bronze axe, no urns broken or entire. No body, no grave, no burial chamber of any kind. Nothing but a slip of whale bone which turned out to be oak. Where were the flashing chevrons, golden nails, lumps of marvellous amber, torques, bracelets, shining lunulae neck pieces, or arrangements of bi-conical beads carved in sullen jet? Not found. Neither were perforated mace heads, nor flint arrow heads, delicately worked, nor conical buttons, nor skull with perfect teeth. Nothing of these, and no sign at all of previous disturbance. Such a pitiful return for capital and hopes honestly invested. But aristocrats are trained to absorb disappointment manfully, and there is little to indicate that the Duke suffered more than temporary embarrassment.

The Merewether tunnels, 1849

If there were to be no Silbury trophies to display at Syon House, the reason may have been that the miners dug hard and straight, but not true. Writing in 1850, Dean John Merewether, who was in a position to know, stated: 'One thing is manifest, that the examiners of 1777 did not hit the actual centre of the tumulus.'[5] Much had been learnt about tunnelling techniques in the intervening years, and perhaps it was experienced gangs of railway navvies who took part in the next organized attempt to find the Silbury Hill treasure. This attempt was led by J. Merewether, Dean of

John Merewether, Dean of Hereford, who tunnelled into Silbury, 1849.

Hereford, in collaboration with a civil engineer, Mr Henry Blandford – a team as truly representative of Victorian England as the landed aristocrat/soldier combination had been of the previous century. Behind Merewether and Blandford lay the support of the Archaeological Institute, whose officers indicated a desire that the dig should coincide with their meeting in Salisbury in the summer of 1849. Accordingly, during July and August 1849, men worked in shifts, night and day, to drive a horizontal tunnel from the southwestern edge to the very heart of the mound – a distance of nearly 300 feet. The tunnel was to be $6\frac{1}{2}$ feet high – tall enough to permit the easy passage of gentlemen visitors wearing top hats, and three feet wide. The entrance to the tunnel was positioned in the ditch between the two causeways. For the first third of its length it was directed at an angle slightly above the horizontal, so as to penetrate the solid natural chalk, till emerging on to the old ground surface. Then, as Merewether subsequently described: 'From the points of junction of the tunnel in the natural chalk with the line of the surface of the original hill, the workmen followed that line as their guide, keeping it about two feet below the ceiling of the tunnel; in as much as there could be little doubt that whatever deposit might be found, would either be on the surface of the original ground near the centre, or in a cist formed immediately below that line.'[6] He adds: 'On my first visit they had advanced about 40 yards.' Before returning to Salisbury, and mindful of the safety of the central deposit, he 'suggested [to Mr Blandford] that it would be desirable that the workmen should stop when they had reached within two yards of the centre'. Another reason for this advice was perhaps that on his next visit he hoped to be accompanied by the distinguished members of the Archaeological Institute, who would therefore be present at the moment of discovery. The Dean's hopes were justified. The Institute were indeed prepared to interrupt their proceedings to travel from Salisbury in his company. They were anxious to be present at the birth of the new tomb. Public interest was also keen. The *Wiltshire Gazette* of 23 August 1849 commented on 'the great number of persons who have visited Silbury Hill since the tunnel was commenced. It is evident that considerable interest is taken in the operations.'

Such had been the enthusiasm of Mr Blandford and his workers that 'on our arrival at Silbury we inspected

the interior when it appeared that the workmen had penetrated to the extent of 88 yards – in effect 16 yards beyond the centre of the tumulus'.[7] But 'nothing had been discovered'. No burial, no grave goods, no chamber of wood or stone was to be found, and 'since the line of the original turf of the natural hill was traceable, it was clear to demonstration that this had not been cut through'[8] – as it would have been if any prehistoric burial pit had been sunk in the subsoil. Mr Blandford, a man of unimpeachable character, reported that in burrowing towards the centre there had indeed been hope of a burial chamber lying substantially above the old ground level. A hollow-sounding place was detected in the roof of the tunnel. This had encouraged them to double the height of the tunnel over the last 80 feet to the centre, but with this extra effort the sound disappeared and was never heard again. On hearing this news the cream of British archaeology returned to Salisbury, while the local gentry gathered on Waden Hill, overlooking the site, and waited patiently for something to turn up.

Although money for the workers was running out, the Dean ordered cuttings to be made at right angles to the tunnel where it passed through the central area, and in one of these side tunnels, just off the main axis, they came across the unstable chalk in-filling of the base of Northumberland's shaft. Merewether could justifiably claim that Drax did not hit the centre of the tumulus, whereas he had 'excavated its very core'.[9] His pattern of tunnels was continued until it came to resemble in plan the shape of an elaborate pastoral staff.

By August 15th it became clear that the dig which had started seven weeks before was going to end without finding treasure. Work stopped. But education can survive without treasure; Merewether climbed Waden Hill and spoke to the assembled inhabitants, taking as his theme the need to treat local antiquities with reverence and respect. The people departed, and so did Mr Blandford, but the Dean returned once more to the tunnel, and dug on until the end of the month. At last he gave in, and Mr Blandford 'reported to the committee that the making of the tunnel and other excavations proved satisfactorily to him that the purpose of the hill was not sepulchral'.[10]

Mr C. Tucker of the Institute drew the following conclusion: 'The sepulchral theory being thus exploded, that which supposed Silbury Hill to have had some

connection with the great temple of Abury, either for the assembling of the people, or for religious purposes, seems to have a better foundation.'[11] It seems that this view found general support during the years that followed, because in 1862 the vicar of Yatesbury, the Revd A. C. Smith, set out to restore Silbury's reputation as a tomb.

A. C. Smith restores the tomb

'I am very desirous to rescue it from the imputation of having been raised for other than sepulchral purposes. Against the probability of its being a tomb of some Sovereign or famous chieftain among the early Britons, I confess I have seen no arguments of any force.'[12]

That the famous chieftain had not been found merely proved to Smith that shaft and tunnels had been driven in the wrong directions. Reasoning from the premise that an important burial did exist under the Hill, he was only surprised that the excavators had expected to discover it at, or near, the centre, since 'Those rude workmen [the navvies of a remote age], as they heaped up their vast tumulus, soon losing sight of the tomb to guide them, would necessarily fail to preserve it as their centre.'[13] He was satisfied that the workmen would not even have tried to keep a check on matters: 'It is not probable that the workmen would have been at any pains to preserve the tomb as a centre, even if it had been so at the first heaping up of the earth'[14] – a carelessness approaching that of nineteenth-century slag heap construction.

Sir W. M. Flinders-Petrie, who excavated near the east causeway, 1922.

Flinders Petrie excavates, 1922

By 1920, the double failures of Drax and Merewether had been assimilated, and the irrepressible hopes for a tomb were taking positive shape once more, and this time among men with international reputations as archaeologists to risk or enhance. While the War Graves Commission set about the formidable task of erecting obelisks and granite crosses all over Europe, and the Cenotaph was set up in Whitehall, Flinders Petrie came from Egypt and began to dig.

A life's work among the pyramids persuaded him to search for an entrance to a burial chamber – first at the southeastern, and then at the southern perimeter of the mound. No entrance was found. The cone was not to be a pyramid,[15] though the entrance to a passage could yet be located elsewhere on the circumference.

It was therefore still possible to believe that such a feature existed, and would one day be found. If so, the walls and roof of the passage would probably be constructed of the irregular slabs of Eocene sandstone, called sarsens, which occur naturally, littering the chalkland surface in the locality. Although chalk itself can be seen used as a building stone in the walls of old Wiltshire cottages, it is entirely unsuitable for employment in a load-bearing tunnel roof. Moreover, it is established beyond doubt that during the Neolithic period, which preceded the Bronze Age, sarsens were used in the construction of the galleries of local long barrows, such as the West Kennet long barrow – a tradition of sarsen passage building available to the builders of Silbury.

The prospect of excavating a zone running round the entire circumference of the mound in order finally to settle the question of a passage represented a prodigious expenditure of labour for a possibly negative result. What were the alternatives?

1 Air survey: By 1920 it had been recognized that the shape of buried features may be detected from the air which are not obvious or in any way visible from the ground. O. G. S. Crawford[16] and others began compiling a library of air photographs of prehistoric Wessex. In the case of Silbury, this work offered no indication of additional concealed features.

2 Probing: A long established and very effective technique, whereby a metal rod is pushed into unexcavated deposits to locate as yet unexposed hard features, such as blocks of sarsen sandstone. No underlying hard feature has been located by probing at Silbury.

3 Electrical resistivity: Using this method, developed in recent years by geophysical prospectors, subsurface irregularities may be accurately plotted. It relies on the principle that different deposits offer different resistance to the passage of an electric current. Sandstone, for example, will offer more resistance than compacted chalk rubble. The system employs four steel probes connected by cable to the meter, two to carry the activating current, two to pick up the current passing through the ground.[17] The method is capable of locating anomalies at a far greater depth than is possible with normal probing.

Dr McKim's survey, 1959

In 1959 Dr F. R. McKim undertook to complete a resistivity survey of Silbury Hill, knowing that however much chalk had fallen or been placed over the entrance to a sarsen passage, the hidden feature would register on his instrument. Working systematically around the base of the Hill, he came across a single well-defined irregularity. Was this the blocking slab of a tunnel? Yes, it was. He had picked up a reading from the iron-bound door incorporated into the hillside by Dean Merewether to seal off the entrance to his passage.[18] Otherwise the results were negative (and the entire surface of the Hill was tested), except that Dr McKim became aware of a very faint overall oscillation in readings, signifying in his view the initial pattern of dumping chalk materials.[19] As regards a prehistoric passage, he said: 'The main purpose of reporting this negative result is to avoid any further application of the same method, with the same undesirable end.'[20] Notice that the *method* is advised against in future, rather than the desire for, and anticipation of, a particular result. In fact both the method and the skill of the operator were quite excellent, and it seems unfair to reproach either since they convincingly contributed to the destruction of a passage-grave theory, and simultaneously rendered almost impossible the existence of an off-centre burial chamber. But the preservation of irrational subjectivity among those who are dedicated to the scientific method remains one of the more beautiful modern mysteries, and for some archaeologists of scientific outlook the conclusion to be drawn from McKim's work was that the elusive vault had not been found, and that the search for it must therefore continue.

Professor R. J. C. Atkinson and BBC 2, 1967

In 1967, Professor Richard Atkinson, who had previously excavated at Stonehenge and the West Kennet long barrow, was sponsored by BBC 2 to carry through 'one of the most exciting researches ever undertaken in British archaeology'.[21] It was called the Silbury Hill Project, and was in many respects a new approach to the problem. 'The Silbury Hill Project has been planned as a combined operation, involving the collaboration of specialists in archaeology, engineering and the physical and natural sciences.'[22] The work was to be divided up as follows:

1 *Department of Geography, Bristol University:*
Insertion of a grid of pegs across the site.

2 *Nature Conservancy Board:*
Study of the modern vegetation of Silbury Hill.

3 *Department of Zoology, Southampton University:*
Survey of present-day animal life of Silbury Hill.

4 *Department of Mining, Cardiff University:*
(a) The digging of a new horizontal shaft, above the level of the 1849 tunnel entrance, following the old land surface, to link up with the 1849 tunnel.
(b) The old workings to be enlarged and made safe.
(c) The installation of a steel door at the mouth of the tunnel.
(d) The installation of steel arches at intervals along the tunnel.
(e) The installation of a light railway, a conveyor belt, powered by compressed air, forced ventilation, electric light and telephones.
(f) 'Like other mining operations', the work was to be carried out in shifts.

5 *Department of Geology, University College, Cardiff:*
(a) Geophysicists to make borings through the mound and the silting in the ditch.
(b) Echo-sounding equipment to be used to discover the depth of the ditch.

6 *Department of Archaeology, University College, Cardiff:*
To be responsible for the archaeological excavation.

7 *Department of Human Environment at the London University Institute of Archaeology:*
The study and recording of buried materials, including the remains of prehistoric plants and animals found in the layers exposed in the tunnel.

Thus a battle order was drawn up consisting of seven divisions of specialists who formed an army sufficiently formidable to solve a formidable problem. What did these forces have in common? They shared a belief in the efficacy and self-sufficiency of the scientific method. Speaking of the whole operation before it was launched Professor Atkinson said: 'We shall concentrate deliberately . . . upon instrumental methods of exploration, so as to define as narrowly as possible the questions to be asked and the areas to be examined, and then answer them by digging or tunnelling.'[23]

To explore by defining as narrowly as possible the questions to be asked may have many virtues as an

The Merewether tunnel of 1849, covered by a Department of Works door of 1921, on which is superimposed the 1968 Silbury excavation sign. Professor Atkinson stands at the door.

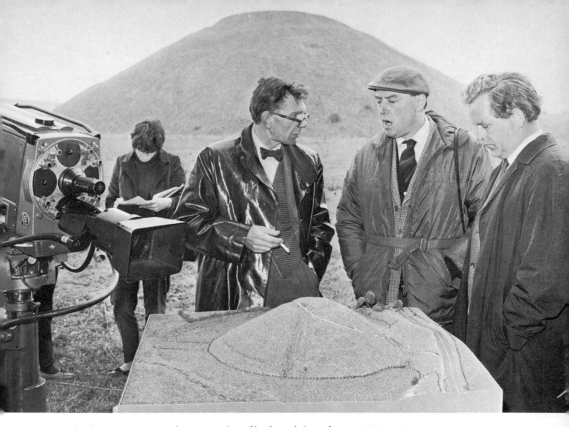

approach, but the procedure can hardly be claimed as novel. Narrowness of definition was known to have been a characteristic of respectable European thought in the late eighteenth century, when the Duke of Northumberland asked, 'Where is the treasure?', and William Blake wrote: 'Man has closed himself up till he sees all things thro' narrow chinks of his cavern. If the doors of perception were cleansed, everything would appear to man as it is – infinite.'[24]

But before misgivings are felt at the threshold of the 1968 opening, reflect on the steel door being set up at the entrance to the new tunnel. Why should such a shiny door be cleansed, and what extra illumination was necessary in the tunnel beyond, where provision had been made for enough artificial light to satisfy the needs of several television cameras? Blake could hardly have guessed that such advanced techniques of recording, if not of perception, would ever have come within an antiquarian's reach. Only a few archaeologists regretted that the public were to be admitted, electronically, into the mound, to watch the excavation. For us viewers, pleasurable anticipation ran high.

'Viewers will see everything of significance as it happens. If a particularly interesting situation develops there may even be five-minute programmes every day

Televised press conference at Silbury, 1967. Professor Atkinson (left) with senior producer Paul Johnstone and commentator Magnus Magnusson (right).

over the crucial period,'[25] Paul Johnstone, head of the BBC2 archaeology unit advised, and spoke half-jokingly of the golden rider on his golden horse.

Professor Atkinson was more circumspect. However, he was prepared to write: 'Some archaeologists believe that it is the largest of all Bronze Age barrows and is likely to contain a royal burial of exceptional richness,'[26] and offered the opinion that it was 'perhaps hardly surprising that previous attempts to probe the secrets of Silbury Hill by digging had failed, in view of the vast size of the site'.[27]

What were the secrets, unsuccessfully probed, to which he referred? Were they the secrets surrounding the precise location of the royal burial, in search of which each of the previous diggers had begun work?

The director of the 1968 excavation was prepared to keep an open mind, and mentioned specifically an alternative interpretation of the monument – 'that it was built as a beacon in a prehistoric system of signalling'.[28] Two reasons may be suggested for the choice of this particular possibility. They are:

1 It was not made of gold, and would not therefore clash with the colour of the horse on which Mr Johnstone had placed his money.

2 It had no legs, being overlooked by the surrounding hills – any one of which would have provided a far superior and entirely natural beacon site, viz. Thorn Hill, 800 feet; White Hill, 650 feet; Tan Hill, 964 feet.

The king from Stonehenge

On the other hand, the alternative (tomb) theory now required that Silbury should be viewed not from these hills, but from a monument lying 17 miles to the south called Stonehenge.

The successful post-war excavation of Stonehenge, conducted by Professor Atkinson, led him to speculate upon the nature of the society responsible for that monument. These speculations in turn carried his thoughts to the very foot of Silbury Hill:

I believe that Stonehenge itself is evidence for the concentration of political power, for a time at least, in the hands of a single man, who alone could create and maintain the conditions necessary for this great undertaking. Who he was, whether native-born or foreign, we shall never know; he remains a figure as shadowy and insubstantial as King Brutus of the medieval British History. Yet who but he should sleep, like Arthur or Barbarossa, in the quiet darkness of a sarsen vault beneath the mountainous pile of Silbury Hill?[29]

And so, on 8 April 1968, began the most systematic, heavily recorded, and widely publicized phase in the long search for the royal tomb. It was to last intermittently until 9 August 1969. On that last day of all, the first man-made container ever to have been discovered under Silbury Hill was brought to light by Colonel Vatcher, deputy director of the excavation. It was a tall, sealed, cylindrical pot, found embedded in the very heart of the hill. Although cracked, the component parts were successfully taped together *in situ*, and in full view of the television cameras the lid was removed. The contents were in a good state of preservation. They were the neatly packed momentoes of the 1849 excavation – newspaper cuttings relating to the dig, an almanack (the *Royal Almanack and Nautical and Astronomical Ephemeris*, 1849), and a large poster advertising a public meeting in Devizes of the Wiltshire auxiliary branch of the British and Foreign Bible Society (the Dean's gift to the ghost of an illiterate but influential pagan). Emmeline Fisher's poem, quoted at the start of this chapter, was also included. Professor Atkinson subsequently described the find as a small consolation prize for enduring the disappointments of the previous two years.

Summing up the dig in 1970, he wrote: 'No trace of any structure, deposit or ancient disturbance was found in the small area near the centre which had not previously been explored.'[30]

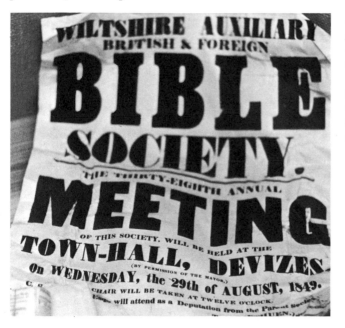

Bible Society poster from the pot placed under Silbury by Dean Merewether, 1849, and unearthed by Professor Atkinson, 1969. The eradication of nature worship by Christian missionaries was a notable feature of nineteenth-century religious activity.

Every part of the central area, where a primary Bronze Age burial would have been placed, has therefore been explored. No shred of evidence has been discovered to support the hypothetical inhumation of a Bronze Age Barbarossa. On the contrary, the closer the investigation, the less acceptable does the theory become, and the very great difficulties in reconciling the external shape of Silbury with a round barrow came into view once more – its strangely irregular and 'uncompleted' ditch, the steepness of the mound, its curious flat top and surrounding terrace, the highly improbable valley floor siting, and the lack of an associated barrow cemetery.

The compulsion to regard Silbury Hill as a tomb may not have played itself out, since it is based on strong and widespread emotional requirements. But if we are determined to remodel Silbury to conform to the romance of heroic capitalism, the new shape is best constructed in the mind. To measure this image against the real facts damages both the fantasy of the warrior king and the physical structure of the Hill. Indeed if every ounce of the total mass were removed speck by speck with a pair of tweezers, till the old ground level were revealed over every square inch of the $5\frac{1}{2}$ acres, burial mound convictions would be destroyed as certainly as the Hill itself.

Inside the treasure

The central core

In August 1849 Dean Merewether stood in his tunnel
under the middle of Silbury Hill, and conceded that
nothing had been discovered – nothing 'excepting the
peculiar condition of the material of which the hill was
composed abouts its centre'.[1] For at a distance of 66
feet from the centre of the mound the workmen had
cut the perimeter of a low, circular mound of matter
which differed markedly in colour and texture from the
chalk through which they had been digging up to that
point. The top surface of this mound sloped gradually
upwards to achieve an estimated height of 12 feet at
the common central axis of the Hill and underlying
core. Merewether described the material of the core as
'a black peaty substance composed of sods of turf
piled together, containing great quantities of moss, still
in a state of comparative freshness, and which had
evidently been taken from the excavated area [the
ditch] on the East, West and North sides of the tumulus,
on the borders of which a small rivulet runs, a tributary
of the Kennett.'[2] But, of course, when this initial core
was deposited, there was no excavated area or ditch,
since it resulted from the quarrying operations that
were to follow. The moss must therefore have come
from some other 'wet and watery locality'. The Dean
was struck by the fact that it 'retained its colour and
texture . . . and the freshwater shells which were inter-
spersed on its surface are still preserved in most re-
markable freshness and transparency.'[3] He goes on:
'Above and about this layer was a dense accumulation
of black earth, emitting a peculiar smell, in which were
embedded fragments of small branches of bushes.'
From within this area 'caudal vertebrae of the ox or
perhaps red deer, and a very large tooth of the same
animal were carried out in the wheelbarrows, so that
the exact spots in which they had rested were not
known.'

Then, recalling a curious visual and tactile memory
he adds: 'I must not omit to state that in many places
within this range [the core], [starting] from the centre,

*Inside Silbury, August 1968.
The primary mound shows dark
and layered behind the Danger
sign.*

and on the surface of the original hill, were found fragments of a sort of string, of two strands, each twisted, composed of (as it seemed) grass, and about the size of whipcord.'[4]

In the branching side tunnels on the right hand or east of the main tunnel, other discoveries were made: 'Following the dip of the heap . . . many sarsenstones were discovered, some of them placed with their concave surfaces downwards, favouring the line of the heap, casing as it were, the mound.'[5] Sarsens were also found at other places around the circumference of the vegetable core mound. 'On top of some of these were observed fragments of bone, and small sticks, as of bushes, and, as I am strongly disposed to think, of mistletoe . . . and two or three pieces of the ribs of either the ox or red deer, in a sound and unusually compact state, and also the tine of a stag's antler in the same condition. It is not improbable that it may have been specially regarded.'

The primary mound

The reopening of Merewether's tunnel during the 1968 dig enabled the core to be re-examined. It was found to be part of a more extensive primary mound, which Atkinson designated Silbury I. From those parts which had not already been dug away, he analysed its composition in the following manner:

'Silbury I stands on an almost level natural terrace. There is no surrounding quarry ditch. All the materials seem to have been derived from the valley bottom deposits collected at a distance of several hundred meters to the North or East.'[6] Initially, a circular area about 20 metres (65.6 feet) diameter was enclosed by a low fence, supported by widely spaced stakes. Subsequently a low circular mound of clay with flints, 5 metres (16 feet) in diameter and 0.8 metres (3 feet) high was built in the centre of the enclosed area, and covered by a heap of stacked turf and soil extending outwards to the fence. This central core was then

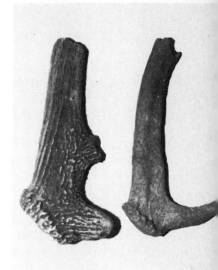

Red deer antler picks, excavated from the Silbury core, 1849.

enclosed within four successive conical layers of mixed material dug out from the flood plain of the adjacent valley,[7] to complete a primary mound with a diameter of 34 metres (120 feet), and an estimated height of 5.25 metres (18 feet).[8] The four conical layers 'were of mixed chalk, gravel, and soil, each about 20 inches thick, and each of horizontally banded structure, the result of tipping individual basket loads in a controlled manner'. In order to explore as much as possible of this central area, the tunnel was enlarged during 1968/9 to a final size of 13 feet in width, and 10½ feet in height.[9]

Atkinson also confirmed Merewether's remarks concerning the comparative freshness of the prehistoric vegetation: 'Some of the grass and moss here is still green, and the remains of ants and insects are so well preserved that an expert can tell that the turf must have been cut and stacked in the late summer (August), because it is only then that the insects would have reached the state of development observed.'[10] In other words, the ants had wings. According to M. V. and A. D. Brian (*Evolution*, Vol. IX, 1955), 'flights for mating occur after the females have matured (in late July) . . . and 25 per cent of queens have mated by August 5th.' The implication of this for Silbury is that the turf was more likely to have been cut and stacked in late July than in late August.

However the primary mound is interpreted, there is no doubt concerning the care with which it was designed and built. The radiating spokes of twisted

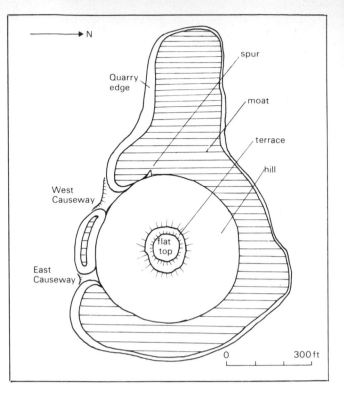

Plan of Silbury (from the BBC pamphlet, 1968).

string, the wattle fence, the studied layering of clay, turf, chalk, gravel and soil, the sarsens and their associated animal bones and branches – all these indicate control and purpose. In addition the layout strongly emphasizes the central axis of the Hill. The internal features reflect and are at one with the outer shape – the circular summit lying directly over the primary mound.

The chalk walls

This arrangement is further emphasized by the pattern of construction employed for the main chalk bulk of the Hill. Flinders Petrie had written in 1922 of chalk-walling as a feature of the periphery revealed by his trenching in the south-east sector,[11] while McKim showed the Hill below the present surface to be 'not a uniform rubble'.[12] In other words, the mound was heaped in level layers, and not added to on the sloping face. The 1968 dig confirmed the 1920 discovery that Silbury was arranged with stupendous deliberation. The entire structure appears to have been planned as a gigantic three-dimensional spider's web, with walls of uncemented chalk blocks representing the radial and concentric elements, while the interstices were packed with small-grade chalk rubble.

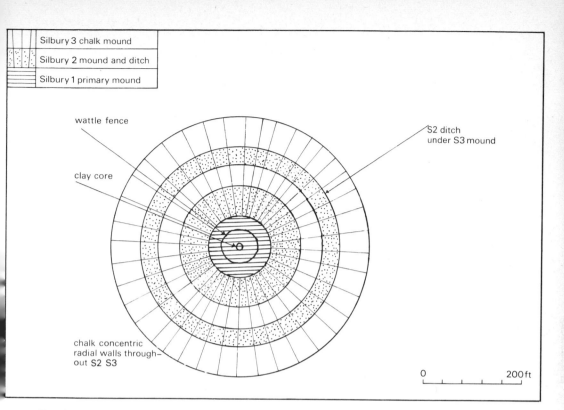

In the figure:
- Silbury 3 chalk mound
- Silbury 2 mound and ditch
- Silbury 1 primary mound
- wattle fence
- clay core
- S2 ditch under S3 mound
- chalk concentric radial walls throughout S2 S3
- 0 — 200 ft

In elevation, this web was a tiered structure, composed of 'six well-defined steps or benches, each approximately 17 feet high',[13] producing a hill the shape of a stepped cone. Both radial and concentric walls have been located on each of the steps, 'and it seems likely that the entire mound was built in a series of relatively small separate dumps of chalk rubble, each revetted by such retaining walls'.[14] On the summit they were found to be spaced radially at intervals of just over two metres, although here, as on the lower tiers, the intervals varied.

The seventh and lowest step is of course the isolated mass of undisturbed chalk, which stands up nearly 30 feet *above* the bottom of the excavated ditch. Against its vertical face, 'chalk rubble had been deliberately piled in horizontal layers, immediately after the initial excavation, and retained on the outer side by stepped timber revetments'.[15] Atkinson reasonably interprets this 'curious and unique device'[16] as an engineering technique to prevent the undermining of the hill by frost action and the possibility of landslides. An additional and positive function will be proposed later.

The shallow steps surrounding the base of the mound are not visible today: they lie beneath the silt which more than half fills the ditch. The 17-foot steps

Diagrammatic ground plan of Silbury Hill.

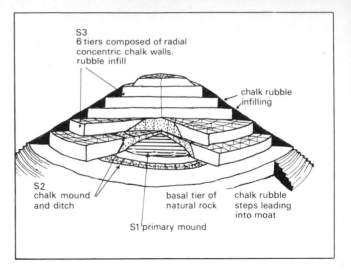

S3
6 tiers composed of radial
concentric chalk walls,
rubble infill

chalk rubble
infilling

S2
chalk mound
and ditch

basal tier of
natural rock

chalk rubble
steps leading
into moat

S1 primary mound

Block diagram of Silbury Hill.

of the tiered cone are not visible (except the uppermost) for a different reason – they were deliberately packed out with chalk rubble very shortly after construction, and therefore lost their identity. The very slight degree of weathering endured by the edges of these steps makes it certain that they have spent almost all their life under cover. In fact A. D. Passmore, a member of the Flinders-Petrie dig, expressed the opinion that the exterior of the mound must have been turfed over immediately after construction.[17] Why was the form altered in this radical manner – from geometrically hard-angled to plump? Should it be seen as the contradiction of one idea by another, or as two necessary stages in achieving a single goal – namely the building of a flat-topped cone, 130 feet high, which would be quite unusually stable?

The second view is most convincingly argued by Professor Atkinson, when he speaks of the 'need to avoid loading the unstable outer edges of the mould until they had had time to consolidate'.[18] In a television interview he described the designers of the Hill as 'being almost obsessively concerned with stability'. In the following pages it will be suggested that stability was fundamental to the function. Meanwhile, the 1922 finding, confirmed in 1968, should be recorded:

'There seems to have been very little erosion of the mound itself.'[19] To all intents it is the same shape as on the day it was completed.

One further important discovery was made during the 1968–9 widening of the Merewether tunnel. On the old and now buried land surface, between the edge of the primary mound and the perimeter of the Hill as

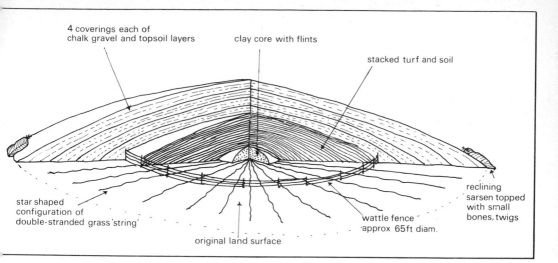

4 coverings each of chalk gravel and topsoil layers

clay core with flints

stacked turf and soil

star shaped configuration of double-stranded grass 'string'

original land surface

wattle fence approx 65ft diam.

reclining sarsen topped with small bones, twigs

The primary mound revealed. Block diagram.

seen today, a circular ditch had been dug into the chalk. This ditch had an internal diameter of 380 feet and a width of 70 feet. Its floor was not at a uniform level – there was a pronounced step towards the outer edge. What puzzled the excavators was the completely unweathered condition of the vertical ditch sides,[20] pointing to the different conclusion that it had been refilled immediately upon formation, and with the same meticulous system of concentric walls which characterized the rest of the chalk mound.

The known physical facts concerning the internal structure of Silbury Hill have been described, and the Hill emerges as a highly remarkable thing, winning the respect of modern engineers by the sophisticated stability of its design.

The search for meaning

The essential historical *meaning* of Silbury Hill is the subject of this book but, before it can be found, it is necessary to establish the age of the monument. The age of Silbury Hill is the key to its meaning.

How old is Silbury Hill? The answer to that question is already available, thanks to the work of a Victorian amateur, A. C. Pass.[21]

In 1886 Pass had dug ten shafts through the silt which half-filled the Silbury quarry ditch. Five feet above its floor, he found a leaf-shaped flint, worked by human hand, and attributed by Mr J. Evans, D.C.L. F.S.A. to the Early Bronze Age. Since the substantial thickness of silt lying *below* this artefact had been laid down over a long period, he reasonably put the Silbury date *before* the start of the Bronze Age, i.e. in the New

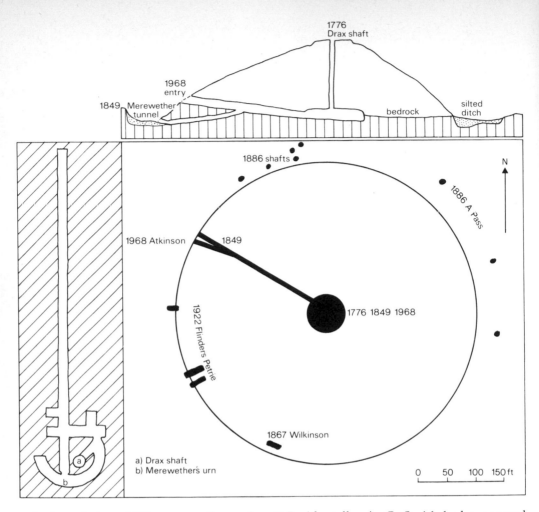

Section and plans of Silbury
excavations, with enlarged
terminal plan of Merewether
tunnels (left).

Stone Age.[22] Incidentally, A. C. Smith had suggested twenty-four years previously (*Wilts Arch. Mag.*, 1862) that Silbury might belong to the Stone Age. He wrote: 'The absence of even the smallest particles of bronze or iron indicates a period prior to the age of metals.'

Pass's flint, discovered in Shaft 5, could not have been moved five feet off the shaft floor by earthworms or some other chance agency, because it was found firmly embedded in a thin horizontal layer of debris, composed of ash, animal bones, and a human thigh bone.

Pass's discovery should have put an end to the Bronze Age barrow theory. He had moved Silbury back into the Stone Age. However, although his results were published, they were largely ignored.

The radio carbon date

Consequently it came as a shock when, over eighty years later, Atkinson also arrived at a pre-Bronze Age

conclusion, by a different route – that of radio carbon dating, which placed Silbury in the third millennium, *c.* 2660 BC.

The Hill is over 4,500 years old. This knowledge was gained by an examination of the organic material in the primary mound – the prehistoric vegetation, first discovered by Merewether, which was as old as the Hill itself. 'The exceptional state of preservation of the organic material . . . has made it possible to assemble sufficient unburnt vegetable matter, consisting mainly of fragments of hazel from the turves of the core . . . for radio carbon dating at Isotopes Inc., Westwood, New Jersey, USA.'[23] Tests, based on an analysis of the carbon 14 content, produced the following dates: 2145 BC \pm 95, i.e. an earliest date at 2240 BC, and a most recent at 2050 BC – a possible range of 190 years.

1968 was a period of reappraisal of the accuracy of the radio carbon technique, in the light of the irrefutable certainties of dendrochronology. Dendrochronology, or the recording of time in the annual growth rings of trees, has made a big leap backwards in recent years, thanks to the long life of the Californian bristle cone pine. Using specimens of this tree, an accurate chronology has been established covering 6,500 years, against which errors in radio carbon dating can be checked and corrected with confidence. (The principal error in the radio carbon method arose from the assumption that the rate of production of C14 was constant throughout past time, whereas it is now known that in 2000 BC much more C14 occurred naturally.) This procedure is now accepted by all archaeologists, and it was with confidence that Professor Atkinson announced the corrected date for Silbury Hill as 2660 BC, a date 'which can be assigned to the structure as a whole', and a date which accompanies a description of the excavation in Avebury Museum.

The Neolithic context

What follows from this change? First, the certainty that Silbury Hill is not a Bronze Age burial mound for a Wessex warrior, since it was built before the Bronze Age, and before the emergence of a warrior society. Instead it must be placed in a context where the prevailing burial habit was *collective* inhumation under *long barrows*, such as the nearby West Kennet long barrow, which could never be mistaken for a Bronze Age structure. If there is treasure in Silbury Hill it cannot be the gold, silver or bronze of a burial deposit, for

Silbury belongs to the Neolithic. The term Neolithic which, by a curious coincidence, was invented by Lord Avebury in 1865, means the age in which people produced their own food, by cultivation of crops and domestication of animals, but still relying entirely on stone, wood and bone as the material for tools. The crafts of weaving and pottery were also characteristic inventions of this age. In Britain, the Neolithic began before 4000 BC.

The term 'Windmill Hill culture' has, since 1930, been used to describe the characteristic way of life of the early Neolithic communities in Britain, after the type site where the physical remains of their living habits were first thoroughly investigated.[24] From Windmill Hill, definite evidence of cereal cultivation was provided by the finding of sandstone grain rubbers on the site – and impressions of grains, pressed accidentally into the fired pottery, establish that wheat was the principal crop, accounting for 90 per cent of the cereals grown. There is also evidence suggesting the cultivation of flax, and the presence of apple pips may mean that crab-apples formed part of the diet.[25]

By another apparent coincidence, Windmill Hill can be clearly seen from the summit of Silbury. A fragment of typical Windmill Hill pottery was discovered in 1969 'from an undisturbed context' on the top of Silbury.[26] This, together with the firm date for the entire structure, makes it certain that the builders of Silbury lived by growing wheat and barley, and by raising oxen, pigs and sheep. They were what we might call 'simple farmers'. These farming communities coiled their dark-grey, round-bottomed pottery, and faced many natural hazards – the marauding of wild animals such as bears and wolves, and the attack by damp and insects upon the precious seed corn. Weeds among the young crop demanded arduous hoeing in the early weeks after germination, and the approaching harvest was at risk in high wind or wet weather.[27] Simultaneously, there was a need to nurture and protect the herds of long-horned oxen.

Silbury and common sense

What place can be assigned in this struggle to the extravagance of Silbury Hill? Why did the community feel compelled to build a solid chalk hill, surrounded as they were by solid chalk hills? At first sight an examination of their way of life only serves to render the act more incomprehensible. But if this is so, it is because

the outline sketched above has been drawn in the manner of the twentieth century A D, rather than in the style of the twenty-seventh century B C. The economic facts, comprehensible to us, have been described, but something vital has been left out. Since that vital ingredient has been omitted, our design for the Neolithic, based on *our* common sense, collapses into absurdity when confronted with the presence of Silbury Hill. The Neolithic cannot be altered to fit an inappropriate model (though many have tried), and if Silbury Hill is not to remain an inexplicable mystery, a new model must be sought, based perhaps on values and suppositions for which there is little contemporary understanding or sympathy. A daunting prospect, and before undertaking such an arduous course, social conditioning (some would say instinct) interjects to remind scholars that in an emergency an appeal should be made to the Army to protect collective values from foreign invasion. In order to defend itself, perhaps, a struggling Neolithic community might erect a system of fortifications like those thrown up in the British Iron Age. Might Silbury Hill therefore have been built to provide a steep-sided fortress, the effectiveness of which would be greatly enhanced by the surrounding quarry/moat? The flat summit, 100 feet across, was perhaps the last refuge of a population under attack.

How does that sound? It sounds very acceptable in the ears of a people who have experienced two world wars, and until recently spent more on defence than on any other item in the national budget, but it fits the Neolithic no better than the idea of non-figurative sculpture. One may search the British Neolithic in vain for signs of military strength. There are none to be found. The only earthworks dug at the time – the causeway camps – are agreed to be totally unsuited to fulfil a defensive role, and archaeologists achieve rare unanimity in their emphasis upon the peaceful nature of Neolithic life. Therefore the model cannot be extended in the direction of war.

So let us come to the point. The key to the Silbury Hill treasure is the Neolithic age of the monument, and the key to the Neolithic Age is the Great Goddess. From her womb, and from her eye, came Neolithic common sense. The Great Goddess is the mystery of the Hill (the image of her body permeated all the Late Neolithic Avebury monuments), and her account is truly extraordinary.

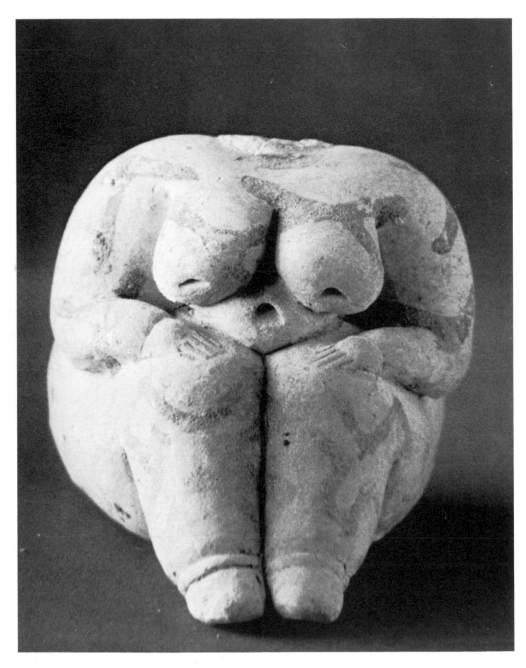

The birth position

The Great Goddess

Great Goddess and Neolithic go together as naturally as mother child. When Silbury Hill was built, Britain, in common with the rest of the Neolithic world, worshipped a female divinity.

'Early farming communities seem to have focussed their worship upon fertility and the life creating forces, expressed through a maternal figure in human form,' writes Jacquetta Hawkes,[1] and when we understand this figure, we will understand Silbury.

'The later patriarchal religions and mythologies have accustomed us to look upon the male god as the creator,' writes Neumann,[2] 'but the original overlaid stratum knows of a female creative being.' 'If one enquires to know her ultimate origin, she is the Primum Mobile, the first beginning, the maternal matrix out of which all comes forth. The meaning is: I am the Mother without a spouse, the Original Mother.'[3] 'The Mother of the Gods, by whatever specific name she might be called, was the oldest, the most revered, the most mysterious of divinities, extolled by the poets, and supplicated by the people, especially for their daily needs, especially to promote the growing of crops.'[4]

'She was the Great Goddess, the universal mother in whom were united all the attributes and functions of divinity. Above all she symbolized fertility, and her influence extended over plants and animals as well as humans. All the universe was her domain. As celestial goddess she regulated the course of the heavenly bodies, and controlled the alternating seasons. . . . She also reigned over the underworld. Mistress of Life, she was also sovereign of Death.'[5]

The confident unanimity of these experts is founded partly on a study of the art of the period. As Hawkes says: 'Nothing can shake the evidence of hundreds upon hundreds of little clay, bone and stone effigies of the mother goddess. They are present in the second pre-pottery settlement at Jericho. They are present in almost every cultural province between Sialk and Britain, and from Persia to Badari. Their presence has

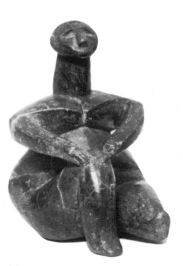

The Great Goddess was worshipped throughout the Neolithic world as the source of life, appearing in similar form in thousands of votive figurines. (Opposite) A painted clay statue of the 7th millennium BC from Çatal Hüyük. (Above) A clay figurine of the late 4th millennium from Cernavoda, Rumania.

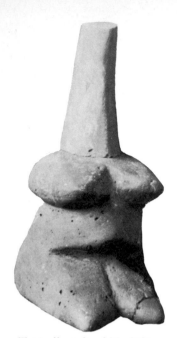

Typically stylized Neolithic figurine with big body, understated limbs, and single column for head and neck. From Hamangia, Rumania.

been repeatedly mentioned in the account of the rise and spread of the primary farming cultures.'[6]

Two characteristic figurines, carved from chalk, were found in a Stone Age ditch on Windmill Hill, overlooking Silbury. Others come from Neolithic sites at Maiden Castle, Dorset, The Trundle, Sussex, and from under the Bell Track, Somerset.

The sacred role of Neolithic figurines is frequently underlined by their settings in shrines, eliminating the possibility that they were made for merely decorative reasons,[7] although of course aesthetic skill contributed to the efficacy of the images, whose spiritual value was also inseparable from *practical* reality.

The religion of the Great Goddess, celebrated at the Neolithic monuments in Avebury parish, including Silbury, was concerned with the three great realities of birth, marriage and death as they affected human, animal, vegetable and mineral events. It also sought to bring all together, within a harmonious universe, itself seen in human female form.

In order to achieve a synthesis of the three life 'thresholds', the goddess was envisaged as a three-in-one trinity – Mother, Destroyer and Lover but, as with our Father, Son and Holy Ghost, each aspect *could* appear separately.

Silbury will be shown to be concerned with the maternal aspect, and this specialization is supported by a great number of the figurines.

The naked pregnant woman, the source of human life throughout the ages, was enlarged in meaning to symbolize the origin of everything. The universal mother who gave birth to all phenomena whatsoever was sculpted appropriately fat, often displaying, in Hawkes's telling phrase, 'the mountainous belly of advanced pregnancy'.[8]

Many of the figurines treat neck and head as a continuous blunted column, presiding over the generous body below. Breasts were often shown big; hands and arms might be given a perfunctory treatment, or omitted altogether. Most importantly, whether legs were drawn up towards the chin, or shins folded under thighs, the goddess was portrayed in a squatting position.

The pregnant squatting goddess

The goddess squatted *because she was in labour*, and was 'modelled as in the process of child labour'.[9] To give birth in this position is still normal in many parts of

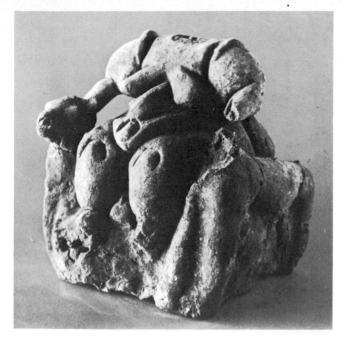

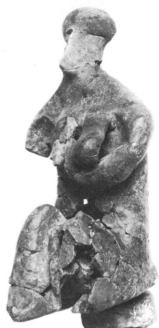

The goddess in childbirth. In most cultures, women kneel, squat, crouch or sit during labour. (Above) The child about to be born from the hollow womb, Tel Chagar Bazar, Mesopotamia. (Left) The goddess in labour with child emerging. Found in a grain bin at Çatal Hüyük, Turkey.

the world, and continued to be normal in Europe long after the Neolithic Age came to an end. Furthermore, the squatting figure motif 'recurs distinctly and plentifully in North West America, Mexico, Guatemala, Costa Rica, Columbia and Venezuela', and is 'undoubtedly the dominant [motif] in Pacific art. In early times, the squatting position must have symbolized the birth position . . . linked to a system of ideas representing life, continuing life, and being alive.'[10]

Some of the Neolithic figurines show an unborn clay child within the clay womb, while Mellaart described one from Çatal Hüyük, Turkey, in the following terms: 'She is actually shown as giving birth to a child, the head of which protrudes from between her thighs.'[11]

There is plentiful evidence to show that the Neolithic squatting goddess stood for fecundity in the broad sense. For example 'the obviously pregnant state' of a female chalk figurine, found in the Grimes Graves flint mine, Norfolk, 'strongly suggests the propitiation of an Earth Goddess, combined with an appeal for more abundant or better quality flint in the next pit.'[12]

Harvests of all kinds were expected from the divine Neolithic Lady, while her shape saturated human consciousness, and became the focus of hopes for fertility, and the inspiration of related human endeavours, great and small.

Silbury revealed. (Right) Ditch and Hill together make the Neolithic Great Goddess, seen again in a painted pot from Hacılar, Turkey (opposite), in the Grimes Graves goddess from Norfolk (far right), and in the diagram of a figurine from Pazardžik, Bulgaria (below).

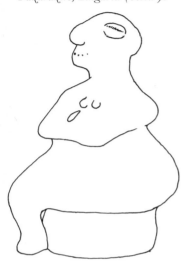

Of these endeavours, none was more remarkable than the construction of the Silbury monument, which was designed to match the physical shape of the birth-giver. *Silbury is the Great Goddess, pregnant.*

Silbury as squatting goddess

The time has come to look again at Silbury Hill, the first monument to be scheduled under the Ancient Monuments Act of 1882 (classified on 8 August 1883), and to tell the lost truth: the Silbury monument is the Great Goddess in her pregnant state. Her womb is the Hill, 520 feet in diameter, and 130 feet high.

The rest of her body is not left to the imagination. On the contrary it is physically present, being clearly defined by the body of silt and water which occupies the carefully shaped surrounding quarry.

Her thigh is water, her head and neck are water, her breast and back are water; even with a 15-foot deposit of silt overlying the original intention (a conservative estimate; in 1968/9 geophysicists found up to 20 feet of silt in the ditch), these features still show as water in a wet March. Even at the height of summer the water level can rise above the deposit of

silt. For example, in July 1971 water was standing over the entire area of the moat. And, wet or dry, the ditch plane describes the mighty female's body in longitudinal profile. Her head extends towards the west, her back faces north, and her breast and knee point south – all plainly delineated by the outer edge of the quarry-lake.

The Hill or womb is (naturally) composed of material derived almost entirely from the mother's body, i.e. the quarry. Mother Earth gave rise to Silbury Hill, and in the process revealed her whole body. Simultaneously she gave visible expression to the improbable equation: Mother Earth = Lady of the Lake.

What is more, she appears squatting in the Neolithic birth position, ready to give birth to the unborn child within Silbury Hill – the child of a million forms and names, one of which *could* be Sil.

From head to thigh, the mother measures 1,140 feet, and the exploratory shafts which A. C. Pass sank through the silt to the Neolithic floor of the ditch body revealed variations in keeping with the image-making process. For instance, his shafts 3 and 4, sunk in a position between the underside of the breast and the hill-womb, hit natural rock only $3\frac{1}{2}$ to 4 feet below the modern surface:

'A projecting mass of chalk for some reason had not been removed,' wrote Pass.[13] The reason can now be seen as the need to accentuate the breast, by retaining a rock 'peninsula' leading a short way into the lake.

Similarly, the neck and head, having less bulk than the reclining shoulder and hip, were dug to a lesser depth – 6 feet, compared to 20 feet. The 'causeways' are also vital to the image. Without them, breast and knee would all but disappear, and so would the vital area between – for the intercauseway moat *is* the child on the mother's knee. This part of the picture was found to be over 30 feet deep, 'with very steep sides and a flat bottom'.[14]

The Silbury lake
Silbury Hill is only half the Silbury monument. A child in the womb presupposes a mother, and the Silbury Hill mother was conceived in water.

When Pass dug his holes, it was 'in the month of September, after a long continuance of dry weather'. The nearby river Kennet 'had been dried up for two months . . . yet water continually stood to the depth of

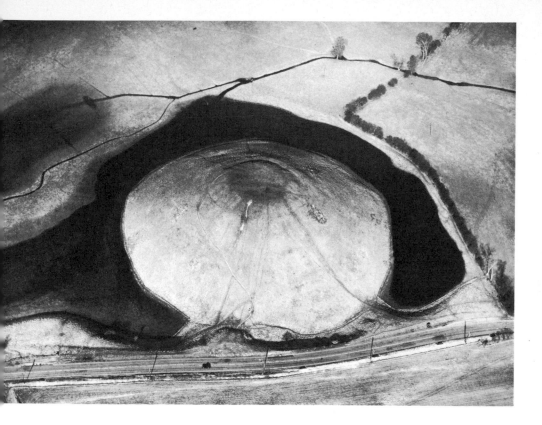

8 feet in the trench at the foot of the mound and the large area to the west of the Hill, although not excavated to so great a depth, must necessarily have been a pond of water during the greater part of every year.'[15]

Water also swamped liberally into the 1968 ditch section, and when geomorphologists add the conviction that the underground 'water table' is *lower* now, throughout the English chalklands, than it was in Neolithic times,[16] there is no escaping the conclusion that the Silbury quarry was *meant* to be wet. Without the silt, the quarry 'would be full of water all the year round', concluded M. E. Cunnington;[17] and Petrie wrote: 'The low situation of Silbury can only be due to the need to make a water fosse around it.'[18]

The importance to the designers of creating an image of the deity, the surface of whose body was water, will be explored in a later chapter, but the merest glance into the lake is enough to reveal the heavens reflected on earth: a patch of deep blue sky, manipulated by the fringe of rain clouds, and when the surface of this sky-water is ruffled, globules of golden sunlight are seen to bounce and roll. The body of the

Silbury's water-body follows the same outline, in large, as that of the 'Sleeping Lady' from the Hal Saflieni hypogeum, Malta.

goddess therefore clothes the elements of earth and water with air and fire – an important demonstration of cohesion, repeated at the contemporary Avebury henge ditch, prior to its silting.

Positive and negative

This sublime device recognizes the potentially munificent interplay between positive and negative forms, i.e. between convex hill and concave hole. In this century much has been learnt of the interdependence of positive and negative forces within the structure of the atom. The existence of an anti-matter universe has also been postulated by many physicists. Form is built as much from absences as from presences. That which is taken away contributes as fully as that which is set in place.

Silbury is a positive hole, excavated to make a full womb, but this natural relationship has been obscured at Silbury Hill by concepts superimposed from our wasteland culture, where a hole is the evidence for extractive greed: a dry scar fit only as a rubbish dump. In this climate, the neck and head of the seated goddess have been wrongly interpreted as a necessary disfiguration of the downland surface – a big mound, surrounded by a big mess.

The 1968 dig rendered this attitude untenable, for the ditch was found to have been immaculately worked, with a flat bottom and very steep sides,[19] a shape of very positive importance leading, near the base of the mound, to the flight of timber-revetted steps. Moreover, the fact that the outer wall of the ditch was cut to the same 30 degree slope as was used in constructing the inner wall and the artificial Hill, is further evidence that mound and ditch were parts of a single image.

The lost sculpture

As an image of the Great Goddess, Silbury is probably the largest surviving version of the subject in Europe. While in Britain most of the corresponding figurines have been shattered and rotted by thousands of British winters, this, the most magnificent of all her sculpts, has retained its shape, because a stupendous bulk was combined with extraordinary skill in construction.

Why has it not been recognized as such in modern times? The open-spirited obviousness of the work perhaps presents a major obstacle to its acceptance today, when profundity is generally advised to stay

hidden, for fear it should turn superficial. We do not expect to find serious truth lying on the surface.

In the second place, the very failure of the experts to recognize the image gives grounds for saying that there is none. Had it been intended, they, the archaeologists, would have seen it. But then, one recalls the case of the Stonehenge dagger, plainly visible, but unseen by generations of experts:

The carvings provide us with a remarkable object lesson in the fallibility of human observation. Few people, who have seen the Stonehenge dagger, will deny that once one knows where to look, it is perfectly obvious: indeed when the sun is shining across the stone, it can be seen from the gate of the enclosure, 100 yards away. Yet during the past three centuries, thousands of visitors must have looked at the dagger without actually seeing it. Nothing could demonstrate better that one sees only what one is expecting to see.[20]

Similarly, for the past three centuries, Silbury has been viewed as a Bronze Age barrow, and so the goddess disappeared from sight.

Architecture as sculpture

We see what we expect to see, and we do not expect to see architecture as sculpture. On the contrary, for modern man architecture is *abstract*. But was architecture always so regarded? Was it divorced from the pictorial image in 2660 BC? To this question the answer of many architectural historians is no. They believe that in antiquity architecture was understood to be a form of inhabitable sculpture, conveying meaning through recognizable pictures. The need to create these pictorial statements found expression both in the detail, and in the broad planning and configuration of ancient buildings.

Moreover, the preferred subjects for the architectural icons usually related to birth, marriage or death. Norberg-Schulz writes: 'Architectural history tells us [that] from the oldest times, the symbolism of architecture was connected with the fundamental stations of human life; birth, procreation and death.'[21]

Therein lies the meaning of the Avebury monuments and their coherence as a group, with each modelled on a critical stage in the human life cycle.

Even today there are thousands of pre-Reformation Christian churches in use which were consciously designed to imitate the body of a god, stretched out in a particular attitude. The cruciform church was a *picture* of Christ's crucifixion, and a picture which the

Sacred buildings often take the form of the deity's body. (Right) A Christian church describes the body of Christ, while (opposite) the Neolithic temple of Ġgantija, Malta, is the body of the Great Goddess.

worshipper could enter, and wished to enter, in order to achieve total union with the divinity. The body of the building was synonymous with the god, and through faith it becomes synonymous also with the worshipper's own body.

Temple building activity may be seen as an attempt to achieve union with the cosmic creator. In the past this desire has often led to the temple assuming the bodily form of the supreme being. To worship within the divine torso – what could be more desirable, necessary, or potentially harmonious? Further, if the concept of deity is taken seriously (and how else can it be taken?) there is nothing improbable in constructing a divine image hundreds of feet wide, and over a thousand feet long. Even on this scale, the image is a tiny figurine, compared with the divinity's largest possible size, which has the dimensions of the complete universe.

'We shall find,' wrote Lethaby, 'that the intention of the temple was . . . a sort of model to scale of the World temple itself.'[22]

The Maltese temples

In the Neolithic, where the godhead took the shapes of a woman, and a primary form was that of goddess as seated woman, one might expect temple shapes to follow the female model. Such is the case. Naturally the evidence is rejected by those who are loyal to recent cultural insistence on abstract architecture. What

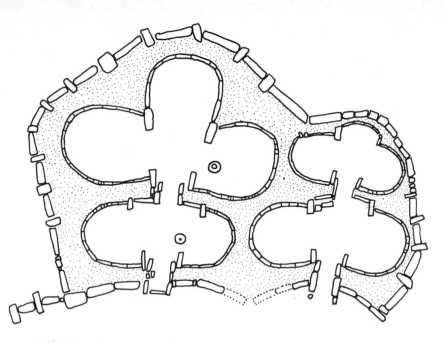

is remarkable is that many observers, with varying degrees of confidence, have broken through the culture barrier. Reactions to the Neolithic temples of Malta illustrate the point:

'Each temple resembles a seated figure.' (G. R. Levy, 1948.)[23]

'These buildings reproduce in a fixed symbolic form the body of the Great Mother. The reader whom this fact does not strike as immediately obvious, is invited to glance at the ground plan of any one of them.' (Professor G. Zuntz, 1972.)[24]

'Entering either the Maltese temples, or the site at Gournia (Crete) would doubtless have meant a return to the Goddess . . . to sleep within such a goddess-shape would itself have been a ritual act.' (V. Scully, 1964.)[25]

Figurines, and monumental versions of the goddess 'at least eight feet high'[26] take their place in Malta alongside the architectural mother, sharing a common inspiration, and a common form.

The Shetland goddess-houses

Recent excavation carried out in Shetland enables one to say that the goddess is also to be found in the design of over 60 Neolithic houses belonging to the British Isles. Here the goddess–house usually measures between 45 and 55 feet in long axis. Contained within thick outer walls, which, as at Gairdie, are egg-shaped, her

Neolithic house at Gruting School, Shetland, showing the goddess in profile, as at Silbury.

body is described by the plan of the chambers within. Sometimes, as at Gruting School and Stanydale, she is seen in profile, with the entrance corresponding to vulva; the occupants of these houses lived out their lives within the protective body of the Silbury shape. At Gairdie, the house–goddess is seen frontally, rather than in profile, and a setting of stones in the head may indicate eyes, nose and mouth. As C. T. S. Calder has pointed out, the plan of Gairdie is closely related to the larger (70 foot) building at Yoxie, on the nearby island of Whalsay. He finds the latter to display a *'likeness to the Tarxien temple, Malta, so obvious that one must assume that they fulfilled a similar purpose'*.[27]

For love of the same goddess, the temple/house/figurine amalgam was probably created in both places.

But how can probability be spoken of, when contemporary written evidence is lacking? Must not objects and structures, unsupported by contemporary texts, remain the subject of mystery, or at best, disreputable speculation? Indeed they must, if our civilization has temporarily lost confidence in the ability of artefacts and structures to contain and transmit meaning directly, without being first converted into written words.

If on the other hand, we are inclined to agree with J. Rykwert that 'symbolism springs from the way the three fundamental experiences of man – birth, copulation and death – stress his description of the outside world',[28] then we may recognize in Silbury Hill, the Gairdie House, and the Grimes Graves figurine, the local expressions of an indispensable human experience.

Figurine-architecture-cosmos

Consider what Ogotemmeli, a man of the Dogon tribe (West Africa) told Marcel Griaule in AD 1947 concerning his people's attitude to their houses:

'The big central room is the domain and the symbol of the woman; the storerooms each side are her arms, and the communicating door her sexual parts. The central room and the storerooms together represent the woman lying on her back, with outstretched arms, the door open, and the woman ready for intercourse. The room at the back which contains the hearth shows the breathing of the woman.'[29]

In fact the rectangular shapes of a Dogon house resemble a Maltese Cross in plane and are far less 'like' a woman than is a Neolithic Shetland house, or Silbury Hill. Yet the symbolism is understood by the entire community:

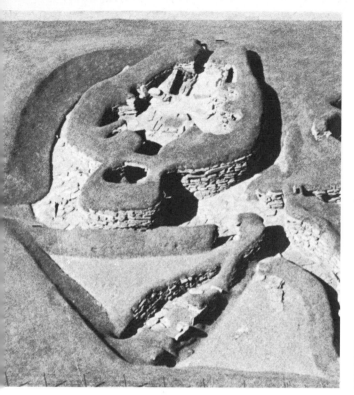

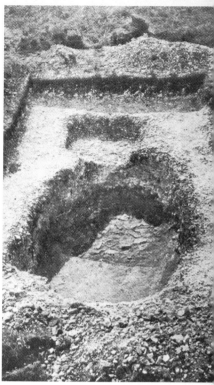

'When a child is born, the woman in labour is seated on a stool in the middle of the large room, her back to the North, [like Silbury] ... the infant is delivered on the ground and takes possession of its soul in the place where it was conceived.'[30]

Here architecture and human activity are in such profound accord as to astonish those European observers who have approached the community with an open mind: 'I am not exaggerating,' writes A. van Eyck, 'when I say that all material objects from the smallest to the largest which support daily life are charged with extra meaning, and are identified in stages with the totality of creation, while every stage contains the whole.'[31]

As with individual houses, so with the overall plan of the village, the cosmic scheme of things is described in human shape. '"The village", said Ogotemmeli, "should extend from north to south like the body of a man lying on his back".'[32]

The Dogon economy – subsistence agriculture, with stock rearing – resembles that of Neolithic Europe, and the builders of Silbury Hill, surprised no doubt by the climate, metal tools and many other important details,

The goddess as temple and habitation. (Left) Skara Brae, Orkney, c. 2100 BC. (Above) A Neolithic pit-dwelling at New Barn Down, Sussex.

The Palaeolithic 'Venus of Sireuil', Dordogne, prefigures the squatting goddess of the New Stone Age.

might nevertheless have broadly understood and sympathized with the cultural ethos.

In both cultures buildings were regarded as the body of the divinity, and the same attitude attaches to much of the monumental architecture of South East Asia. For example, temples of the curved roof variety, like that called Lakshmana at Sirpur (seventh century AD) were, and still are, believed to be 'the representation of the divine and cosmic body which the Vedas call Purusa. The names given to the principal parts of the building correspond to this cosmic body. The roof itself was called *gandi*, which literally means "the trunk of the body". Other parts are known as *deki* or throat, and the *khapuri* or skull.'[33]

Silbury on her side

The Silbury goddess is seen on her side, yet the Maltese figurines and temples express a preference for a frontal

view of the deity. But in this respect Silbury relates very satisfactorily to the strong profile views characteristic of a seated goddess at the Gruting School and Stanydale houses in Shetland, and to figurines from many other parts of the world. Indeed, most figurines incorporate within a truly three dimensional treatment an equally convincing reading from both front and side. There is no conflict.[34]

Investigation of Old Stone Age engravings dating from before 20,000 BC show the profile view, subsequently used at Silbury, to have been firmly established in France long before the two countries were divided by the English Channel. The profile view selected for the Silbury goddess cannot be said to represent a departure from either Neolithic or Palaeolithic tradition.

Silbury and Everyman

Because conditions in the British Neolithic preclude the possibility that the work of building Silbury was enforced on an unwilling and uncomprehending population, we are bound to believe that, for those who toiled over its completion, it represented what Lethaby called 'an architecture which excited an interest, real and general, through a symbolism immediately comprehensible to the great majority of spectators'.[35]

What symbol excited more interest, real and general, throughout the Neolithic world, than the Great Goddess in labour? When she was widely displayed as figurine, house and temple, it is hard to deny her presence at Silbury. For, there, the evidence of our eyes confirms her shape in rock and water, and reminds us that architecture was the mother of the arts.

Cornucopia

The horn of plenty

We live in an age of signs, as distinct from symbols. Each of our signs is constructed to convey a narrowly defined message with the utmost clarity – to signal a category and to direct our choice of alternatives within that category. Consequently, we might be inclined to reduce the Silbury symbol to a sign simply replacing the 'wrong' sign, 'Tomb for a King', with the correct sign, 'Goddess in Labour'.

But the civilization which flourished in Neolithic Britain habitually used the single image to transmit a *constellation* of meanings and sentiments. Because the cosmos was then experienced whole, it had to be described whole, rather than in isolated fragments, and Silbury was therefore designed to accommodate variety and paradox. The monument shows how diverse elements were made compatible within a single image, where the contribution of each could yet be readily distinguished, as in an orchestral score. So if we ask the finely balanced Neolithic orchestra to play only in unison and only the Pregnant Goddess tune, we will be effectively flattening Silbury Hill to a level far beneath its sophisticated original range. It will have fallen to the modern primitivism of false alternatives.

The eye

Silbury the squatting mother is also Silbury the eye goddess, for although 'The Neolithic Goddess is directly descended from her Palaeolithic ancestress',[1] her eyes grew bigger with the passage of time, and it is into those accentuated eyes that we should now look.

Let us begin at Hacilar, where Mellaart found that the eyes of the seated figures were sometimes heightened in effect by using black paint in the pupils.[2] The link is equally secure at the temple site of Tel Brak, Eastern Syria, where hundreds of figurines have been found dating from *c.* 3500 BC 'of a Goddess, closely connected with fertility, whose cult image had staring eyes and eyebrows which met at the top of her nose'.[3]

The eye goddess. To the squatting mother image inherited from the Old Stone Age, the Neolithic added an emphasis on the eyes, as (below) at Tel Brak, Mesopotamia, c. 3000 BC, or (left) Folkton, Yorks., c. 2000 BC.

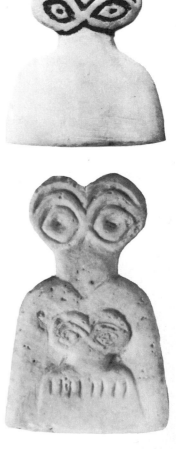

At Tel Halaf the seated goddess was associated with painted pottery. Of all the forms of decoration 'particularly striking is the eye pattern in rows',[4] writes H. Schmidt. From the same site comes a figurine of a type instantly recognizable as the seated goddess. Texts of a later date declare both types of image to have been forms of the Great Goddess, whose local name was Ishtar.[5]

The eye motif played an orthodox and vital part in Great Goddess worship, wherever Neolithic culture developed; certainly it was important in Spain, France, and the British Isles. In these places, the oculi designs were integrated so thoroughly as to become wholly characteristic, appearing on pots, portable idols, such as the chalk Folkton Drums (East Riding, Yorkshire), and engraved on the walls of tombs. How should the eyes be interpreted when seen in isolation, as they sometimes are? Daniel is in no doubt that they should be regarded as 'a formalized iconography of a goddess figure' and that they 'assume the visual role of the complete figure seen elsewhere'.[6]

What part, if any, does the eye motif play at Silbury? If one stands at the western end of the moat and looks east, the view is interrupted by the biggest eyeball in Britain, set in the watery head of the Great Goddess. The goggle woman of the dazzling chalk eye is the squatting goddess turned upside down.

Seen from the west, the goddess is all eye, head and neck. The stem of the moat becomes neck, the thigh

becomes hair, the breast becomes lower lip, and the area between the causeways turns into a pudgy nose. At the base of the chalk eyeball (the Hill) is the dark retina of the core, contained by the wattle fence. (A comparable central roundel appears in many rock carvings of the eye theme found in the British Isles.) At Silbury, this hidden feature would have been known through the normal operation of oral tradition – always active in stable, preliterate societies – and also from its hollow replication in the adjacent and contemporary temple hut, now called the Sanctuary, a truncated cone bounded by a wattle fence of exactly the same diameter as that of Silbury.

Overlapping and extending beyond the Silbury fence is the striped material of the iris (the layers of chalk, gravel and soil). As in many other Neolithic representations of the great eye, linear rays stream radially, and in concentric rings, outwards from the pupil/iris centre. These are indicated at Silbury by the arrangement of chalk walls. Being white, they reflect the colour of the human eyeball, and their dynamism is resolved into an overall convex shape resembling that of the eyeball's protrusion, but modified at the summit to emphasize the pupil, and thereby the fact of the underlying retina.

The Neolithic Eye. (Above) Concentric rings with radial spokes from Dowth, Co. Meath, Eire, c. 2500 BC, and (right) spiral from New Grange, Eire are accepted forms of the oculi divinity. The former is incorporated in the construction of the Silbury eye, as shown in the diagram on page 43. (Opposite) Silbury as Eye.

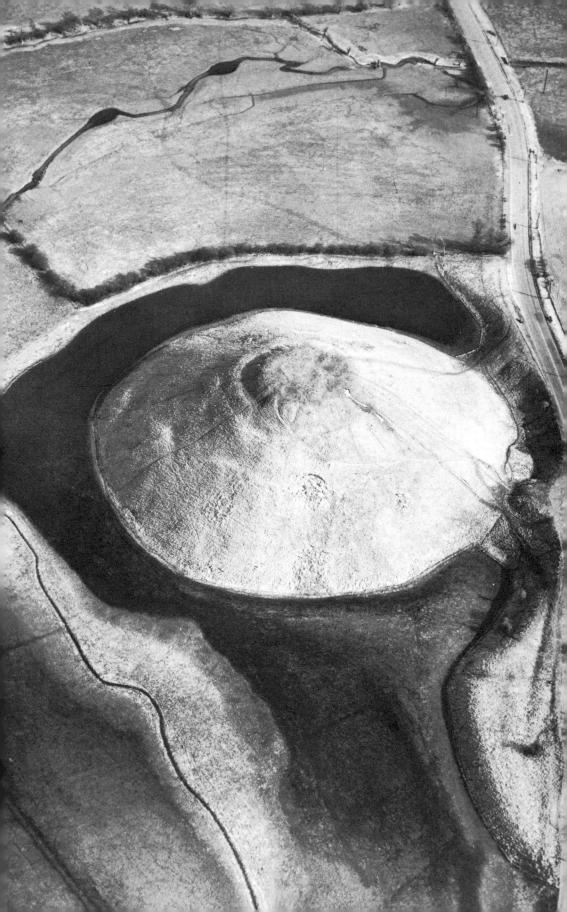

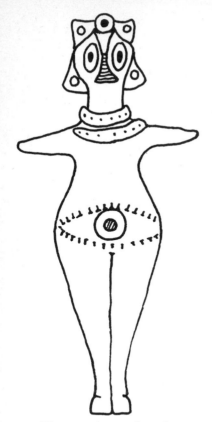

The generative eye. Sumerian figurine from the 3rd millennium BC.

The womb-eye fusion

Silbury Hill shows the two principal Neolithic manifestations of the goddess – as eye, and as seated pregnant woman – brought together in a single image combining both eye and womb. If the moat is included, as it must have been, the same message emerges in a more extended form: the head, which is the western aspect of the Hill and the moat, becomes the squatting goddess when Hill and moat are viewed from the east.

The indivisibility of mind and matter was one of the chief convictions of all Neolithic societies, and here it is expressed in one of their greatest architectural statements. The same is true of many contemporary figurines, and this attitude will be seen (in Chapter 10) to have passed into the etymology of Silbury.

The Silbury womb–eye synthesis resolves the fundamental split between mind and body, spirit and matter, which has troubled successive European cultures for at least 2,500 years, in fact ever since the Iron Age, *c.* 500 BC. Significantly, the ancient Greek writers who first postulated the mind-matter split also reflected dim awareness (albeit in a distorted form) of an earlier harmony. For example, Plato and Hippocrates, one a philosopher, the other a doctor, both regarded the womb as *physically capable of migration to the head.* They maintained that 'This invasion brings the sufferer to extreme distress and causes all manner of disorders',[7] especially hysteria. The name itself derives from the Greek word for womb.

By Plato's time, war had been declared within the human body. The head, where reason and the spirit lived, was held to be besieged and threatened from below by what he called the Errant Cause, i.e. physical necessity. Christianity exacerbated this tragic divide still further, and the Silbury synthesis was lost to all but the peasant subculture.

Primordial Hill

There is a third sense in which Silbury Hill stands at the very core of Neolithic life; it partakes in the idea of the primordial hill – a recurring feature of Neolithic cosmology, and a concept of creation also having very widespread currency in other cultures. Thus in later Greek temples, E. O. James finds that the 'Omphalos', or navel of the world, was 'a symbol of both the earth, and all birth, taking the form of an eminence representing the sacred mountain which emerged out of the waters of chaos'.[8] The ancient Sumerians believed 'that heaven

and earth were conceived as a mountain whose base was the bottom of the earth, and whose peak was the top of heaven'. This mountain was held to have been engendered from an eternally existing primeval sea.[9] The world egg is born in, and bobs up through, the primeval sea. Of this water J. Campbell writes: 'In all archaic cosmologies it surrounds as well as lies beneath and supports the floating circular island Earth.'[10] At Silbury, the Hill, reflected in the divine water body, becomes the complete cosmic ball, and the magic mountain, engendering all mountains.

A stele from Carthage, second century BC, set on a hilltop, and inscribed in honour of Astarte and Tanit of Libanon, shows the longevity of the White Mountain–Goddess fusion. Libanon means the White Mountain.

Water and holy mountain also come together in the Persian text *Zend-Avesta*, which says: 'To the East [of Persia] rises the "Lofty Mountain" from which all the mountains of the earth have grown. This heavenly mountain is called "Navel of Waters" for the fountain of all waters springs there guarded by a majestic and beneficient goddess.'[11]

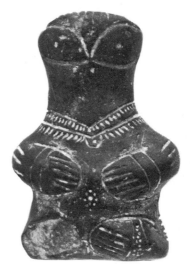

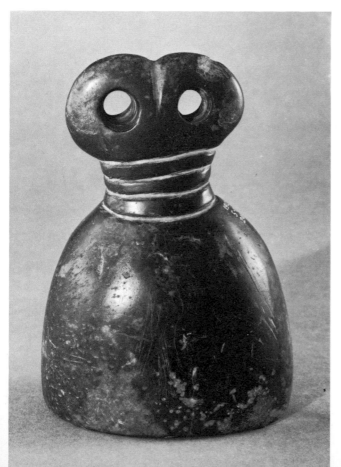

(Above) The squatting eye goddess from Caykenari Hüyük, Turkey (3rd millennium BC) repeats the eye theme on the navel. (Left) A Sumerian stone figurine illustrates the essential synthesis of the themes of the eye, squatting goddess, and primordial hill.

71

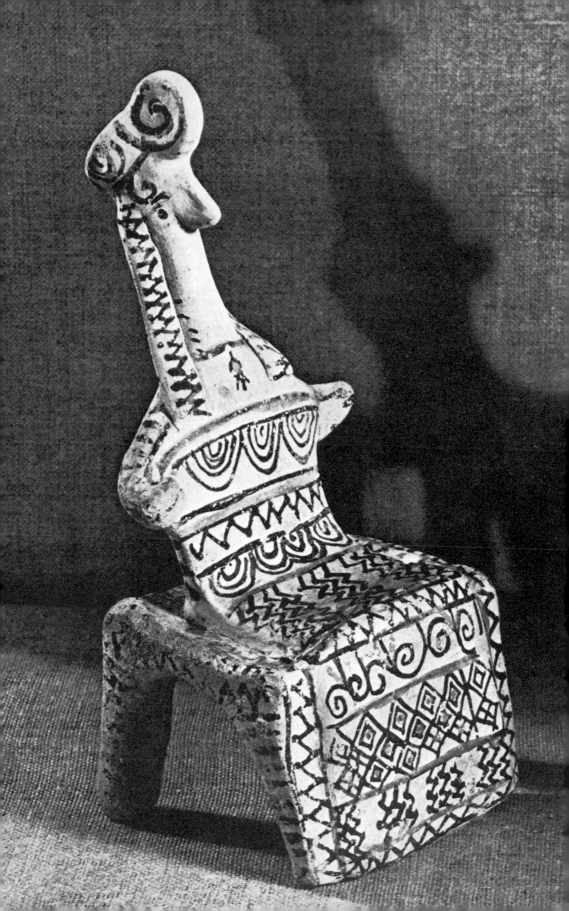

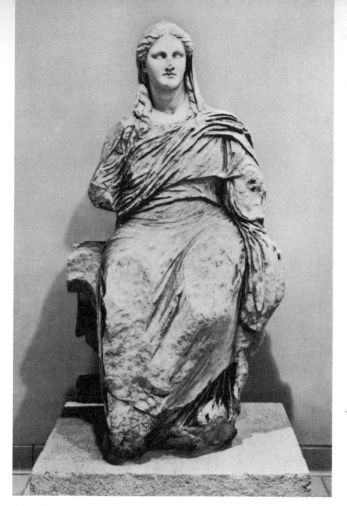

The goddess enthroned. (Left)
A marble statue of Demeter
from Cnidus, Asia Minor
(c. 330 BC), reiterates the
theme of the Neolithic figurine
(below), while the Boeotian
Greek statuette c. 580 BC
(opposite), proclaims a fusion
of the two.

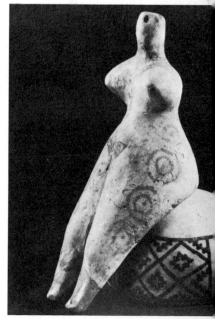

The throne

The first mountain was understood to be synonymous
with the goddess, and with her throne, and therefore
with treatments which showed her seated on a throne.
'The Great Mother *is* the throne, pure and simple,'
says Neumann,[12] and adds: 'It is no accident that Isis
(the Egyptian Goddess) means the Seat or the Throne,
the symbols of which she bears on her head,'[13] and
even in patriarchal societies the throne often remains
the embodiment of the Great Female. According to
Hocart, in Indian coronation ritual the king sat on a
throne which represented the womb.[14] In Egypt, early
versions of the Heliopolis creation myth literally equate
the deity Atum, 'the Complete One', with the primeval
hill.[15] And in Mesopotamia 'the Lady who gives birth'
(Nintu-ama-kalamma), was also known as 'the Lady
of the mountain' (Nin-hur-sa-ga).[16] At Silbury the
womb-throne-eye-mountain-egg probably retained at
least some of its functions into and beyond the British
Iron Age.

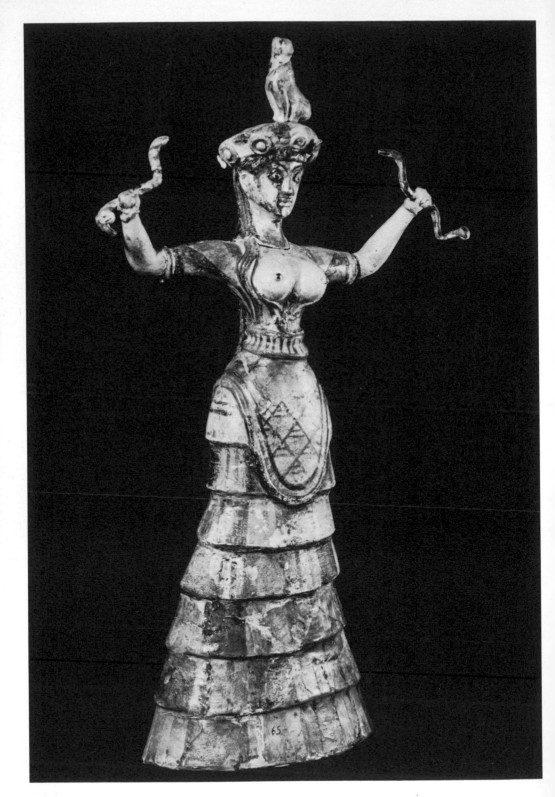

The Silbury snakes, and the weaving goddess

Silbury also fulfils the normal association between Great Goddess and snake. The snakes, so often held in her hand or painted on her body, were found at Silbury to lie in a star-shaped formation at the very centre of her womb. Dean Merewether's discovery of a 'sort of string, of two strands, each twisted, and composed of grass' can be seen as an orthodox Great Goddess expression. Throughout the ancient world, she was regarded as capable of assuming a reptilian form. The figurines from Mesopotamia illustrate an intermediate stage in this metamorphosis. Memories of the goddess-serpent ran deep into the Assyrian Iron Age: 'The Chaos-Serpent is the body of a woman . . . it was the Queen of Chaos who ruled while the earth lay like a cosmic egg in her coils, in the time when as yet none of the gods had come forth.'[17]

The snake is an archetypal image for the life force. In practical human terms, life flows from mother to child down a twisted double-stranded snake, known as the umbilical cord. Thus Merewether's string was well placed in Silbury, from the top of which glimpses may be had of the paths of those mighty architectural serpents, the West Kennet and Beckhampton avenues, expressing another phase in the annual cycle.

Now that the structure has been revealed by excavation, one may speak of the *fabric* of Silbury Hill in a very literal sense. Both the plaited string in the primary mound, and the warp and woof of chalk walling, which makes up the great tiers, are reminders that from the Neolithic period, when spinning and weaving were invented, the Great Mother was typically involved in these new magic arts which were seen as a cultural mode of the female capacity to generate:

'The Great Mother spins and weaves because she is the primal embodiment of the triad of weavers of all earthly things, of growth, of time, of destiny – just as the woman spins in herself the tissue of another being's flesh.'[18]

At Silbury, these first organic threads lead out to the woven chalk mound, for when 'the mother becomes the spinning goddess of destiny the child becomes the fabric of her body'.[19] Thus Aphrodite 'weaves the coarse fabric of tellurian forms from crude matter, while material fecundation and the pangs of childbirth attend her work'.[20] In the same way, the Silbury mother simultaneously worked at creating herself, her child, and the coming harvest, in one seamless cloth.

Goddess with snakes. (Opposite) Minoan snake goddess from Knossos, Crete, c. 1600 BC. In addition to the snakes, she displays many of the Silbury features – seven-tiered, with U-shaped apron terrace, full breasted, and with accentuated eyes. (Below) A snake radiates from the womb of a Central Asian figurine, evoking the grass 'snakes' in the Silbury womb.

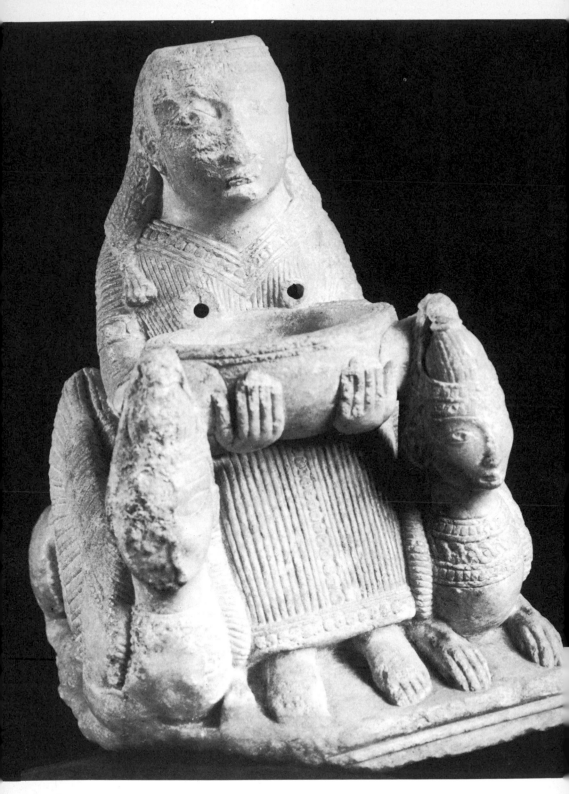

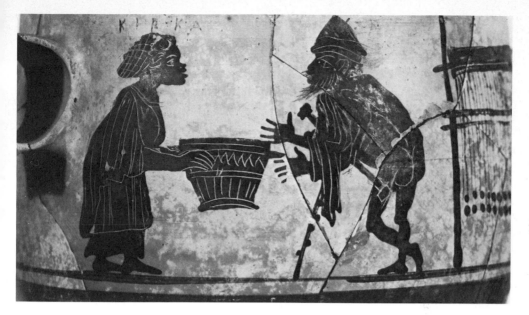

The Silbury posset

Silbury was built by Britain's first farmers, who milked the first domesticated cows, and made the first pots, bowls and possets, coiled from snakes of rolled clay.

These vessels, as in all pot-making primitive societies, played a role in the cosmology of the group. In the Neolithic this meant that the posset was equated with the body of the goddess as universal provider (an attitude which filtered deep into the Christian era and known in the Middle Ages in the guise of the magic Grail vessel). Therefore Aubrey's folklore record, associating a milk-giving vessel with the growing (building) of the Silbury Mother, is remarkably consistent with a great tradition. His statement, 'the hill was raised while a posset of milke was seething', has a very authentic sound. Milk, bubbling and frothing as it rises from the underworld, makes Neolithic sense. We are dealing with the facts of maternity in general, using human imagery in particular. That was the Neolithic way. When the farmer waited for the new grain to ripen, and the new flour to follow, it was natural to express the hope in terms of new milk.

A statue from Bordjos, Serbia, *c.* 4000 BC, shows the seated goddess holding a bowl 'as though proffering milk'[21] and the posset continued to be an attribute of the Great Goddess in later ages. The cult statue of Astarte from Tutugi, Spain, has a hollow body and nipples plugged with wax, which melted to allow the milk to issue into the proffered bowl.[22]

Bowls and pots, first made in the Neolithic Age, were natural attributes of the milk-giving Mother. (Opposite) A statue of Astarte from Tutugi, Spain, expresses the direct relationship of breast and bowl. (Above) A fifth-century Greek vase painting shows Circe handing Ulysses the posset. Her loom appears on the right.

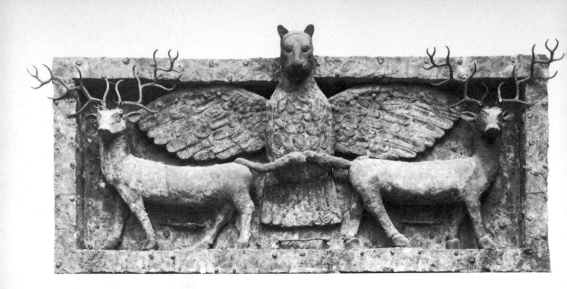

The goddess as stag. This copper panel, appearing on the door of the pre-Bronze Age temple of Al Ubaid, Mesopotamia, was dedicated to the mother goddess, Nin-Kharsag. Excavated by Sir Leonard Woolley, and re-erected in the British Museum.

Antler and the birth goddess

When A. C. Pass dug through the silt to the bottom of the Silbury ditch, he found 'stag's horns' and marks on the chalk showing that red deer antlers had been used as picks by the original builders. In a very literal sense the red deer antler was involved in the birth of the hill and was also incorporated within the primary mound, as Merewether discovered. The preference for the human image did not preclude cross-reference to the animal world.

Mallowan found that 'the symbol of the Sumerian Goddess of childbirth was a stag'.[23] The relationship is also seen at Al Ubaid where the pre-Bronze Age temple of Nin-Kharsag, the mother goddess, has two large copper stags placed immediately over the main entrance.[24]

Antlers are not permanent structures. The stags shed them, usually between the end of February and the end of March (in time for Neolithic planting). F. J. Taylor-Page states that the new growth is closely connected with reproductive activity:

By April the new set are beginning to show; by May a sensitive covering of hair and skin envelops the growing bone, called velvet. . . . By June, the form of the antler is well established, and in July the tines are almost fully grown; the development is completed in August, when the velvet is shed to reveal hard, white tines.[25]

The similarity of this rhythm to that of spring-sown Neolithic cereal growth is quite remarkable. Also helpful is the behaviour of the hind, whose solicitude for her calf is proverbial, a model of maternal devotion. 'She will rarely desert her youngster, and will even turn back to search for her calf in a forest fire.'[26]

Recent work by A. Marshack[27] on Old Stone Age imagery has proved how important were 'time-factored' sequences, drawn from the animal world. Long before the Neolithic began, human communities had shown themselves sensitive to unifying correspondences of the type suggested here, and when we see a Romano-British version of the seated goddess with stags' horns springing from her head we are reminded once more of the Merewether Silbury antler, the antlers found in 1723 on the Silbury summit, and the antlers from the moat.

For a Neolithic parallel, consider the pot from Tarxien, where pot (body) carries large engraved eyes, surrounded by a strong antler pattern, inlaid with bone. In addition, J. G. McKay has written: 'There formerly existed in the Highlands of Scotland a deer goddess cult, probably originating in pre-Celtic times, when woman was paramount. The deer is still regarded there as *the* fairy or supernatural animal, and the red deer was the common form into which the fairy woman transformed herself.'[28]

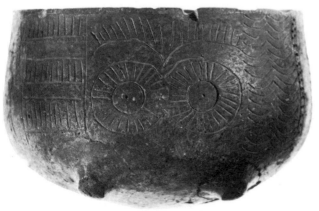

Eyes and antlers on either side of a bowl from Los Millares, Spain, refer to different aspects of the same mother goddess.

Antler and bisexual Silbury

The implications of the Silbury antlers are profound,
for they bring the concept of bisexuality to the monu-
ment. The shape of the female deity, resembling the
curvilinear flow of an antler, is shared with that of a
vital tool from the stag's crown. If the body of the
goddess is synonymous with the antler, she incorporates
masculinity at its most flamboyant. The battle of the
sexes is resolved or, more accurately, does not begin
until the Bronze Age, when many other foolish battles
were joined for the first time. In the Neolithic, the male
element was presented neither as a miserable appendage,
nor as jealous overlord, but as surrounding and em-
bracing the womb-eye with happy confidence. Male
and female were experienced simultaneously.

Is this surprising? Perhaps not if the divinity was
universal: for if the divinity was universal, it could not
be sexually exclusive. Exclusion of any kind was
uncharacteristic of the Neolithic, as will become
apparent in a study of the monuments surrounding
Silbury Hill, which proclaim the full presence of the
male within the body of the Great Goddess. There is
also an international context for this finding: 'The
androgynous Great Mother Goddess, equipped with
a phallus and sometimes a beard, is a universally dis-
tributed archetype', states Neumann.[29]

Viewing the monument from the east (as squatting female), the male element appears between her breast and knee, in the phallic shape of the intercauseway moat.

Into this context, King Sil of the seventeenth century does fit, in the modified sense that every mother goddess had a male consort (ultimately part of her own body) whose energy, sexual wounding and annual death played a vital role in the birth process. This pattern is reflected in the wounded Fisher King of the medieval Grail legend, who significantly spent much of his time rowing on the lake surrounding the Grail mound in order to ease the pain in his genitals.[30] So the dying August consort at Silbury is to be found in the wilting penis of the intercauseway moat, where 'he', the male member, shows on a scale commensurate with the divine Mother, whose lover he has been, earlier in the year.

Silbury as symbol
Silbury is a symbol which has survived into an age remarkable for the degree to which it does without symbols.

A symbol was the physical demonstration of a community's recognition of the unity underlying apparent diversity. So, when a stag was a pregnant woman, when a snake was an umbilical cord, when the primordial act of creation was felt to be the present, then the search was for a way to *show* these perceptions of harmony.

The symbol contained and conveyed the wisdom and the physical life of the society from the past into the future. It had an active role to play for the general good, which is why it so often assumed a scale big enough to embrace large numbers of people, i.e. the symbol was laid forth as monumental architecture. As Norberg-Schulz writes: 'The symbol-milieu must find its direct expression in monumental architecture.'[31]

But if it *must*, why doesn't the architecture of our own times concern itself with symbol, as a matter of priority? The answer is that we have no vision of cosmic unity, and therefore have no use for symbols on whatever scale. By wielding the analytical axe we have chopped up the universe and taken pride in establishing distinctions between animate and inanimate, natural and supernatural, physical and mental, subject and object. To describe these fragments, we employ vast numbers of highly specialized signs, whose effectiveness we measure, like jockey's shirts, by the ease with which they can be distinguished.

When confronted with Silbury, which is a symbol, we regard it either as an incompetent sign, or as a heap signalling nothing but a narrowly functional role (tomb cover). When the rationalist explanation fails, we view the monument with total incomprehension. That is what happened to Silbury despite the availability of insight into ancient religions, and of surviving 'primitive' communities provided by a string of workers,[32] toiling against the grain of our own brittle certainties. In vain does Mircea Eliade affirm: 'Systematic research has revealed the importance of symbolism in archaic thinking, and also the fundamental part it plays in the life of any and every primitive society.'[33]

In vain does the man who has been described as 'the greatest living interpreter of primitive and archaic religion' attempt to convey to English prehistorians 'that the examination of symbolic structures is a work not of reduction, but of integration.'[34] Or that 'an essential characteristic of religious symbolism is its *multivalence*, i.e. its capacity to express simultaneously several meanings,'[35] and 'that in all primitive societies, the emblems and functions of Woman retain a cosmological value'.[36]

Some archaeologists may choose to ignore his words, preferring through force of habit to plant the rationalist flag on Silbury Hill. But cultural colonialism of this kind gives little satisfaction to the conquerors. Forced to speak a foreign language, Silbury will have nothing to say, knowing that the proferred treasure would be dismissed as a ridiculous impossibility by the scientific overlords, and by Renaissance-style humanists, as an affront to the superiority of Man over woman and the animals.

What a shame! What a waste! – especially now, when the fragmented condition of our own civilization is felt to be a bed of nails. In these uncomfortable circumstances we have come to need the real Silbury treasure again, and *because* the desire is great and growing perhaps the chances of rediscovery are correspondingly improved.

To list the components contained within the Silbury symbol is a compromise between the Neolithic spirit and the ethos of the filing cabinet. At least one should add that the list offered below does not imply an order of importance nor a chronological sequence of changing meaning; far less an arrangement of candidates from which all but one should be rejected. Finally, no claims are made that the list comes anywhere near to being a

complete catalogue of probabilities. Even in terms of this book, it represents a brief and unfinished sketch.

Silbury synthesizes the following items:

1 The pregnant seated goddess.
2 The goddess half buried in the ground.
3 The eye goddess, supreme intelligence.
4 The White Mountain in the primordial water.
5 The cosmic egg.
6 Sickle, grain and cornstook.
7 The throne.
8 The stag.
9 The umbilical snakes.
10 Mother and child.
11 Women with phallus – the androgynous being.
12 The spinning and weaving goddess.

All these should be familiar to students of the International Neolithic, where each has a place of great importance. At Silbury they appear together to form a symbol of awesome comprehensiveness.

Silbury could carry this burden because it was not felt to *be* a burden. The 'non-human' elements in the

The Abbots Bromley Horn Dance, Staffordshire, takes place annually at harvest time (September 4), and represents the survival of a ceremony originating in the Neolithic Age.

symbolic pattern could be admitted with confidence because they partook of the human essence, sharing the universal spirit, which was regarded as 'nurturing, not neutral'.[35] *Kinship*, rather than kingship, was the ultimate reality.

The living invitation

The Silbury elements and meanings emerge most effectively when the visitor stands on the specially provided observation terrace around the summit. Indeed, the 'messages' can only be really understood by being physically experienced, as might be expected of a structure built at a time when the female principle was exalted. The hugeness of the womb is understood best by attempting to run up its 30 degree slope, and once on the top terrace of the universal mountain a slow perambulation through 360 degrees reveals the melodious architecture. At Stonehenge the movement from viewpoint to viewpoint was required at the Bronze Age trilithons, if the range of sun and moon risings and settings was to be experienced. At Silbury one may

experience the architecture of huge body turning into even huger head, of mighty antler, and throbbing eyeball (or is it the sound of one's own heart beating from the climb? One is not sure and that, the merging of subject with object, is the point). The treasure, including the intellectual daring, is presented freely, at first hand, given to the touch, but less easily to those who are determined to observe only from a 'safe' distance. Silbury is architecture, wet and dry, and was built to be physically explored by the people who streamed across the causeways and descended the steps into the moat, or spread across the big belly wall.

Why did they come? They came to be with their Goddess, who was pregnant and near her time; because seeds put into the womb in the spring had grown big. The moment of joy was at hand, and the harvest was about to start. They came to bring the sickles, and to offer her a sight of the tall green corn, the first fruits of the new crop: which means that they arrived at the end of July and the start of August – the season of the year when, it is known, the primary mound was built.

The scale of the monument, and something of the original builders' intentions, can best be experienced by an actual visit to Silbury. (Opposite) A view of Swallowhead (far right) from the Neolithic observation platform. (Above) A view of the moat between the causeways, showing the enveloping scale of the monument. (Overleaf) Framed in the hollow at the Hill's foot, the Neolithic landscape extends to the horizon.

Big Sunday and the British goddess

The belief in a squatting goddess, giving birth to the harvest in August, persisted in Britain long after the Neolithic Age came to an end, *c.*2000 BC. Vestiges of the original body of belief and behaviour have survived into modern times. Much has been lost but enough has been recorded to throw reliable extra light on the Silbury goddess.

The Irish first fruits ceremonies

In 1942 the Irish Folklore Commission sent out a questionnaire to rural districts and received replies from 316 correspondents. The enquiry was headed 'Garland Sunday', and the questions asked were:

Was the last Sunday in July, or the first Sunday in August, a special day?
Had it a connection with the first potato digging or the beginning of harvest?
Was the day celebrated by a visit to a mountain top or eminence?
Was the festival regarded as having religious significance?
Was the festival approved of by the clergy?[1]

On the basis of the replies, Máire Macneill wrote: 'It can be shown that either the Sunday before or the Sunday after August 1st has been, and in some places still is, a day of outstanding significance and has associated with it a body of custom and belief of extraordinary interest and extent.'[2]

Late July and early August, it will be recalled, was when the primary mound of Silbury was constructed, trapping the briefly winged ants within the turf, and the start of August marked the start of harvest. That was its outstanding significance.

Of twentieth-century Ireland, Macneill declares: 'There can be no doubt about the nature of the festival. It marks the end of the period of waiting for the new crops to mature and the first enjoyment of the new food supply.'[3]

(Opposite) Keshcorran, Co. Sligo, a Big Sunday harvest hill. Gatherings at the start of harvest were still widespread in the mid-twentieth century AD. The hump-backed limestone hill, overlooking fertile country, was said to have been the place of the goddess Aine.

The festival was recognized as the longed-for day marked down in the equivalent Scottish proverb, 'It's lang to Lammas'. Lammas, from the English Loaf Mass, was one of a number of names by which the festival was known in Ireland. Others were:

Harvest Sunday
Garden Sunday
Sunday of the New Potatoes
Rock Sunday
Mountain Sunday
Height Sunday
Big Sunday

In some places it was believed that to dig *before* this right day would stunt the growth of the rest of the crop. Conversely, if the first root was *not* lifted on Big Sunday, it was believed that the crop would have scab for the rest of the year.[4] Strong fears are the obverse side of high hopes, the combination being a fundamental trait originating in the ancient solemnity of the festival.

The first fruits were eaten at a ceremonial meal. 'The farmer who failed to provide his people with new potatoes, new bacon, and white cabbage on that day was called a wind farmer.'[5] A correspondent from County Galway observes: 'Long ago great respect was shown for the new crop by covering the floor all over with fresh green rushes. That custom existed all over the country long ago.'[6]

Even in the twentieth century, the wife sometimes wore a special white apron to mash butter and milk in with the potatoes. Mrs Macneill comments: 'The offering of First Fruits is so bound up with religion that it can hardly be doubted that the first partaking of the new food supply was also invested with a sacred character.'[7]

The conical hills
The meal was usually eaten on the Friday prior to Big Sunday. On Big Sunday itself the whole population assembled on one of hundreds of traditional hilltop sites, scattered throughout Ireland. In 1942, 195 assembly sites were known for certain, and 'the conclusion is inescapable that formerly [the festival] . . . was celebrated at many more places than are indicated by existing records.'[8]

Almost all the known sites were on hilltops: isolated hillocks, often conical in shape, and sometimes flat-topped, were generally preferred to mountain summits,

and a siting amidst farm land, rather than in uncultivated areas, was the norm.

The non-correlation of the August assemblies with the Christian Church is very striking. Of the 195 assemblies, only 17 had accepted transformation into pilgrimages of Christian sponsorship.[9]

Big Sunday survived into modern times as a communal expression of joy. 'About all the assemblies it may be said that they were regarded with special favour by the people as the most joyful in the year.'[10] The behaviour associated with the grassy summit of Ard Eirann, in County Leix, illustrates the nature of the festivities:

Reports in 1942 spoke of crowds on the hill, of streams of cars, pony traps, and bicycles from Tullamore and Birr, and all the surrounding country, passing through Kinitty to the Gap, and of the Leix people making their way up from Camross. The farmhouses near the hill were held open for friends and relatives and in the old days it was said that the visitors stayed for 3 days before the festival. There were dances in the country kitchens, and at the crossroads after the descent. All around . . . the tradition still lived that this was the day for which the first potatoes were dug. Both in

Lammas celebrations still survive at Ballycastle, N. Ireland, with an annual fair, music, dancing, and traditional foods.

recent and more remote times, the main diversions were the same – dancing, country sports, bilberry picking and sociability, but whereas in modern times, the people after reaching the summit, sat around in groups, eating picnic lunches, in olden days, there were booths on the height. Musicians with fiddles, melodeons and flutes played for the round dances known as sets, formerly there were contests in step dancing between the mountain boys and girls and those of the lowlands.

The harvest woman

Behind this rapidly fading pattern there lies an even fainter image, known until a few generations ago: the archetypal divine female.

We are told in one report (and this as though it were a recently practised custom), that a chair was placed on the Cruachán (summit), on which a girl sat, crowned with flowers and garlands strewn at her feet. From another correspondent, we hear of an old woman's tradition that in her mother's day there was set up in each locality on Garland Sunday an effigy of a woman, garlanded and decorated with ribbons, and round this figure the dancers moved, the girls either touching the garlands as they passed, or plucking off one of the ribbons.[12]

How may the lost effigies be interpreted? How do they relate to the revered hill, cursed by a priest,[13] and to Big Sunday? Perhaps Bron Trogain moulds the threads together. In the ancient Irish manuscript *Tochmarc Emire*,[14] the name Bron Trogain is explained as meaning The Beginning of Harvest, when the earth sorrows under its fruits – a metaphor based on the travail of birth and one which causes Eleusis and Silbury to flash into view. The mountain in labour, ridiculed by Aesop, is the full womb at the start of August, the archaic seated goddess who gives and gives, year after year, all over Ireland.

The Neolithic root

Dr Ross describes this goddess, known variously as Bride, Ana or Danu, as 'more archaic than the gods', and speaks of her responsibility for the fertility of the land.[15] When did this responsibility begin? If the answer is to be reconciled with common sense there would appear to be little room for manoeuvre. It is known that the first male pantheon was established in the Bronze Age. Danu, being older than the first male pantheon, must therefore have been acknowledged before the Bronze Age, i.e. in the New Stone Age, the age of the first Irish farmers and the age of Silbury Hill.

The worship of a mother/funerary goddess during the Irish Neolithic is firmly attested by the archaeological record,[16] and it requires no great speculative leap to propose that one of the primary functions of a mother goddess is the bearing of children.

In England Silbury Hill, the full womb, has survived. In Ireland many natural Silbury Hills have survived and so have vestiges of the Neolithic ritual necessary for safe delivery of the child/harvest. The divine birth is the ripening of wheat; goddess and farmland are one (the anthropomorphic attitude to landscape is plain in names like the Paps of Dana, Co. Kerry, where the divine attribution is unequivocal); and the identity is symbolized by the shape of a conical hill, which provides a focal point for ceremony. That is why barren women lay in a certain spot on the summit of Croagh Patrick[17] on the night before August 1st – so that they might, through empathy, eventually enjoy the Bron Trogain, the labour pains.

That is why, at Ganiamore, Donegal, 'a flower was worn by everyone going up the hill and on the summit all the flowers were put in a hole specially dug for the purpose, which was then covered with earth, as a sign that summer was ended.'[18] The petals had done their attractive work; the season of fruit was about to begin. On the same day, a sheaf of green oats was given to the stock.

Even during the patriarchal Iron Age and Christian periods, the subject of the Irish August gatherings remained a goddess, as is shown by the definite association between the great assembly at Teltown and the goddess Tailtiu, Mother of the Cattle Reivers, 'who cleared away the roots to make the fertile land we now call Meath',[19] and who was identified with Rath Dubh, an artificial hillock, 100 yards across, surrounded by a ditch. At Emain Macha, Co. Armagh, the August gathering also took place on an artificial mound, which was 200 feet in diameter and 20 feet high.

Matching Mother Earth as pregnant August Hill are numerous post-Neolithic versions of the squatting goddess image, carved on or from stone, continuing into the medieval period. These occur both sides of the Irish Sea. For example, there is a squatting goddess at Lower Swell church, Gloucestershire, in the chancel arch. In Ireland such figures are now called Sheela-na-gigs.

'That pagan ideas and practices were associated with these stones in comparatively recent times and even

The goddess of fertility in post-Neolithic Ireland. Sheela-na-gig carvings from Seir Kieran, Co. Offaly (above), and Lavey, Co. Cavan.

today, can hardly be doubted,' wrote E. M. Guest, in 1935, adding, 'Some of these stones are still touched to facilitate childbirth'.[20]

Scottish Lammas towers

Scotland has similar figures to show, e.g. the squatting female at Knockraich and a corresponding body of Lammas folk behaviour *which includes the construction of 'little Silburys'* or Lammas towers:

I beg leave to communicate the following account of an ancient custom that long prevailed in the Lothians and which, within a few miles of this city, was universally known about 30 years ago, though it is now fallen almost into disuse [wrote James Anderson in 1792.][21]

. . . The celebration of the Lammas Festival was most remarkable. Each community agreed to build a tower in some conspicuous place, near the centre of their district, which was to serve as the place of their rendezvous on Lammas Day. This tower was usually built of sods; for the most part square, about 4 feet diameter at the bottom, and tapering to a point at the top which was seldom above 7 or 8 feet from the ground. In building it, a hole was left in the centre for a flag staff, on which was displayed the colours on the great day of the festival.

This tower was usually begun to be built about a month before Lammas, and was carried up slowly by successive additions from time to time being seldom entirely completed till a few days before Lammas, though it was always thought that those who completed theirs soonest and kept it standing the longest time before Lammas, behaved in the most gallant manner, and acquired most honour by their conduct.

From the moment the foundations of the tower was laid it became an object of care and attention to the whole community.

As the great day of Lammas approached, each community chose one from among themselves for their Captain, and they prepared a stand of colours to be ready to be then displayed. For this purpose they usually borrowed a fine table napkin of the largest size from some of the farmers' wives within the district; and to ornament it they also borrowed ribbons from those who would lend them, which they tacked upon the napkin in such fashion as best suited their fancy.

Things being thus prepared, they marched forth early in the morning on Lammas Day, dressed in their best apparel, and each armed with a stout cudgel and repairing to their tower, there displayed their colours in triumph; blowing horns and making merry in the best manner they could. About 9 o'clock they sat down upon the green; and each taking from his pocket bread and cheese, or other provisions they made a hearty breakfast, drinking pure water from a well, which they always took care should be near the scene of their banquet.

At about midday, they marched 'with horns sounding towards the most considerable village in their district, where the lasses and all the people came out to meet them, and partake of their diversions.' These included racing: 'A bonnet ornamented with ribbons was displayed as the prize of the victor of the first race. The prize of the second race was a pair of garters and the third a knife. . . . Next day the ribbons and napkin that formed the colours, were carefully returned to their respective owners. The tower was no longer a matter of consequence, and the country returned to its usual state of tranquillity. . . . The name of Lammas towers will remain (some of them having been built of stone) after the celebration of the festival has ceased.'

In Wiltshire the name Lammas is 'very common in field names, such as Lammas ham', and has reference to certain lands under private cultivation till harvest, after which they reverted to common pasture from August to March.[22]

How can such concerns be related to Silbury Hill? The answer may be that they relate to it in the same way as does an imminent total eclipse to the full face of the moon or the sun. By 1800 the towers had been covered by total obscurity. Yet surely, in the 1760s, there is evidence to show that the tenuous connections with Neolithic practice were more striking than any number of differences. The towers were built at the same time of year as Silbury had been, and of similar materials – turf and stone. Like Silbury, they were 'always of a

Ceremonial corn stack from Whalton, Northumberland, 1901. The layered structure and conical shape are evocative of the Scottish Lammas towers and of Silbury Hill.

conical form', according to the Revd James Nicol, another contemporary observer, who added that 'the Lammas Festival was once universally celebrated'.[23] They were built among unenclosed corn lands (i.e. cultivation strips shared by all sections of the community, not divided by hedges), by cattle herders, and constructed by collective effort. Moreover, each tower was located by a well of pure water, drunk on the big day.

The last Silbury gatherings

All folklorists agree that the Lammas first fruits festival collapsed in England long before it surrendered its date and meaning in Scotland and Ireland (if indeed it yet has, in the latter country). When Stukeley visited the area in the first half of the eighteenth century, he reported that 'the country people have an anniversary meeting on the top of Silbury-hill, on every Palm Sunday, when they make merry with cakes, figs, sugar,

and water fetched from the swallow head, or spring of the Kennet.'[24] He went on to write that the spring (which lies only 522 yards away) gave much less water than formerly. 'They say it was spoil'd by digging for a fox who earth'd above in some cranny thereabouts; this disturbed the sacred nymphs, in a poetical way of speaking.'[25]

Despite the wrong date, the dying rite involving water, cakes and figs nevertheless resounds with forgotten first fruits significance, stretching back far beyond the mysteries of the Great Mother, Demeter, held at Eleusis. The worship of fecundity in maternal realization has flavoured these victuals wherever they have been eaten, through the greater part of human history.

In the relatively recent English tradition, 'motherhood and the Mother of the Gods'[26] were especially honoured with figs and simnell cakes on Mothering Sunday.[27] Mothering Sunday is the fourth Sunday in Lent. The closest important day in the Christian year is Palm Sunday – the day chosen, according to Stukeley, for the last Silbury assemblies.

Silbury, the most remarkable of all the Lammas towers, finally died, as a stage for communal behaviour, in the nineteenth century AD. In 1853, William Long reported: 'The practice of resorting to the top of Silbury Hill is still kept up by the children of the neighbourhood.'[28]

The death rites of the Neolithic mother goddess were observed by Queen Victoria's children. Then, one year between 1853 and 1900, they ceased to come. The long veneration was finished, and the Silbury corpse was handed over to the Ministry of Works.

There was an old woman
Lived under a hill
And if she's not gone
She lives there still.

Anonymous Nursery Rhyme

The Swallowhead spring

The Irish Big Sunday festival, and the Scottish Lammas behaviour, both relate to the original Silbury purpose. They also serve to emphasize the intimate dialogue between monuments and natural landscape, and prompt the question: was Silbury sited with regard to natural features of special importance?

Landscape and religious inspiration

The landscape certainly provided the Silbury builders with their raw materials – chalk, water, sandstone blocks and riverine deposits. Equally important, though seldom appreciated today, the landscape was a source of perceived imagery which stimulated the prehistoric imagination and quickened the religious impulse, to a pitch where a response was offered, in the form of monuments modelled to harmonize with the topography. In Henri Frankfort's words:

We touch here upon a distinction between the ancients and us, which is of the utmost significance for our enquiry. . . . [Whereas] for modern, scientific man, the phenomenal world (including landscape) is primarily an 'it', for ancient man and also for primitive man, it was a 'thou'. We shall see in fact that natural phenomena were regularly conceived in terms of human experience and that human experience was conceived in terms of cosmic events.[1]

Accepting this insight, we may say that Silbury as squatting woman-cosmic giant, was built to complement a squatting human figure previously identified in the local scenery for, when Silbury was created, 'Mother Earth' was not a mere figure of speech, but the literal truth. 'The assimilation of the human mother to the great telluric mother was complete,'[2] and indeed remained so into modern times among 'primitive' peoples. (Earth is called *Naestsan* in the Navajo language, meaning the horizontal or recumbent Woman, and they still mean what they say.)

Vincent Scully has shown that, in Crete, the Great Goddess's temples were 'always located in a clearly defined pattern of landscape' whose elements included

natural evocations of breasts, raised arms, and the female cleft. 'These sculptured masses of the land . . . defined and directed man's part (temple building), so that the natural and the man-made, created one ritual whole.'[3]

Silbury too contributes to 'a sacred landscape . . . in which the degree of collaboration between natural forms and conscious design is most marked'.[4] So let us look at the Silbury landscape, to see how the Neolithic development of the few square miles around Silbury Hill, as a focus for worship, depended on the recognition of potent anthropomorphic qualities in the natural setting, which were acknowledged from the first and enhanced in the later work.

The reclining woman
It is important to ask what the landscape looked like after the first farmers had begun to clear the light forest cover, and to realize that in all essentials it looked the same as it does today: the same broad expanse of chalk upland with higher chalk downs swelling above the general level – modified, according to Professor Atkinson (*Antiquity*, 1961) by an overall loss of up to

The Winterbourne and Silbury. One flat meadow lies between the foreground stream (flowing north to south) and the goddess's water thigh, whose lower edge is now additionally defined by the hawthorn hedge.

Reclining Figure *by Henry Moore. 'It is this mixture of figure and landscape. It is what I try in my sculpture. It is a metaphor of the human relationship with the earth, with mountains and landscape.' Henry Moore, 1962.*

two feet through the natural process of chemical weathering, but cut by the same dry valleys, and leading down to the damp flat floor of the main valley, through which flowed the same river Kennet. Their landscape is our landscape. The common sight of it links us all together as surely as it links the monuments to one another. The layout of hill and river is therefore a document of the highest value in the search for Neolithic truth.

What does it say? First, and from a Neolithic viewpoint, foremost, the message is: 'Reclining Woman.' The reclining woman is to be found all over the English chalklands. It could be claimed that no other geological formation erodes into forms more strikingly and directly reminiscent of the rounded limbs of the human female, nor more likely to bring to mind Oeri's remark: 'The human body participates in its environment. It is a landscape itself, permeable, and mutable, with valleys and ridges, cavities and peaks.'[5]

For a society like the Neolithic, which saw life in terms of a Great Goddess, the compelling attraction of the chalklands is apparent, for there the people of the New Stone Age could walk on the torso of the divinity, explore her breasts, her armpits, the space between her thighs, or run the endless swell and ripple

of her back for mile after mile, all the way from Dorset to East Anglia, of from Kent to the Yorkshire Wolds. In Wiltshire, 'rounded slopes, resembling buttocks' are often named in the records as 'le buttokes', or 'les buttokes', as a conscious act of anthropomorphic identification, according to J. E. B. Gover.[6]

In geomorphological terms, one could describe the chalklands as deeply dissected by valleys which modulate smoothly between convexity and concavity, producing an overall profile which is often vigorous but rarely abrupt. As three-dimensional form, chalk topography generally creates a sense of massive intimacy, while if the shallow soil is scraped away, the rock revealed is almost uniformly white (though in certain areas, such as parts of the Chilterns, a thick deposit of orange clay is found to cover the underlying rock).

The white goddess

There are grounds for saying that the colour of chalk provided another source of attraction to the New Stone Age community. It is known that, in non-chalk areas, great efforts were made to cover the outer surface of some major structures with white material. As an example, consider the quartzite pebble layer on the great mound at New Grange, Co. Meath.[7] Those who are familiar with the sombre rocks of North Devon may also recall how frequently the megalithic monuments are selected from strata into which pinkish-white quartz has been heavily intruded, while Francis Jones finds a continuing association in Welsh folklore between white (wen), sacred wells, and a shadowy female personage called Lady Wen, generally understood to be the guardian of the well. He writes: 'It is widely believed that wells containing in their names the elements WEN (meaning white, blessed, holy), possess a religious origin.'[8] He goes on to list 76 examples. At some of these, white pebbles were cast in as oblations until comparatively recently.

In the form Albina, the white goddess is identified by Pliny with Albion (Britain). White as a full moon is the dazzle of exposed British chalk. Born beneath the cretaceous sea, this great uplifted formation, sculpted by streams and rivers, became Albion par excellence, and the obvious setting for our greatest Neolithic achievements.

To the New Stone Age population there was a causal connection between the chalklands as goddess and

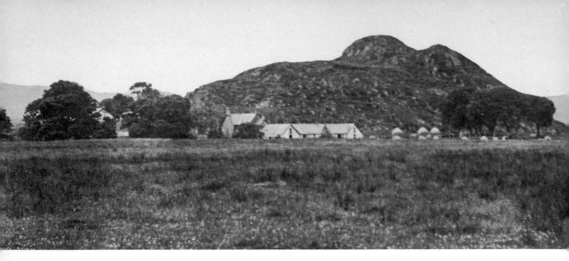

Dunadd, Argyllshire, called the birthplace of Scotland. A notable hill in flat country, within sight of the Neolithic monuments of Temple Wood, Kilmartin, and Kilmichael Glassary. Viewed from the southwest.

chalklands as good farming country. Gifford is right to say, 'their outstanding importance has been in the provision of extensive areas of light, well drained and easily worked soils suitable for occupation by early agriculturalists.'[9] The most impressive group of Irish Neolithic monuments is placed in the exceptionally fertile Boyne valley. The outstanding concentration of Neolithic monuments in mid-Argyllshire coincides with an area of unusual fertility in a Scottish Highland context. But because 'primitive social life is permeated with sacredness', the responsiveness of this land to the attentions of the first farmers was necessarily seen by them as a function of the divinity, whose form and colour they recognized in the configuration of the natural scenery, confirmed in miniature by the abundant nodules of flint.

Flint
Flints, lumps of white-crusted silica formed in the cretaceous sea by the solution of fossils with a high silica content, are to be found throughout the chalklands. Their biomorphic forms are often strikingly evocative of the goddess figurines. To this coincidence can be added the knowledge that 'in the oldest tradition of the hunting peoples, going back to the Palaeolithic, the stone "bone" was the very source of life'.[10]

That may be why flints were set so thickly in the clay mound at the very core of Silbury Hill, and why A. C. Pass found a layer of flints, 9 inches thick, on the floor of the moat (Shaft 7).

Flints are known to have been deposited under many Wessex monuments of Neolithic date, e.g. at Bowls Barrow, Wiltshire (*c.* 3000 BC). Need we search further for a reason than that provided in a world-wide context by Eliade?

'If the Earth is a living fecund Mother, all that she brings forth is at the same time organic and animated, not only men and trees, but also stones and minerals. All things that she carries in her bowels are homologous with embryos or living beings in the course of gestation.'[11]

Where flints were naturally plentiful, as they were (and are) on the Avebury hills, the prospects of general fecundity were thought to be enhanced.[12]

Sarsens or Bridestones

Several factors combined to make the Neolithic population of England choose the Avebury district, of all the chalklands, for their national metropolis.

Accessibility was important, and it lies in that part of the downs from where chalk arms branch out to the northeast, east, south and southwest coasts, and is therefore a natural meeting place. The famous prehistoric track, the Ridgeway (Norfolk–Dorset), passes through the area, within sight of the principal monuments. Routes such as this were used by people who actually lived on the densely settled escarpments, and by travellers from much further afield.

The Avebury district also had sarsens in its favour. Sarsens, or Bridestones, are massive blocks of hard sandstone which lie recumbent on the surface of the hills around Avebury. They can be over twenty feet long, but are usually the size of a large sheep. Composed of 'white, greyish and yellowish quartz sand, cemented by secondary silica',[13] their origin is uncertain, but they may represent the concreted remnants of a continuous layer deposited some fifty-five million years ago, in the Eocene Age. Because the stones are hard, yet do not have to be quarried, they offered marvellous opportunities to the Neolithic builder. Incorporated, according to Merewether, in the Silbury mound, they were also extensively used at the Avebury henge. No other district had Bridestones as big or as plentiful.

Because their shapes are characteristically 'diversified by knobs, furrows and basins, cavernous hollows and rifts',[14] they tend to register as natural sculpture, and even to a modern geologist 'there is something in their grey recumbent forms, half hidden in the long grass and scrub, that awakens a lively interest in the beholder. . . . They stir the imagination.'[15]

The name Bridestone is derived from the ancient goddess, Bride, otherwise known as Brigid, and christianized into Saint Brigid, though her devotees in

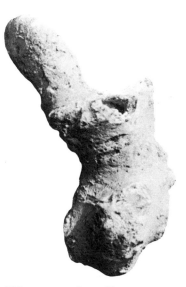

Flint as squatting goddess. Natural flint nodule, length 4 in., from a field near Silbury. In the Neolithic, when the earth was regarded as a living fecund mother, single stones were also seen as organic and animated. Sometimes they shared the form of the Great Goddess herself.

Bridestone or sarsen. The name Bridestone derives from the pre-Celtic goddess Bride. There can be little doubt that to the Neolithic community the stones were forms of the goddess. Even in modern times the belief that the stones are capable of independent movement has not yet died out.

Ireland and the Scottish Isles included many pre-Christian elements in their veneration. There can be little doubt that Bridestones were regarded by the Neolithic community as manifestations of the deity, in her many forms, who thus bestowed great sacredness upon the district.

By the time the Silbury plans were made, the choice of neighbourhood was also suggested by a long tradition of veneration. Silbury followed where more than a dozen mighty long barrows, including the biggest in England, had previously led. No fewer than three causewayed camps constructed before 3000 BC also point to the ancient popularity of the locality, with the only known triple ring camp, Windmill Hill, being the closest to Silbury.

Melbourne rock and Plenus marl

Like the mighty Avebury henge, lying one mile to the north, Silbury was sited on, and dug from, the lowest layers of what geologists call the Middle Chalk formation. These layers yielded two special commodities vital to the building programme, namely Melbourne rock and water.

Melbourne rock is the name given to a seam, 4 feet to 6 feet thick, of what (for the chalklands) is an

exceptionally hard limestone, which can be quarried into freestone building blocks. At Silbury, the concentric and radial walls were made of this material. Immediately below the Melbourne rock, and appearing in both the Silbury and Avebury ditches, was a thin layer of sticky, grey-green clay, now called Plenus marl.[16] This layer had the important effect of inhibiting the free downward percolation of water. Water which could not pass downwards was instead forced *sideways* and thus seeped into the ditch. And lo! the ditch became a lake.

Without the Plenus marl, the Silbury quarry would have been as dry as most other chalk quarries. *Because* of the Plenus marl, the water goddess could be made.

The Silbury designers knew of the formations described above, prior to starting work, because they could see them exposed naturally at the Swallowhead spring. They were able to note the massive qualities of the Melbourne rock, which formed, then and now, a natural semi-circular wall around the spring.

They saw an underground stream issuing from the base of this rock and running out across the underlying marl.

A quarter of a mile to the northwest, the same formations were exposed at Waden hill, with the same result on the underground water – the Waden hill spring was seen to flow. From these observations the correct deduction was made that a quarry dug through the low spur of a hill, between the springs, would strike the same water-yielding layer.

For the Neolithic community, the evidence offered by the springs made Silbury possible and necessary. Practical opportunity was combined with religious inspiration, for the great artificial image of the mother goddess was built to complement a particular and remarkable version of the same subject, discovered in the natural landscape.

Silbury and the Kennet

Surface water is rare in chalk country. In the neighbourhood of Silbury Hill, there are many more stream and river valleys than there are streams and rivers. Most of the valleys, in common with the vast majority all over the English chalklands, have been dry for thousands of years. Therefore the river Kennet brings an unexpected animation to the silent hills. We might also see in its winding course a thread leading backwards into the labyrinth of prehistoric belief.

'Water, like earth, has always been recognized in the human psyche as a feminine element',[17] and in British folklore rivers are often identified with a supernatural female, thus: the Tees with Peg Powler, the Severn with Sabrina, and the Lancashire streams with Jenny Greenteeth, while 'Dee' is Celtic for goddess.[18]

Specifically, the name Kennet is linked by Ekwall to the Celtic word *kuno*. He finds 'a meaning such as "the exalted holy river" would be most suitable'. And 'the river name would then be one more example of names testifying to the worship of rivers.' The Cunnit (as it was known in the eighteenth century) 'may well be assumed to have been the object of religious worship'.[20]

What sort of worship? In the post-Neolithic classical world, river worship 'was pre-eminently a cult of women – for prophesies of marriage, help in childbirth and protection of young children',[21] though this may represent a specialized reduction of the full New Stone Age attitude.

The Kennet cycle

The Kennet exhibits a marked seasonal rhythm in its flow, and since the Neolithic habit was to attempt to synchronize the animal, vegetable, mineral, and human cycles, a river which shared in an annual death and resurrection was likely to excite interest and to be recognized as divine.

In autumn and winter, the upper Kennet disappears underground and the two springs are dry – summertime surface evaporation on the downs having caused the underground saturation level to sink below the Plenus marl layer. Not until this level has risen again, during the next low-evaporation winter, does the river reappear. Its revival in February–March coincides with the general revival of life in spring. In Neolithic times it seems likely that the period of total Kennet failure was of shorter duration than in an average modern winter, because of the advance of 'scarp foot' springs in the clay vales flanking the downs.

In this way the landscape in Avebury parish shared the goddess image, not as a static design but as a living being, whose vital bodily functions could be witnessed in time, proclaiming the unity of the living world. Cassirer has shown this concept of 'biological time' to have been common to all pre-logical societies,[22] while Campbell has rightly drawn attention to the vital role played by water in achieving both the movement and

the coherence of this type of cosmology: The goddess 'personifies the mystery of the waters of birth and dissolution – whether of the individual, or of the universe'.[23]

Swallowhead

The mystery and value, in a concentrated natural form, were found at the Swallowhead spring.

Today, this feature has a radius of approximately 8 feet, with a vertical height of 4 feet 6 inches, topped by a 3 feet mass of coomb rock and soil. The rock wall is slightly undercut by the leakage of water, but the main flow is from a distinct channel, a foot wide and 18 inches high, the mouth of a clearly defined underground watercourse. Here the Kennet is born. From here the shallow water swills through the horseshoe enclave and threads its way around clumps of grass and lumps of sarsen (the largest being $5\frac{1}{2}$ feet long, and dished on one face). With trails of spirogyra floating beneath its reflecting surface, the stream trickles 22 paces to meet, between an old hawthorn and a willow tree, a river much bigger than itself. This river has travelled 4 miles from the north, but it is called Winterbourne, not Kennet. Winterbourne is *turned into* Kennet by the modest contribution from Swallowhead. Recent geological studies and the eighteenth-century folk tradition agree about this.[24]

From the earliest times, human beings have worshipped at, in, and before water-issuing caves, because the cave epitomizes those states of transition which are of compelling and universal interest: light-dark, enclosed-open, in-out, life-death. These pairings and paradoxes have sexual reference in the broadest sense, and the symbolic amalgam is also contained in the name 'Swallowhead'.

Swallowhead is perhaps the most physically memorable inland cave-spring to be found anywhere on the chalk, and because, in Cassirer's words, 'all the sanctity of Mythical Being goes back ultimately to the sanctity of the origin',[25] we can see why the Silbury birth woman was built beside it.

The sixteenth-century topographer John Leland emphasized the connection: 'Kennet riseth at Selbiri hille botom',[26] while Stukeley again and again links Swallowhead to Silbury, although to do so contributes nothing to his theory that Silbury was a hero's tomb:

'The person that projected the forming of this vast body of earth . . . pitched upon the foot of the Chalk

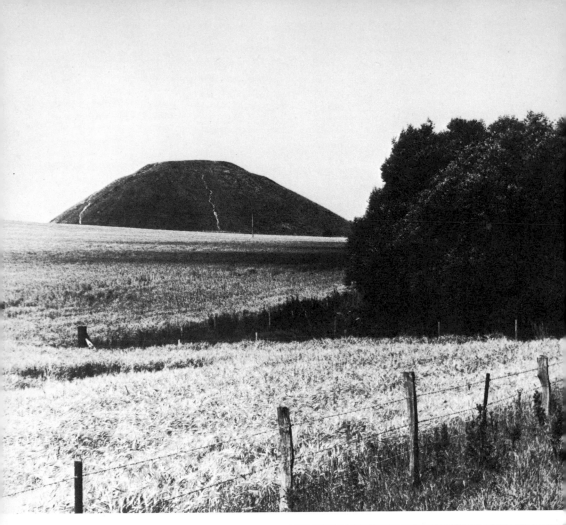

(Above) Silbury stands over the Swallowhead spring, whose horseshoe shape (right) is defined by the natural chalk wall, from the base of which water seeps. This contains the principal tunnel outflow (opposite).

hill, by the fountain of the River Kennet. . . . At Silbury Hill [the river] joins the Swallowhead or true fountain of the Kennet, which the country people call by the old name of Cunnit and it is not a little famous among them.'[27] Further on he writes: '. . . Silbury Hill, where the real Head of the Kennet is'.[28]

This pairing is further supported by the frequency with which Irish Garland Sunday hills were associated with holy springs, and also by the description of the siting of the Great Goddess's temple at Eleusis: 'But now let all the people build me a great temple . . . upon a rising hillock above the Kallichoron.' Scholars agree that the Kallichoron was a well.

Cunnit

With the help of the Avebury peasants of Stukeley's day we may yet rediscover the Kennet as Cunnit, and the Swallowhead as Cunt. The name of that orifice is carried downstream in the name of the river. Cunnit is Cunnt with an extra i. As late as 1740, the peasants of the district had not abandoned the nomenclature, and the old name was in use all down the river to Hungerford, in 1723.[29] The antiquity of the form is clearly shown by the Roman riverside settlement called Cunetio – their principal town in the entire Kennet valley.[30]

The rediscovery of the Silbury Hill treasure partly depends on unearthing what Eric Partridge, in his *Dictionary of Slang*, describes as 'the most notable of all vulgarisms. . . . Since 1700 it has, except in the reprinting of old classics, been held to be obscene, i.e. a legal offence to print it in full.'[31] Unable to take the risk Partridge settles for C*NT, but perhaps he should not have included the word at all, because J. S. Farmer affirms that it is not slang, dialect or any marginal form, but a true language word, and of the oldest stock.[32] Other language stocks show:

Latin	CUNNUS (Andrews E. A., *Latin English Lexicon*, 1854)
Middle English	CUNTE (Stratman F. H., *Middle English Dictionary*, 1891)
Old Norse	KUNTA (*Ibid.*)
Old Frisian	KUNTE (*Ibid.*)
Basque	KUNA (Griera A., *Vocabulario Vasco*, Vol. II, 1960.)

(Opposite) The Mouth of Hell was often equated in the medieval clerical mind with the female vulva, as in this miniature from the Winchester Psalter, c. 1150.

The Basque *kuna* is particularly interesting, since the Basque people are the only living representatives of Neolithic European man. At one time they constituted a great people numerically, and they have definitely been shown to be pre-Celtic in origin.

Although the dreaded C*NT (the medieval cleric's Mouth of Hell) was not, and is not, admitted into the *Oxford Dictionary* fragments of the old world which she generated are included:

CUNABULA: cradle, earliest abode, the place where everything is nurtured in its beginnings, associated with:

CUNINA: the goddess who protects children in the cradle (Roman).

CUNCTIPOTENT: all powerful, omnipotent.

CUNICLE: a hole or passage underground (obsolete).

CUNICULATE: traversed by a long passage, open at one end.

CUNDY: (N. English dialect) a covered culvert.

CUNNE: inquire into, explore, investigate, to have experience of, to prove, test, make trial of, to taste (obsolete).

CUNNING: (in its earlier sense) to know, possessing a practical knowledge or skill, able, skilful, expert, dexterous, clever. Possessing a magical knowledge or skill.

The cunning woman

With reference to this last meaning, it is interesting to recall that, in 1874, the Reverend A. C. Smith, vicar of the parish adjoining Avebury and champion of Silbury as a king's tomb, threatened to prosecute the village 'cunning woman', whose store of herbal and other wisdom continued to hold the respect of the villagers, much to his annoyance.

Perhaps she gathered her best herbs from Swallowhead, for Stukeley reported: 'I took notice that apium grows plentifully about the springhead of the river Kennet. To this day the country people have a particular regard for herbs growing there, and a high opinion of their virtue.'[33]

The magic knowledge also resided in the water itself, which was accordingly carried from 'the sacred spring of the area, not a little famous among them',[34] to be drunk on the Silbury summit, so passing from birthplace to birthplace, and from eye to eye. 'For a woman, they say, has an eye more than a man'.[35]

The Irish material also points to a connection between the level of river water and the subsequent harvest hill delivery: 'The custom of measuring the height of the water in a stream on the night of July 31st and the morning of August 1st was known [at Athea, Co. Limerick] in 1942; a rise in the water was a good omen.'[36] Radford reminds his readers that in recent English folk tradition (which has suffered so heavily from inversions and distortion), 'uncertain springs in Chalk country are still called corn springs, because they were formerly thought to foretell the price of corn'.[37]

Wading in the Kennet stirs up the white silt, and instantly turns the clear water into 'milk'. The noting of a similar effect may partly account for the name given by the Ainu of North Japan to their feminine streams supplying domestic water: *nupuru tope a e-urespa* (mysterious together upraising milk).[38] The same effect could be raised from the silt in the Silbury moat breast, and gives added point to the Posset of Milk legend.

The Swallowhead eye

Silbury, combining eye and womb imagery, was built beside a spring which, long after the Neolithic Age was over, was probably understood to do the same. The old double image of body and head underlies and explains the otherwise baffling emphasis in English springhead folklore on the curing of eye ailments.

More than 28 per cent of the 'holy wells' listed in 1893 retained a connection with eyes. In many cases the benefit to the eyes was the only surviving belief, and this common conviction, so persistent and widespread, must surely stem from the time when all springs, including Swallowhead, were read as eye-head images – natural versions of the eye goddess. Her heritage, incidentally, is equally marked in Wales, where 'the disease mostly mentioned concerns the eyes – blindness, weak sight, inflammation, styes and sore eyes'.[39]

In addition to the uterine role, Swallowhead was also perhaps the divine cranium, with the river a stream of supernatural tears. When we recall that orthodox opinion in classical antiquity traced generative power equally to both head and genital organs,[40] with the head 'thought to contain the seed, the very stuff of life, and life-soul associated with it',[41] we can see how closely the two ends of the body were drawn together in the ancient world, and how well the English name

Swallowhead expresses the ancient synthesis. (In Roman times, also, the source of a spring was called its 'head' in a direct reference to the human head, as Onians explains.)

Nor should it be imagined that the head replaced the womb, for they led a truly compound existence and, even in the opinion of the rational Aristotle, 'after conception women . . . experience a sensation of darkness in front of their eyes, and suffer also from headache';[42] while the physical migration of womb to head was the result of delaying conception.

Consistent with the eye tradition was the use generally made of apium, the plant which still grows in the Swallowhead water, and around many of England's once sacred springs. It has white, star-shaped flowers, arranged in circular clusters, blooming in July and August (Lammas). Botanically (and in appearance) the most closely related cultivated plant to apium is parsley. In the Fens, newly turned from marsh-apium country into fertile farmland, parsley was steeped in rainwater and then applied to the eyes of a newly born baby, to ensure good vision. Parsley was also thought to improve brain power, and retained a strong matriarchal flavour, spelled out in the proverb: 'Where the Mistress is the Master, parsley grows the faster'.

Apium nodiflorum, noted by Stukeley at Swallowhead, was employed in eighteenth century medicine to cure complaints of the tear ducts, and later 'recommended by Dr Underwood in those eruptions which frequently infest the faces and necks of children'.

Swallowhead, like Silbury, was a double image, combining vulva and eye, physical deed and spiritual understanding.

It was to the tattered remnants of this synthesis that the 'Cunning Woman' clung. It also lies at the root of both forms of the river name which have come down to us:

KEN :	range of sight or vision, to generate, mental perception, to give birth to, to know.
CUN :	to learn, to know.
CUNNOG :	(Welsh) a posset to hold milk.
CUNT :	****

The flowers of apium nodi-florum, *can be seen today, as in* Stukeley's time, *'growing plentifully about the springhead'. Blooming in July-August* (Lammas), *they were held to be a specific against eye infections.*

Two waters

When Silbury was built, all landscape and all springs and rivers were regarded as aspects of the divine body, and read in human terms. Therefore, it might be argued,

View from Swallowhead, down the 22-yard watercourse to join the Winterbourne (which here changes its name to Kennet), between the two trees. The rocks in the water are natural sarsens.

any tract could have inspired the Avebury monuments. This chapter has been written to show that selection from a context of general availability was based on the attractions of the area: white, fertile, flint-studded chalkland, the special local endowment of sarsens, the water-holding Plenus marl, and the spectacular seasonal regime of the river, running through otherwise dry country. Additional focus was provided by the close proximity of two remarkable springs, which caused the underlying rock to be exposed. Both springs enacted the birth process, and became subjects for keen Neolithic response.

Taken together, the advantages listed here indicate that the site of Silbury was far from being an arbitrary choice. But there is another factor which gave the Kennet source a truly unique status, eliciting in the monuments a reply of unparalleled strength. The Neolithic designers worked with what they found. By a stroke of amazing good fortune, they found that to stand at the point where the Swallowhead water joins the Kennet (which

we will call K1), and to look from there at the confluence of Waden spring water with Kennet (K2) – a quarter of a mile downstream – was to face 70° east of north, with one's back 250° east of north.

This 70°–250° line was *the* birth axis of the agricultural year, as will be shown in Chapter 12. By what we would call a complete fluke, and what they would doubtless have regarded as the tangible operation of divine favour, the two spring-river confluences formed between them a vital creation axis running through their entire cosmology, and drawing celestial, terrestial and underworld truth into a single working reality. Sun and moon, fire and water, earth and air were strung on this line, and together they made harvest. Around this line, the biggest group of Neolithic monuments in the world were accordingly constructed.

The Waden tributary follows the foreground tree line from left to right before joining the Kennet at K2. View of Silbury from the southeast.

Silbury 'mathematics'

For the Neolithic community, the Swallowhead and Waden springs gave a vivid display of the divine birth act, with their streams running from source to river (SH–K1 and WS–K2 respectively), and carrying their mysteries from the underworld to the Kennet main-stream. These natural happenings helped to inspire the construction of Silbury Hill.

Now it is hoped to show that the two tributaries also determined the modular units of proportion employed in the construction work, both of Silbury and through-out the Avebury group.

In Chapters 4 and 5, the Silbury shape was related to an established iconography, in which the squatting woman and eye motifs were very important, but the question of size was not discussed. Concerning the size of the monument, one might argue that because the imagery employed had international currency, one should therefore look for an equally international system of measurement and proportion underlying the design and determining the scale. According to Clark, 'a system of mathematical proportion appears in the nude long before the element of beauty. The sculptor Polyclitus *c.*430 BC, codified it.'[1] A tradition of artistic creation, using a numerical system, has been a feature of Renaissance and modern times, and this tradition is normally traced back to Pythagoras, *c.*550 BC, who believed that 'numbers are the first principles, indeed the very elements of the things of nature'.[2]

Working on this precept Silbury, like all architecture and sculpture, would be given form and sustained by the invisible blood of pure and abstract number, pumped from the head to all parts of the monumental body. The immense boost to the advocacy of 'number as the true nature of reality,'[3] given by the prestige of modern theoretical science, helps to make it our natural approach to the question of Silbury's size. Symptomatic of this preference is the fact that when we have information to communicate about the height of the edifice, we invariably read from a universal scale, and offer 130.5 feet (converted into metres on request).

Although we do not assume that the Silbury designers employed feet and inches, the very ease with which we can apply a universal calibrated scale to the matter predisposes us to grant them the benefit of possessing a building rule, likewise marked off in intervals, both abstract and regular. Indeed, in 1967 A. Thom, a professor of civil engineering, set out 'to demonstrate unequivocally the existence of a common unit of length throughout Megalithic Britain and to show that the value was accurately 2.72 feet'.[4]

The assumption that Neolithic 'number' was abstract tends to invalidate queries (apart from those asking for help with the multiplication of the favoured abstract unit), concerning the *significance* of the chosen Silbury dimensions, and it could be said that the very neutrality of 130.5 feet (48 Megalithic yards in Thom's unit), signifies that we have truly absorbed the monument into the world of modern mathematics, and thereby drastically (if temporarily) altered the Hill's fabric. In giving *our* numbers, we have asked the monument to support our attitude to numbers, including the belief that they must retain a spotless non-involvement with the matter which they measure, or be totally ruined.

But Silbury was the product of an age when number invariably arose from sensory matter, and exuded rather than excluded local meaning, which means that the two traditions are strikingly at odds. Cassirer coined the phrase 'mythical consciousness' to describe the earlier approach, current throughout the Neolithic, but the pressure on modern commentators to ignore or reject Neolithic 'number' in favour of our own tradition amounts almost to an obligation. The very word myth is now frequently used as a synonym for untruth. Moonshine, then so heavy with import, is nonsense, and the wisdom of old wives' tales a proverbial joke. However, if we want the Silbury treasure we must take courage and go among these despised castoffs and inversions in order to discover that 'in the Age of Myth, number did not possess abstract universality, but *was always grounded in some concrete individual intuition*'.[5] When Silbury was built, '*there were no numbers as such.*' Rather, the 'notion and appelation of number grew out of a particular numerable thing'.[6]

Silbury and the concrete modules
The key to Silbury's proportions therefore lies in discovering what concrete individual thing or things they were grounded upon. Speaking of the Neolithic

designer, Lévi-Strauss says, 'the rules of his game were always to make do with whatever was at hand.'[7] His 'supremely concrete approach'[8] must surely, in this case, have led him to consider the possibility of using as modules the lengths of the two tributary streams, Swallowhead–K1 and Waden spring–K2, both visible from the site chosen for the monument. In 2660 BC, to build at a place was to share the life of a place. To use SH–K1 and WS–K2 would thus be to merge with the active *genius loci* for, in mythical thought, 'whenever it is apparent that two quantities can be coordinated member for member, Myth explains this possibility by imputing a common mythical nature to the two quantities'.[9] The effect of using both modules at Silbury would be to declare the topographical and monumental goddess to be the same. The monument received the active power of the river, and simultaneously declared the two tributaries to be *one* within her own body, and therefore *one* in essence.

Moreover, because the modules were used *throughout the group of monuments*, each of the temples was able to achieve a fundamental identity with the others. For example, the Swallowhead–K1 module, 65.25 feet, determines the width of the West Kennet long barrow façade (65.25 feet), the diameter of the Sanctuary hut (65.25 feet), the gap between the perimeters of the two henge circles (65.25 feet) and the diameter of the wattle ring fence in the Silbury primary mound (65.25 feet). Over a few square miles, the common denominator and ruler was the sight, sound, and touch of the topographic deity, locally displayed *in the act of giving birth*, who, transferred to monumental proportions, thereby imparted a profound optimism to the entire ensemble. To primitives, according to Levy-Bruhl, numbers are not abstract, but are 'invariably the "number-names" of certain classes of persons and things'.[10]

The Silbury and Sanctuary wattle fences were in complete harmony with the Swallowhead to Kennet (SH–K1) tributary. By such means, the painful gap between natural and artificial was avoided, and Silbury could accordingly be expected to participitate in life by giving birth when the right moment came.

Civilization without theory

It is easy to see why a community with this outlook did not resort to the invention of abstract mathematics. Not only did they not need mathematics; they would

have regarded it as a weakening of the bonds achievable only through direct comparison.

The 'mythical conscious' attitude to proportion was extremely widespread in the ancient world. Sir Leonard Woolley categorically states that the Egyptians who built the pyramids 'did not study mathematics for its own sake. There were no principles which could be generally applied. Every problem had to be worked out individually.'[11] Conditioned by post-Pythagorean enthusiasm for abstract number, it is normal for us to sympathize with the Egyptians for their theoretical deficiencies, but our sympathy is misplaced, for they, like the Silbury designers, *wanted* to work only with numbers attached to real phenomena for very positive reasons. Similarly two other civilizations, great by any standards, developed without abstract mathematics. The Chinese word for maths, *suan*, is not older than Confucius, and there is apparently no long tradition behind maths in India.[12]

The Megalithic stride

Something of the extraordinary correlation between the major dimensions of the Avebury monuments and the proposed river modules is apparent from the table opposite, from which it will be seen that the modules were used directly, in multiples, and as fractions.

That modular measures had been used in the earliest monument of the group, the West Kennet long barrow, is clear from Piggott's excavation report, though he does not say what the modules were based on:

'It is clear that some kind of regular plan was envisaged, presumably to define units of measurement, and with a knowledge of ratios, and that the building followed this plan so far as practical difficulties in handling large masses of stone allowed.'[13]

Simple multiplication of SH–K1 is equally characteristic of Silbury:

height	SH–K1 × 2
diameter of chalk mound	SH–K1 × 8
edge of mound to moat head (measured along long axis)	SH–K1 × 8

Bearing in mind the *tangible* nature of Neolithic modules, information gained from the tributaries was probably conveyed accurately to the building site (without recourse to an abstract measure), by using the *human body* as a measure, and thereby strengthening still further the landscape-human-deity synthesis.

Dimension	Feet (to nearest foot)	Mega-lithic Yards	River unit
Diameter of mound (Silbury III & IV)	522	192	SH-K1 × 8
Height of mound (Silbury III & IV)	130	48	SH-K1 × 2
Length of moat (east-west long axis)	1109	408	SH-K1 × 17
Max. diameter of ditch berm (Silbury II)	400	147	WS-K2 × 1
Max. diameter of ditch deep section (Silbury II)	391	144	SH-K1 × 6
Diameter of mound (Silbury II)	240	88.8	$\dfrac{WS\text{-}K2}{10} \times 6$
Diameter of mound (Silbury I)	120	44.4	$\dfrac{WS\text{-}K2}{10} \times 3$
Diameter of external summit flat	100	36.75	$\dfrac{WS\text{-}K2}{4}$
Diameter of wattle fence (Silbury I)	65–66	24	SH-K1 × 1
Diameter of clay mound	16	6	$\dfrac{SH\text{-}K1}{4}$
Long axis of ditch between causeways	240	88.8	$\dfrac{WS\text{-}K2 \times 6}{10}$
Western causeway (narrowest width)	65	24	SH-K1 × 1
Eastern causeway (narrowest width)	16	6	$\dfrac{SH\text{-}K1}{4}$
Top terrace at 'corners' (maximum width)	130	48	SH-K1 × 2

Summary:
in planning the structure of Silbury Hill, SH-K1 and its multiples and fractions appear to be used at least 8 times, and WS-K2 fractions appear to be used at least 6 times.

SILBURY HILL
Major dimensions related to the river units:
Swallowhead to Kennet (SH-K1) = 65.25 feet
Waden spring to Kennet (WS-K2) = 400 feet

A double realism was involved – the reality of the stream, and the reality of the walker who paced the stream, back and forth, splashing through the shallow water between spring and river. Since the average height of the Neolithic adult in Britain, gauged from skeletal remains, was 5 feet 6 inches, the normal pace may well have been around 2.72 feet, which is Thom's standardized Megalithic yard. There are 24 such strides between Swallowhead and the river at K1 – a figure which had local meaning and could be easily transferred to a paced-out Silbury ground plan (and in its multiples and fractions).

Again, the precedents in antiquity for using a human intermediary in this manner are overwhelming. Throughout classical antiquity measurements were based primarily on parts of the human body. The Olympic foot standard is said to have been taken from the foot of Hercules (an interesting choice, since Hercules was both human and divine), and $2\frac{1}{2}$ feet = 1 pace. The Roman *passus* was derived from, and continued to be descriptive of, a soldier's marching stride (and even today the British Army pace of 30 inches is recreated on parade grounds in living demonstration).

The process by which units of linear measure were codified into abstraction probably began in Babylon *c.* 2500 BC, but even in that country of early mathematical propensity their basis remained physical – the finger for length, the grain (of barley) for dry weight. Therefore the British Megalithic Yard, proposed by Thom, if it is accepted, should certainly carry with it the sound of human footsteps.

One may conclude that Silbury Hill, conceived in human form, and identified with living women, was probably designed using a module based on the two tributaries, expressed in human strides:

Swallowhead–K1 = 24 Megalithic yards
 (65.25 feet)
Waden spring–K2 = 147 Megalithic yards
 (400 feet)

The shifting Kennet?

Rivers are not fixed. Their courses, like their water, are liable to change, yet the claim that SH–K1 = 24 MY or 65.25 feet, presupposes a river line stable for 5,000 years. This assumption must be examined.

In a river's life span, 5,000 years is a short time, though long enough to effect major shifts in riverbed alignment on the flat plain characteristic of the seaward

end of a typical English river. But we are concerned with the Kennet's *headwaters*, where it lies at 490 feet above sea level, and where its energy is chiefly spent in downcutting rather than lateral shift.

Around Swallowhead, horizontal stability is greatly enhanced by an important structural boundary. As the Winterbourne sweeps into the Swallowhead bend it abuts onto a solid rock wall – the most northerly edge of a unified tectonic mass which in geological terms 'dips' northwards.[14] For hundreds of yards on either side of the spring the river is held in a geological strait-jacket composed of low cliffs. Because the volume carried by the youthful river is small, the cliffs are not being actively eroded, and they are clothed in a stabilizing mantle of thin soil and vegetation.

The geomorphological evidence indicates that today point K_1 is almost exactly where it was in 3000 BC. The greatest movement one can reasonably imagine is that the apex of the V-bend has migrated a few feet towards the southwest (i.e. towards the spring), due to minor undercutting. This would compensate for the migration of Swallowhead itself, in the same direction, and by an equivalent amount, due to frost action on the exposed back wall of the spring. Therefore the distance from Swallowhead to the river at K_1 was very probably 65.25 feet during the Neolithic period.

The use of the *two* spring-river modules in combination was more than a matter of convenience, for, as will be shown in Chapter 12, the tributaries in combination played a vital role in the Lammas birth ceremonies. The individual strength of the longer watercourse derives from its rising at a clearly defined fixed spot; its dramatic situation at the base of Waden Hill where the hill had been subsequently artificially scarped (see Chapter 8); and the fact that it is the only watercourse in the area, apart from SH–K_1, suitable for use as a linear module.

Although WS–K_2 has so much in common with SH–K_1, it is not a duplication. The addition of a much longer building module, nearly six times the SH–K_1 length, was undoubtedly a help to the designers, but their decision to use it was probably also founded on anthropomorphic necessity. The Waden Hill stream, like Waden Hill itself, has all the features of *the goddess in long form*. Whereas Swallowhead is the orifice for a broad bulky mass of downland, analogous to the squatting goddess image, Waden Hill is a slender form, whose length is three times its breadth.

The fortuitous conjunction was probably interpreted as yet another sign of very unusual favour, drawing a response of unparalleled splendour from the Neolithic community, and that response was measured in terms of SH–K1 and WS–K2 units. We shall find this to be so at all the Neolithic monuments in the Avebury group. Each temple displays a common allegiance to the river modules which were employed with striking consistency as units of proportion in the design and layout of the sacred sites. In a very real sense, the Avebury Cycle revolves around the two tributary lengths.

$WS–K2 \times 1$ (400 feet) = Silbury II, ditch, maximum diameter.

= Avebury henge, distance between centres of north and south circles.

= Avebury henge, distance between obelisk and south causeway post hole.

Among many examples of WS–K2 fractions are:

$$\frac{WS–K2 \text{ (100 feet)}}{4} = \text{Silbury summit, diameter.}$$

$$\frac{WS–K2 \text{ (80 feet)}}{5}$$ = West Kennet long barrow mound, greatest width.

= West Kennet avenue, longitudinal interval between stones.

WS–K2 was also extensively used in setting out inter-site distances. The distance *between* the monuments appear to have been drawn with the same scrupulous allegiance to the two modules as characterizes the temples themselves.

The river units and human need
The key to the Silbury measurements is to be found in the lengths of the two tributaries SH–K1 and WS–K2. The choice of these as modules expressed an allegiance to plainly defined rock and water combinations. In addition, by using spring-to-river measurements at Silbury, a seasonal climax was implicitly linked to the general stream of life. There was, too, an identification with dramatic natural thresholds, which explore the light-dark, day-night cycles (thus the two measurements both began at the mouths of underground caverns),

and contact with death, since both tributaries are bone dry in December.

We may also infer an allegiance to the human body through the use of megalithic paces; and, perhaps most important, a closing of the subject-object, or spectator-landscape, gap and the creation of a truly integrated Landscape with Figures.

The architectural formulae were on permanent public display, as working prototypes inviting social participatory acts (e.g. carrying spring water to Silbury). Moreover, the view from the Swallowhead confluence at K1 to Waden spring confluence at K2 defines a point on the horizon of the utmost significance in the annual sunrise cycle. Similarly, the view in the opposite direction defines the related and equally important full moon set (see Chapter 12).

The chosen modules ran with life, as they still do, and, through the operation of sympathetic magic, it was hoped to embody this life in Silbury, so that river and monument might share the vital activity of the birth myth, which could be witnessed and directly participated in by the whole community every year, at Lammas.

Truly Lévi-Strauss does not exaggerate when he finds in the Neolithic 'a consuming symbolic ambition such as humanity has never again seen rivalled, a scrupulous attention, directed entirely towards the concrete, and the implicit conviction that these two attitudes are but one'.[15]

This rationale may be foreign to our own wisdom, but at Silbury, one of the greatest of all Neolithic achievements, we are offered an exhibition of how it worked. The Silbury figures add up to a splendid orthodoxy, characteristic of the Age.

Neolithic harvest hills in England

Hills and henges

The Lammas towers of Midlothian, constructed less than 200 years ago, have disappeared, and our knowledge of them depends entirely on contemporary written reports. We can expect no such reports of vanished Neolithic harvest hills, and it would be safe to assume that most of them were long ago wiped from the face of our overcrowded and intensively cultivated land, leaving Silbury, saved by its extraordinary bulk, bereft of the smaller contemporaries which once fulfilled the same purpose in other parts of Neolithic England.

Yet a consideration of the henge monuments from the same period makes it clear that traces of many henges far less grand than Avebury *have* survived into modern times. Indeed, H. A. W. Burl has listed no fewer than 78 examples,[1] though many of these exist only as occasional crop markings, or as faint shadows on air photographs. We may therefore hope that a search for lesser Silburys may not be entirely futile. If successful, the enquiry will provide valuable evidence for the orthodoxy of the harvest hill theme, from the beginnings of agriculture, and greatly strengthen Silbury's credentials.

Where shall we look? First, perhaps, at the Great Goddess. Always and everywhere she has been a trinity, and Silbury describes only her maternal being. For her other manifestations, expressed architecturally, we must look to the adjacent barrows, and the Avebury henge. We will observe that they are grouped together, for the ultimate reality was Three in One. (As in the fairy tales, time showed the Old Hag to be beautiful Maiden, to be Mother, to be the Old Hag, and so on.) For dramatic effect and convenience, the actresses in the drama stood close together. As Piggott says, 'Silbury takes its place *as an element* in the Avebury ceremonial centre,' and goes on, most importantly: 'One may perhaps compare the situation with that of Knowlton in Dorset, where an exceptionally large

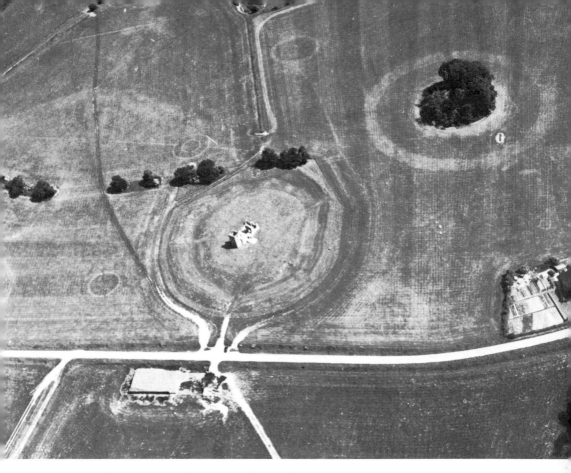

circular mound, 125 feet in diameter, adjoins the henge monuments.'[2]

The advice is clear. Other Silburys may be found in close proximity to other henges. Knowlton itself is 20 feet high, and surrounded by two concentric ditches (the outermost being 354 feet in diameter and 34 feet across),[3] which help to complete a monumental rendering of the eye motif, matching the numerous miniature examples, engraved on megalithic slabs. The majestic scale of the edifice disqualifies it as a Bronze Age barrow, and since Neolithic barrows in Dorset are long, not round, a harvest hill function is a reasonable provisional attribution. Thus, though the Knowlton mound is called the Great Barrow, it is not at all likely to contain a burial except perhaps as a secondary interment, inserted at a later age.

The Derbyshire examples
The henge-hill juxtaposition has been noted by observers working elsewhere. For example, E. Tristram comments: 'Each of the larger stone circles of Derbyshire has a mound of unusually large size associated with it . . .

Henge-hill juxtaposition at Knowlton, Dorset. Neolithic harvest hills were characteristically built near contemporary henge monuments. Here the tree-covered great mound, 20 ft high by 125 ft in diameter, stands close to the Neolithic henge, where the location of the church illustrates the continuity of sacredness.

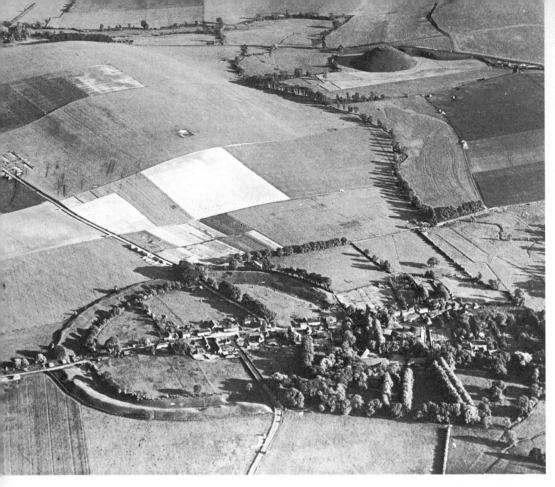

(Above) Silbury and the Avebury henge. Silbury (top right) takes its place as an element in the Avebury ceremonial centre.

which leads to the suggestion that Silbury Hill was similarly associated with Avebury.'[4] He cites the much disturbed flat-topped artificial hill, 70 feet across, which lies beside the henge at Dove Holes, and 'a large mound near a stone circle at Ford Hall'.

A Silbury–Avebury parallel was also drawn by Thomas Bateman, following his excavation into Gib Hill, when he wrote of 'the analogy borne by Arbor Low (henge) and its satellite, Gib Hill, to the plan of Abury'. Gib Hill, lying 1,043 feet from the finest henge in the north of England, has much in common with Silbury. It is Neolithic and shaped like a truncated cone – 'Very conical, of immense size',[6] says Bateman, who, with his father, reduced its height from 20 feet to 17 feet in the process of digging. Like Silbury, it was usually regarded as a burial mound until investigation showed otherwise.

(Opposite) Arbor Low and Gib Hill, Derbyshire, from the air. The hill lies close to the fringe of woodland.

For Bateman, the Gib Hill dig was regarded partly as a means of dating the neighbouring henge, which had, at that time, yet to be fixed. The probable contemporaneity of the two monuments was made the

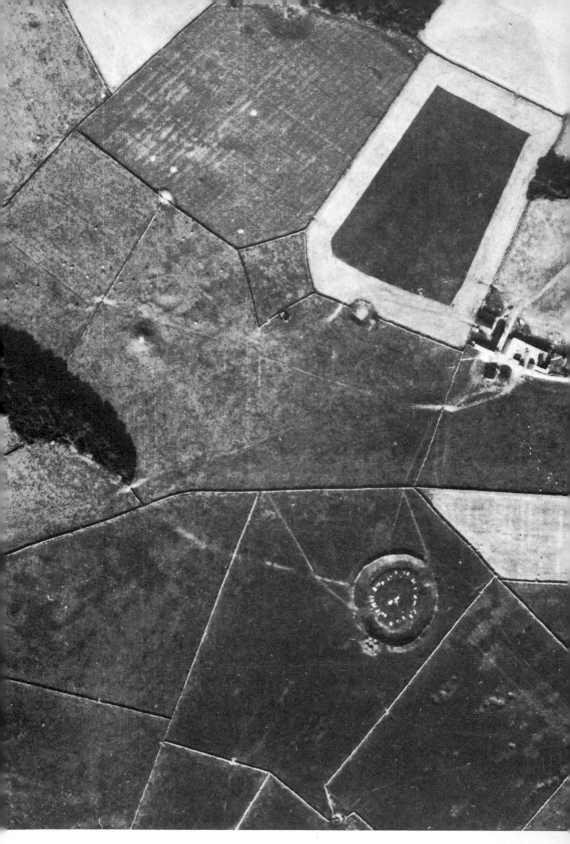

more likely by a third, which physically joined one to the other: 'A rampire of earth, running in a serpentine direction, and not dissimilar to the Avenue through the celebrated temple of Abury.'[7]

What remains of this snaky Derbyshire bank is now known to be Neolithic. Characteristic flint tools of the period were discovered in an excavation there at the turn of the present century. This dig also proved Arbor Low to be Neolithic, and since all the parts of the Avebury group, including the avenue, are now also proven Neolithic, the pattern emerges, north and south, of a typical ensemble in which the pregnant goddess/harvest hill formed an indispensable part.

Gib hill as harvest hill

Gib Hill, like Silbury, was not built as a tomb. Echoes of Merewether and prophecies of Atkinson reverberate through Bateman's report:[8]

Gib Hill, with the Arbor Low henge in the distance. Together they constitute a smaller version of the Silbury–Avebury henge pairing.

Our excavation was continued until the undisturbed surface of the earth was reached and laid bare for the space of 25 feet × 18 feet without disclosing any interment whatever. A review of these facts leads to the conclusion that Gib Hill was not in the first instance a sepulchral mound. So large a portion of the interior having been removed down to natural rock, without any deposit of human remains being found. . . . It appears impossible for any interment to have escaped observation at the base of the tumulus, where it would naturally have been placed at the time of its formation, had any such existed.

The fact that, 18 inches below the *top* of the hill, he came across an Early Bronze Age burial, is further evidence for a pre-Bronze Age foundation, and no more points to an original sepulchral function for the hill than does Stukeley's Viking burial, found at a similar depth beneath the Silbury summit.

Internally, Gib Hill has much in common with the Silbury primary mound. The clay core at Silbury is reminiscent of the deposited clay, over which Gib Hill was found to be raised.[9] The Silbury flints within the clay core, and in a thick layer on the ditch floor, are matched at Gib Hill by 'numerous pieces of white calcined flint. Because pure flint is not indigenous to Derbyshire, it would have to be brought from a considerable distance.'[10] Layers of vegetable matter are common to both constructions, and Gib Hill contained hazel twigs to set alongside Merewether's twigs.

'Disconnected bones of oxen' also help to draw the two monuments together, as does the employment in both hills of bands of limestone alternating with other materials,[11] which in the case of Silbury were gravel and soil, and at Gib Hill earth and amygdaloid – an igneous rock containing mineral nodules of an almond, or eye shape.

The case for regarding Gib Hill[12] as a smaller Silbury is further advanced by looking at the nearby and contemporary collective tombs of Five Wells and Minninglow; they reveal that Gib Hill is no more like a Neolithic *tomb* than Silbury is like the West Kennet long barrow.

The Marden Giant

In 1769, seven years before Colonel Drax sank his Silbury shaft, the antiquarian John Mayo noted of mid-Wiltshire: 'Hatfield barrow is the largest barrow in these parts except Silbury.'[13] Like Silbury, it was shortly destined to be drastically probed:

'In company with Mr Cunnington and his pioneers, I made a laborious but unsuccessful attack upon this huge pile', wrote Sir Richard Colt Hoare in 1821.[14]

Unsuccessful? or shall we say that, put to the test, yet another of the exceptionally large Neolithic mounds in England was successfully proved not to be a tomb, but rather, in Colt Hoare's words, 'either a Hill Altar, or place of general assembly'.[15]

Certainly the resemblances to Silbury go far beyond the matter of size, and help to bring closer the time when the pregnant harvest hills will once again be

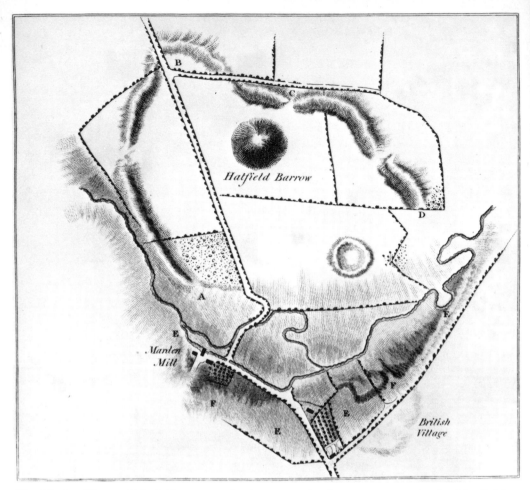

The Marden Giant and Hatfield barrow. Plan from Sir Richard Colt Hoare's account, 1821, when he and Cunnington excavated the great harvest hill, known as Hatfield Barrow, and found no burial. The river Avon forms part of the henge wall.

recognized as an orthodox component in the Neolithic monumental repertoire.

With regard to hill-henge grouping, Hatfield 'barrow' could hardly strike a more penetrating note of integration, for it was built *within* the 35 acre Neolithic henge at Marden[16] in the Vale of Pewsey. Hatfield also vividly illustrates the vulnerability of even the biggest harvest hills in the face of modern agriculture. Two hundred years ago it stood 30 feet high and 80 feet across. By 1809, 'having been some time in tillage',[17] its elevation was 22.5 feet. Today, it has completely vanished, together with the wide, deep, and water-filled ditch by which it was surrounded.

In the vain search for a burial, 'sparing neither labour nor expense', an area of over 60 square yards was excavated from the mound's centre to the original ground level. The mixture was the familiar harvest hill material – the native soil and rock (in this case Green

sand), combined with fragments of wood (especially near the core), and animal bones. Here, as at Silbury, the red deer is specifically mentioned. Neolithic hopes for future prosperity were based on what are, to us, unglamorous materials.

Colt Hoare concluded that the Marden Giant 'may have been devoted to religious as well as civic purposes ... either a Hill Altar, or a locus consecratus'.[18]

Surviving members of the same class may include the enormous structure on Silk Hill, Wiltshire (G.R. 1929, 4671) – a large circular mound 135 feet in diameter, 18 feet high, and encircled by a ditch. This edifice was opened by Hoare, who doubted whether it was sepulchral. There was no sign of any interment, and the only finds were 'animal bones of deer etc.'

Silbury and the Picturesque

Colt Hoare applied the same description to Silbury Hill, and we should not expect him, of all people, to pursue the function of Silbury beyond the vague generalization that it was 'a place of assembly or hill altar', because his view of the Neolithic birth drama was obscured, even more than our own, by the recently devised cult of the Picturesque, which was nowhere better displayed than in the grounds of his own mansion at Stourhead, Wiltshire. Unfortunately for Silbury Hill, the inheritance of the Picturesque has passed into our collective bloodstream, and any modern examination of the harvest hills should take this into account.

The first recorded dig into Silbury Hill was not motivated by antiquarian curiosity but by the demands of landscape gardening. In 1723 a Mr Halford ordered some trees to be planted on the summit. We can be sure that his attitude to planting a tree on the mound was not shared by the Viking (?) whose bones he accidentally struck, buried just below the surface. For a Viking warrior, an ash tree on a mound signified Yggdrasill – the sacred pillar which sustained his cosmology. Among the tree's branches he believed the gods sat in council, while the roots were anchored in the subterranean realm of the frost giants.

It is important to realize that our own attitude to trees (and mounds) is probably closer to Mr Halford's, for whom they had shed their symbolic load. His trees were an agreeable, harmless, and relatively inexpensive form of decoration. Their placement was intended to mark him as a man of taste and aesthetic sensibility, aware, perhaps through the paintings of Claude

Lorraine, that antique monuments had a part to play among the rural stage scenery. A gentleman was expected to 'point up' the prehistoric props on his estate.

The nymphs whose 'charms' decorate the spare corners of a Claudian composition may be labelled 'attendants to the Goddess', but the idea that they should turn from their languid splashing games to assist the divine hill in her birth agony would be unthinkable. The Picturesque view of architecture and landscape was static, non-functional (attempts were made to disguise real cows as useless ornaments), and non-anthropomorphic. The original living Silbury had no place in this aristocratic limbo, where form was deliberately drained of all but the most vestigial content, and where the temples of antiquity were made to share the trance.[19]

In this spirit, Henry Colt Hoare (grandfather of Richard) built a temple to the mother goddess Ceres in his park, beside a spring which he called the Paradise Well, and enclosing a statue of a sleeping nymph in a cave. We can only guess at the significance, says Woodbridge![20] Real belief does not leave so faint a trail of meaning, but the very fact that we can take a mild pleasure in Hoare's conversion of these former archetypal images into chic pavilions and grottoes, shows our continuing attachment to the genteel nothingness of the Picturesque. It is we, not the nymph who sleeps.

The Picturesque mentality also got to work on the kingship/heroism tradition, when Colt Hoare built a King Alfred folly at Stourhead. King Sil became a natural part of this game, which is not to say that kingship/heroism was an entirely trivial matter in the eighteenth and nineteenth century, but that there was a serious gap between its real content and its outward form. The King Alfred folly, for example, serves to reduce rather than to illuminate the idea.

The Marlborough Mount

The physical and intellectual impact of the Picturesque on what was probably a Neolithic harvest hill is well illustrated five miles east of Swallowhead, at Marlborough, where Colt Hoare noted 'a huge pile of earth and inferior in proportions only to Silbury Hill. Each are situated on the river Kennet; the one near its source, the other near its margin; and I have no doubt but that in ancient times each had some corresponding

connection with the other. . . . In more modern times the sides were sliced down to form a spiral walk. As near as we could tell by trial with our chains, we guess the base to be about one thousand feet circumference and the diameter of the summit one hundred and ten feet.'[21] (In 1950, the height was 60 feet, and the base covered one and a half acres.[22])

Even before Silbury was generally known to be a New Stone Age monument, H. C. Brentnall favoured a Neolithic date for the Marlborough Mount, basing his claim on 'a pocket of red deer antlers found from 2–3 feet within the mound',[23] and half way up; 'prolonged contact with the chalk of the mound had thoroughly impregnated them, and rendered them very brittle. They showed in several cases the broken stump of the brow tine, and certainly appeared to be the remains of antler picks.'[24]

Capable of matching the Silbury water, a spring fed a moat at the foot of the Mount in Stukeley's day. He also reported that Roman coins were found during the reshaping of the cone's surface, *c.* 1650. They provide further evidence of its long history.[25]

The cult of the Picturesque. This statue of a sleeping nymph, erected beside a spring at Stourhead by Sir Henry Colt Hoare, exemplifies the static, non-functional attitude to landscape typical of the eighteenth century.

The Marlborough Mount in 1723 (opposite), and in 1810 (above), where the pond gardens of Stukeley's time have been replaced by the Romantic Picturesque. Asymmetry and fir trees blur, but do not obliterate, the possibility of an underlying harvest hill.

In 1654 John Evelyn 'ascended the Mount by windings for nearly half a mile'.[26] Discounting the summer-house which crowned the summit, it was twice as high as the royal purpose-built cone at Hampton Court, causing some observers to wonder 'whether it was raised by Art or Nature', and to claim it as 'the most famous of its kind, and hath a most pleasant and easie ascent and from the summit thereof you have a good air and a fair prospect'.[27]

A cave was dug into its side (the roof ornamented with patterns in shell work) and called Lady Hertford's Grotto,[28] making another unconscious and dainty pastiche of the harvest vulva, rendered more poignant in its hollowness by the realization, common to some later authorities on landscape, that the mount-building tradition was indeed of prehistoric origin.[29]

The mount in many clothes

Clifford parts the Picturesque curtains, and declares: 'The Garden Mount is mysterious; it has not one origin but many, including the Hanging Gardens of Babylon and the semi-mythical queen Semiramis. Garden mounts of a not very dissimilar form are recorded from Ancient China and 15th Century America . . . as the abode of the Gods.'[30]

The enclosed garden – the maidenhood image, so often the scene of the Virgin Mary's conception of Christ – persisted as a symbol throughout the Middle Ages, while Mary pregnant, and garden mound, remained interchangeable forms.

But that is the last glimpse we get of the ancient symbolism. From then on, the garden is abstract. Sometimes, as with Capability Brown, the Silbury *materials* – simple contours, turf, and mirrors of still water, are used, and the *grammar* remains faultless. ('"Now there" said he, pointing with his finger, "I make a comma, and there, where an interruption is desirable to break the view, a parenthesis, now a full stop, and then I begin another subject".'[31]) *But there is no subject.* 'No subject, no statement, no narrative',[32] and no need for active response, physical or mental. This is the intellectual tundra. If you want to exercise your mind, bring a book to read.

The same detachment pervades the bulk of modern treatises on landscape architecture, and the work of contemporary land artists, such as the late Robert Smithson, whose earth mounds, we are vaguely told (and how easily we are satisfied), 'are designed to enhance or augment the surroundings for human delectation'.[33]

A fifteenth-century painting of the Mountain Mother, with a spring flowing from the base of the hill, shows a modified version of the Neolithic theme.

Semi-natural cones

One result of the Picturesque attitude to landscape, accidentally helpful to a Silbury enquiry, is that it marks at least a nominal return to the ancient habit of drawing man-made, semi-natural, and natural landscape into a unified pattern. 'The [eighteenth-century] gardening of landscapes gave the nation its country-

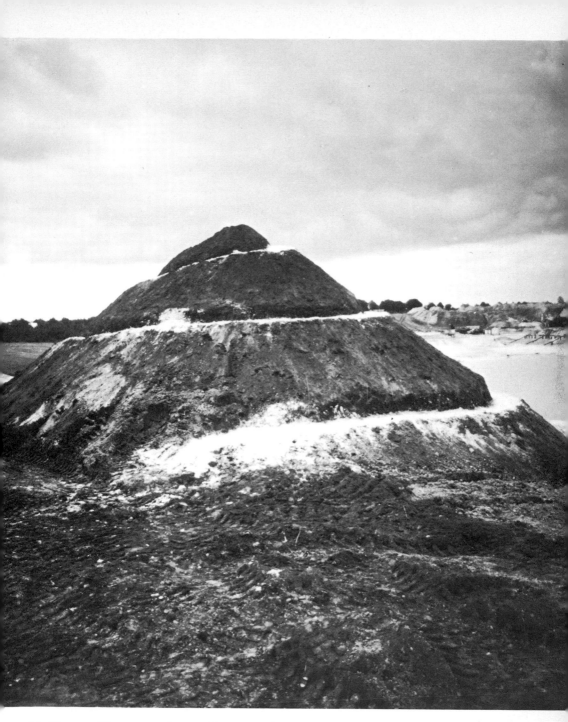

side,'[34] says Hussey, and provides a modern context for the question: where are the pre-Silbury Silburys?

Silbury was not built until 2660 BC, yet we know that people began farming in the area two thousand years earlier. Where was the pregnant goddess at that time? When the New Stone Age garden was first tilled around Swallowhead, all was natural, and the Great

Smithson's Spiral Hill, *'designed to enhance or augment the surroundings for human delectation' (Art Forum, October 1971), inherits the abstract detachment of Capability Brown.*

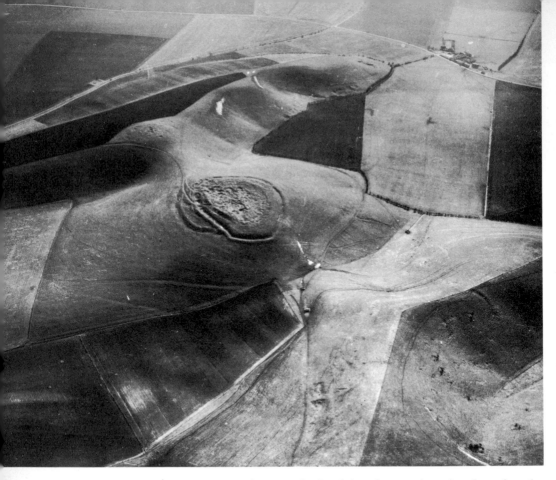

Rybury and Clifford's Hill. Explored on the ground or from the air, two pronounced spurs running from Clifford's Hill register as superhuman limbs. Both knolls have Neolithic trenches.

Mother *was* the land (as she continued to be, after the Silbury construction date). The need for community affirmation of this truth led to the search for a local isolated hillock where she could be easily seen on a sympathetic scale. In Ireland many of these hillocks, some bearing anthropomorphic names, remained in seasonal use till modern times, without any modification of their features.

In England, where evidence from folk survivals is much scantier and more debased, one is reduced to guessing. Waden Hill and Windmill Hill are both conveniently close to the springheads and sufficiently isolated from the general mass of the downs, and one could hardly complain of a lack of archaeological evidence for Neolithic gatherings on Windmill Hill.

But where a strikingly anthropomorphic natural eminence is combined with major Neolithic work *and* folklore fertility survivals, a strong case takes form. For example, five miles south of Silbury the segmented Neolithic ditch on Clifford's Hill, roughly semi-circular in plan, helps to emphasize a natural knoll, from which two spurs run east and west like limbs, while north-

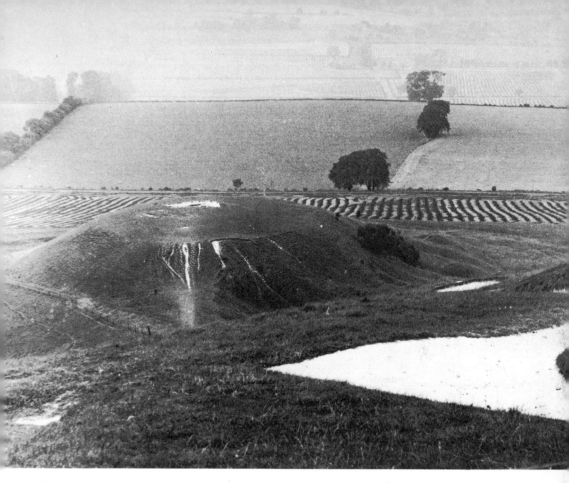

wards a natural bridge forms a 'waist' expanding to the
Rybury womb. The Rybury summit is crowned by a
causewayed Neolithic ring ditch.[35] Discovery of Neo-
lithic pottery at the site confirms a pre-Silbury date for
this cultural enhancement of a possible natural hill-
goddess in labour, supported further by the St Ann's
Day fair (August 6th) traditionally held (until 1932)
overlooking the site.

As in Ireland, the Wessex harvest hills appear to
have ranged from the entirely natural to the largely
artificial and, also following the Irish pattern, they
seem to have continued in use with modifications and
additions through the Iron Age. Certainly Rybury dis-
plays a superimposed Iron Age trench. Maiden Castle,
Dorset, illustrates a typical continuity of interest from
Neolithic to Iron Age in a cult site, while at Uffington,
Berkshire, the well-known White Horse hill figure was
added to a pre-existing cult centre, where a Neolithic
long barrow and an outstanding dramatic 'trimmed
and flattened'[36] truncated cone, called Dragon's Hill,
are grouped around powerful scarp foot springs. The
horse is regarded by Fox and others as an evocation

*Dragon's Hill, below the White
Horse at Uffington, Berks (part
of which shows in the foreground).
The Hill has been described by
Professor Stuart Piggott as
'artificially trimmed and
flattened'.*

of the horse goddess Epona.[37] Fertility associations on and around the image continued into modern times.

The reinterpretation of the archaic mother goddess as the dragon who must be killed by a hero or sky god is of course a classic pattern, and strongly suggests that Dragon's Hill was a Neolithic first fruits site.

Nature and culture

The Neolithic harvest hills, defined as those recognized forms of the pregnant goddess probably employed in first fruits ceremonies, should be seen as manifestations of a common impulse, without attempting to classify them rigidly according to the measure of human moulding of each site. Instead it should be remembered that at the heart of the most splendid 'artificial' example, Silbury, there was a pile of mud and stacked turf, and that all Neolithic achievement (including the development of wheat from grass), remained willingly rooted to the ground.

Far from being raised in opposition to nature, the intention of the man-made harvest hills was identical with their natural counterparts – to facilitate union with the goddess of nature, whose body they both were.

What gave substance to this common cause, apart from the womb-eye shape, was the thin but vital layer of soil. The discovery that the outer chalk skin of Silbury had never been subjected to erosion[38] makes it almost certain that the Hill was covered with soil as the final act in its construction.

Soil has preserved the Hill for over 4,500 years, because soil is alive with continuously reborn plants and their stabilizing roots, and is therefore also uniquely in keeping with the fecundity theme. The harvest hills *grew plants*, as a welcome contribution to the iconography. For the same reason, the steps of Sumerian ziggurats were planted with sacred trees.[39] Indeed, the experience of soil could be said to sum up the Neolithic fusion of nature with culture, since the natural ground paradoxically required endless expenditure of human skill and attention, in order to promote the natural miracle of harvest.

When, in the patriarchal Iron Age, the goddess was equivocally rejected, the soil and harvest were put at risk and, most interestingly, the Dragon's Hill folklore from Uffington refers to a white sterile patch on the summit where soil and vegetation vanished as a consequence of the dragon-goddess's execution.[40]

But even when every patch of farmland in Neolithic Britain was regarded as the divine womb lining, there was still a need for specific harvest hills, because where belief is deeply and widely held the urge towards group ritual is correspondingly strong. Accordingly, those spots were sought out where reinforcing insights could flow from particularly vivid shared observations.

To some degree, all the sites listed in this chapter afforded such opportunities. They represented answers to the local needs and, like the Scottish Lammas towers, they now provide a necessary context for Silbury.

Other examples will perhaps come to light as the search proceeds, but it is hard to imagine that any gave a more comprehensive account of the collaboration of natural phenomena in achieving harvest within the human body than was provided by Silbury.

Silbury inspired visits from all over England and Wales, judging by the range of implements brought to the vicinity,[41] through its power to give extra understanding and practical effectiveness to the pilgrims, a power which could be carried back to their own distant farms and to their lesser harvest hills.

Silbury, the name

The changing inheritance

What does the name 'Silbury' mean? When was it given? What light, if any, does it shed on the original nature and purpose of the monument? Concerning the use of linguistics as an instrument of prehistory, Professor Swadesh advises:

It is necessary to bring to bear every possible line of evidence on each problem of prehistory. Specialists should try to fight free from any tendency to limit their efforts to a favourite procedure, or to close their minds to clues derived from other sources of study and from other disciplines.[1]

Whether we are dealing with the present or the past, 'language is, in part, a guide to social reality',[2] and 'traceable affinities between language and culture can now be taken for granted'.[3]

Affinities include those which link inherited place names, like Silbury, to the attitudes and customs of whatever society pronounces the name. To us, the word Silbury is solely a means to identify a particular spot. Silbury takes its place alongside the now equally abstract Tilbury, and the modern 22 East 53rd Street, NYC 10022.

One layer of recently abandoned meaning, to which we have relatively easy access, was disseminated (if not deposited) by John Aubrey when he coupled the name with that of a monarch, King Sil. To him, Silbury Hill was King Sil's Hill. Thus the name clung like a shadow to the cultural priorities of the time, which were felt particularly keenly by Aubrey, a loyal courtier to Charles II. Silbury spoke up for His Majesty, showing how sensitively a name can monitor changes in meaning without necessarily changing its letters.

Place-name experts hope to go beyond King Sil, so J. E. B. Gover,[4] employing an ampler perspective than Aubrey's, traces the surviving written forms of Silbury to the thirteenth century AD, and lists:

Seleburgh (1281 Assize Roll)

Selbyri
Selburi } (1540 Leland)

Selbury
Silbury } (1663 Aubrey).

He is able to identify the second part of the name –
burgh, byri, buri, bury – as an Anglo-Saxon word,
commonly meaning mound or hill. What remains is
the mysterious Sele, Sel, or Sil, and there the trouble
begins. He writes: 'Unluckily we have very little to go
upon in the interpretation of this name.'[5]

His disorientation can be traced to the profound
qualitative change which has overtaken the Silbury
word since 1281. Perhaps it would serve us better to
turn to the archaic and obsolete meanings of Sele, Sile,
listed in the *Oxford Dictionary* (1933):

Sele (pronounced *Sil*): alternative forms Sael, Seal,
Seale, Sil, and Seille. Derives from the Old Norse,
Saell, meaning Happy, and Old Teutonic *Saeli*, meaning
Good or Blessed.

The dictionary continues: 'In English the word
means:

(1) Happiness, prosperity, good fortune, happy.
(2) Favourable or proper time, occasion or season, e.g.
 Barley-Sele.'

Either taken separately or together, these meanings
surely relate to the moment of first fruits, the prospect
of plenty, and therefore to the most characteristic theme
in the lives of all coherent agricultural communities.
The *English Dialect Dictionary* supports the start of
harvest, offering: *Seal, Seel, Sele, Seil, Sale* – Time or
Season, e.g. Wheat seal, Barley seal are the respective
seasons of mowing those products of the earth.

Far from being arbitrary, the name Silbury is a pass-
word which admits us to Sele, the pre-Renaissance
annual harvest birthday, and tries to tell us something
of what it was like.

Silbury in the medieval world

The word Seleburgh, in 1281, described a working
harvest hill, when harvest hills held an indispensable
place in the rural way of life.

In Wiltshire, as throughout Britain, the village year
was divided into four quarters, with each quarter
straddling either an equinox or a solstice. Each quarter
was ushered in by a major folk festival:

QUARTER	OPENING MONTH	OPENING FESTIVAL	CHRISTIAN-IZED FESTIVAL NAME
Spring	February	Bridget's Day	Candlemas
Summer	May	May Eve	Whitsun
Autumn	August	First Fruits (Sele)	Lammas
Winter	November	Hallowe'en	Martinmas

The Christian authorities hoped to subtly transform the pagan festivals, since they were unable to suppress them altogether: 'For we ought to take advantage of well-built temples . . . the people will continue to frequent their places as formerly, so coming to know and revere the true God.'[6]

The result was that in Saxon England the Sele Festival, the joyful start of harvest, was also known as Lammas (Hlafmaesse, meaning Loaf Mass). Adhering closely to aspects of the pre-Christian subject, the Church kept the quarter day as 'a harvest festival, when loaves of bread made from the new grain were consecrated'.[7]

But this priestly version, lacking a harvest queen, did not satisfy the rural population, who preferred their own drama, built around the corn mother.

'This defiance of the Church must mean that there was still a religious and ritual significance in the ancient popular drama, and that the people obstinately believed that their welfare depended on its performance at a sacred spot and at a sacred time.'[8] Life itself, as they understood it, must have been felt by them to 'originate in the ritual and to derive from it all meaning'.[9]

At May Eve, a sacred spot was the Avebury henge where, in the fourteenth century, 'the Christian authorities found it necessary to take drastic action against the pagan cult'.[10] Nor is the continued use of the henge and adjoining Neolithic monuments surprizing, since both Anglo-Saxon and Viking populations brought with them a strong and strikingly persistent tradition of Great Goddess worship: 'Probably of all the cults, it has had the longest enduring influence, after the (official) end of paganism in the North.'[11]

When it came to celebrating the August quarter day in medieval North Wiltshire, the ceremonial focus shifted from the May henge to Seleburgh. The name declares a continuity of harvest function reaching back to Neolithic times.

So strong was the allegiance to the image of the pregnant goddess that she was even set up, in a smaller version, within the body of Christ's Church at Winterbourne Monkton, two miles north of Silbury. This act incidentally confirms the belief of many historians, and the evidence of contemporary documents, that the village clergy often acquiesced in, or actively supported, the preference of the pagan community. Despite widespread iconoclasm in the sixteenth and seventeenth centuries, carvings related to the Winterbourne figure survive at Lower Swell, Gloucestershire, St Michael's, Oxford, and elsewhere.

Carved on the drum of the twelfth-century font at Winterbourne is a naked female figure, twelve inches high. Her raised right arm holds a sickle, which touches a band of zig-zag or chevron 'ornament', the ancient water symbol, that runs around the drum and bursts into luxuriant vegetation against her right side and into her lowered right hand. It may well be that the Winterbourne itself was the local water reference here.

The Winterbourne Monkton goddess, carved on the twelfth-century font of a church two miles north of Silbury. Vegetation springs from her vulva.

The stream runs past the church, close to the Avebury henge, and around the Silbury water thigh before becoming the Kennet at K1 (below Swallowhead). Water from the stream was probably used in the font.

The woman's badly damaged head reveals little, except to show a triple-horn hair arrangement – possibly a faint echo of the ox goddess – but her body below the waist is a Silbury statement of the greatest importance. She is carved with a big belly, and in a squatting position. Between her widely spread legs, from a vulva rendered with unequivocal directness, emerges not a child, but a sprig of living vegetation! Here is the harvest divinity (the mother of all phenomena) performing the pre-Christian miracle.

In fact the miracle was discontinued when it became generally regarded as foolish, rather than a blessing, and today, when Silbury has no connection with harvest, the image on the font has lost her superhuman power, and is rapidly losing her capacity to be seen at all. She appears in none of the standard works on English fonts, nor in Pevsner's *Wiltshire*, where the font is described only as 'circular, Norman with decorated trumpet scallops and zig-zag'.[12]

An example of sustained oversight came to light in April 1974 when two ladies who were arranging flowers in the church (they had worshipped in the building all their lives and had been baptized in the font), were asked about the figure. They were astonished to behold it, having never consciously set eyes on it before. Such is the power of cultural censorship, operating not least within those of us who presume to write prehistory.

Sil and anthropomorphic Silbury

The medieval craftsman who carved the woman-vegetable-stone-water fusion was operating within a folk tradition where synthesis was normal. Surviving folk ritual and song are permeated with double references based on the premise that land is woman:

I said, 'My pretty maid, what do you stand in need?'
'Oh yes, kind sir, you're the man that can do my deed,
For to sow my meadow with the wanting seed
For to sow my meadow with the wanting seed.'

Then I sowed high and I sowed low,
And under her apron the seed did grow,
Sprung up so accident-a-ly without e'er a weed,
And she always remembered the wanting seed,
Wanting seed,
And she always remembered the wanting seed.[13]

Given this context, it is hard to separate Silbury from her posset of milk or to escape the conclusion that, in the popular mind, the posset was filled from the monumental water-breast, especially when the quarter day rites retained a strong female emphasis. Great assemblies of witches were customarily held on Lammas Eve – Barbara Napier of North Berwick was accused of being present at just such a convention, where three covens (thirty-nine persons) were assembled[14] – and all over Britain the fairies from the mounds were believed to come forth at Lammas. The fairies themselves were known as Silly Wychtis in Scotland[15] and The Mother's Blessing in Wales,[16] while 'in medieval accounts of the magic mound dwellings women are far more prominent than men'.[17]

The harvest queen
The goddess who gave birth to the harvest held sway throughout the autumn quarter, called the Generous season, and the Silly Woman's season.[18]

Traditional English corn dolly (the word derives from idol) of the type known as Mother Earth. The cone shape comes in an unbroken line from the Neolithic goddess. Plaited from the wheat of one harvest, she was returned to the fields the following spring to oversee the next year's crop.

In England it was affirmed not only that she gave birth to the corn, but also that she *was* the corn and its stalks. The Sele prosperity had the superwoman literally woven into the word through the creation of corn dollies, idols traditionally made in female form and very big below the waist. Moreover, other well-known English patterns, such as the star and the horn of plenty, are also found relating to the Great Goddess repertoire of images.

Plaited from the last sheaf to be cut, corn dollies were miniature versions of the mighty harvest queen statues that were still being constructed in England in 1598, when two German travellers noted at Eton an image 'by which perhaps they [the villagers] meant to represent Ceres'.[19]

From Northumberland Hutchinson reported: 'I have seen in some places an image apparelled in great finery, crowned with flowers, a sheaf of corn placed under her arm, and a scycle in her hand ... carried into the field and fixed on a pole all day. This they call the Harvest Queen and it represents the Roman Ceres.'[20]

What emerges is a pattern of worship where figurine, statue, and first fruits hill were used to mark and to *help bring about* the climax of the annual creation process. Timely creation, the ultimate subject and motivating force behind all the folk festivals, and Lammas in particular, is the hidden message in the English Sil name.

Silbury and recurring time

The widespread custom of carrying the corn dolly to the farmhouse for the winter, before returning her to the fields in the following spring, was in keeping with an ancient cyclical attitude to time that can be detected in the Sele word. Silbury gave birth to time itself, for in the Middle Ages 'the eternity of life lay not in the fact that it had once begun, but solely in the fact that it was constantly being begun. In each reiteration or renovation, the re-acting was as primary and original as the very first acting.'[21]

Unlike our linear concept of time, running from the creation of the universe (or the world, or Jesus Christ) to the end (Doomsday), the Anglo-Saxon farming community felt time to begin anew every year. Sele was the birth of the world.

That was natural, i.e. at one with nature, compared with which the priestly *Anglo-Saxon Chronicle*, with its chronological history, meant nothing, and would have

The White Goddess of harvest, Whalton, Northumberland, 1901. The central figure in the harvest celebration, she is seen here in a context of mistletoe and oak leaves.

meant very little even if the community had been literate. On the other hand, the frequent references to Lammas in the *Chronicle*, and the emphasis given to storms and farming matters, make it as a record something of a compromise between 'village time' and 'historical time'. Indeed, it began as an annalist's notes in the margins of the Easter Calendars.

To the individual farmer, experience revealed that each year was born to grow, to generate, and to die, while he fulfilled the functions of midwife, nurse, arranger of marriages, and sexton in the course of a year's work, and watched and shared in the parallel activities among the human population of the village. When this cyclical programme was given extra coherence at the seasonal festivals, it brought a truly religious dimension. In the words of Lévi-Strauss: 'Social life validates cosmology by its similarity of structure.'[22]

Therefore, in the minds of those who used Silbury, the foundation date of 2660 BC was of no account compared with the next July/August. The only creation that was 'real' was the contemporary creation. Hence the word dazzled with such urgent splendour. It was saturated with immediacy.

Sel and the mermaid
Students of mythology find that when the feminine principle is subjected to sustained attack, as it was from the medieval Christian authorities, it often quietly

submerges. Under the water (where organic life began) it swims through the subconscious of the dominant male society, occasionally bobbing to the surface to offer a glimpse of the rejected harmony. In short, Sel or Sil turns into Selkie, Silkie or Selchie.[23] The last three words are assigned in the English folk tradition to mermaids and seals, with the understanding that there is considerable interchange possible between the two, and that one can be a metamorphosed form of the others. They populated the rivers as well as the seas of medieval Britain and were taken very seriously,[24] not least by the celibate clergy, with whom they actively struggled.[25]

The superhuman Selchies may well bring us back to Selburgh, because the Hill stood at the centre of a group of parishes known collectively from Saxon times till 1872 as Selkley or Selchelai Hundred.[26]

The hundred was an administrative unit, occupying a position between parish and shire. One of its most important functions was judicial, and hundred courts were held regularly. Up till AD 1200 they usually sat in the open air at some well-defined central spot, such as a prominent prehistoric barrow. This practice was also followed by shire courts. For example, the Berkshire shire court met at Scutchamore Knob.

The site of the meeting place for Selkele (1196), Sulkele (1291) or Sylkele (1305)[27] Hundred is not known. The name of the hundred does not derive from any

(Left) The fish-tailed goddess, Elamite, 3rd millennium BC. The mermaid or Selchie (opposite), carved under a misericord in Exeter Cathedral, represents the continuation of the amphibious mode of the goddess in Britain.

of the villages in the group, nor does it seem to relate to any natural or man-made feature, with the notable exception of Silbury Hill, whose central position, flat top, and long tradition of sanctity would make it an obvious choice.

The surrounding ditch, being clogged with silt, was often dry but, when the water rose in March, the litigants might have seen the mysterious woman curled around their court like a capricious Selchie, and named their hundred in honour of these occasional appearances.

Sul-Minerva

If Selkele and Selchie offer only enigmatic hints of a lost water-goddess, she takes firmer form, while retaining an association with water, during the Romano-British period when, according to H. M. Scarth, 'the influence of the British Goddess, Sul, extended over the greater part of south west England, and her worship appears to have been conducted *on the tops of hills, overlooking springs*. Thus near her springs at Bath we have the isolated hill called Solsbury, or Sulisbury, probably the seat of her worship.[28]

It is known for sure that at Bath the Romans identified the goddess Sul with their own goddess of wisdom, Minerva, and set up altars to Sul Minerva, as well as statues to Minerva. The message is clear: for Sul read Minerva and vice versa. In Roman Britain the name Sul lived on, though it could be, and often was, replaced by Minerva, without implying rejection of Sul. The same relationship may well have existed between Freyja and Sel.

In Celtic Britain, the eye goddess's name was written large on the altars at the sacred hot springs of Aquae Sulis, and almost certainly lived on at the greatest chalk 'eyeball' overlooking a holy Swallowhead. At both places, Suil demonstrated the union of body and spirit, for the monumentally substantial was combined with 'a little transient invisible breath that constitutes a spoken word'.[29] Land, architecture and word made a consistent symbolic entity, the character of which flowed freely into the life and language of the people.

Passing the word

How should the strong similarities of sound and meaning between Celtic and English Sil/Sel/Sul words be explained? Linguists do not generally favour chance or coincidence to account for such correspondences. 'An explanation of similarities as the result of chance

Base of a lost statue of the ancient British goddess Sul, or Suil, at Aquae Sulis (Bath), flanking the chief altar of the temple. As at Silbury, the eye goddess Sul at Bath stood beside a notable spring.

can be eliminated,' says Thieme, and though 'correspondences between languages could, in principle be described without making use of any hypothesis, they become meaningful only on the assumption that they are due to original identities.'[30]

An example, close to Silbury, is of course the river. English Kennet was Celtic Cuno. Should we evoke the same direct transfer for Suil/Silbury? Swadesh believed that 'when two cultures have more (word) traits in common than can be explained by coincidence', there are two principle possibilities:

1 *Borrowing*, by one language from another ('and there are few languages which have borrowed so liberally as English').
2 *Archaic residue*, the common words representing 'all that is left of a once-extensive complex, anciently shared by fore-runners of the two cultures'.[31]

As Swadesh pointed out, (1) and (2) are not necessarily mutually exclusive – for example, the Celtic *cuno* could itself be borrowed from an archaic residue, perhaps of

Neolithic age, and the same possibility applies to Silbury.

Of all European languages the most archaic is Basque, spoken in and around the West Pyrenees. Both the people and their words are of Neolithic stock[32] – the same stock indeed as constituted the Neolithic population of Britain.[33] 'Allowing for the changes which it has doubtless undergone in the centuries which have brought us to modern times', the Basque language may furnish us with a clue to 'the language of at least one group among Neolithic Man in England',[34] writes Professor Baugh.

Searching the Basque language, we find:
Selaru – a granary, a fruitful country; and
Selaun – afterbirth.

There, one might tentatively suggest, in a language whose roots are contemporary with Silbury's erection, the harvest child is preserved! But that would not be true. Grain and child have parted company. The child has gone away, just as Basque culture has been much altered by other influences. The Great Mother has been deposed and her temple, as the Basques say, is now *Suil – an abandoned or forlorn edifice*!

This precisely describes the present condition of Silbury.

Silbury, sun and moon

The celestial eyes

The Neolithic Silbury synthesis depended upon drawing up power (water), from the underworld, and drawing down power (light), from the sky. Only if these elements could be brought together on the terrestrial plane, within the Mother figure, could the universal birth be properly achieved.

Work done on megalithic Stone Age monuments (by N. Lockyer, G. Hawkins, C. A. Newham, A. Thom and others) has clearly shown that throughout Britain the population took an intense interest in the sun and moon, with special attention being paid to the rising and setting positions of these celestial bodies. For example, according to Professor Hawkins and C. A. Newham, the Station stones at Stonehenge, which are contemporary with Silbury, were concerned equally with solar and lunar observation. Newham's explanation reads:

The moon phase provides a very suitable means to regulate day-to-day activities, by use of such time indications as 'the night of the full moon'. However, for defining important annual events, necessary for a settled agricultural community, the moon is inadequate. A reliable solar calendar, based on knowledge of the points of the horizon where the sun rose or set at regular times each year was required. Thus both solar and lunar phenomena had to be investigated. It is likely that attempts would have been made to correlate their two 'calendars'.[1]

At Silbury, solar and lunar calendars were brought together within the body of the supreme Mother. The reflections cast on the moat by the two principal celestial bodies quickened the earth Mother into full life, by introducing dramatic movement, drawn in light on the water body.

The desire to incorporate sun and moon within the human body was normal in prehistory, and still is normal among modern 'primitives'. Cassirer's massive researches (which have often been ignored but rarely challenged) show that, for Neolithic communities, the

objective world of sun and moon 'became intelligible only when analogically "copied" in terms of the human body':[2]

'Mythical Time is *always* conceived both as the time of natural processes, and of the events of human life.'[3]

'Flowering and fading of plants, and cyclical order of the seasons were apprehended in mythical consciousness only by projecting these phenomena into human existence, where it perceived them as in a mirror.'[4]

While the sun and moon helped to impart life to the Silbury goddess's lake-mirror, she reciprocated by confirming their place in the anatomy of the cosmic female, whose body was the size of the entire universe. If the Silbury Mother was to give birth successfully to the harvest child in August, she herself had to be nourished through the rest of the year. Sun and moon had to feed her with strong images, emphasizing parts of her body that were physiologically significant, and at moments of the year that were astronomically relevant.

The measure of the Silbury achievement is that not only does the monument correlate solar and lunar events, but that it combines them to bring the deity in human form to a credible and continuous life, which could be witnessed by all.

The solar contribution

In the Stone Age view of the metabolism of the cosmos, sun settings and risings represented moments of great drama, where the threshold between underworld, earth and sky (the horizon) was crossed. These moments were accordingly employed at Silbury.

From the hundreds of different sunrise-sunset positions which occur each year, the megalithic observers normally selected for their scrutiny the longest and shortest days (solstices), the equinoxes (in March and September) and the midpoints between these four divisions. One of these midpoints was Lammas, August 8th – halfway on the sun's route between the summer solstice and the autumn equinox. Thom finds 'the data in the field on which these subdivisions rest is sufficiently convincing and reliable [to amount to] . . . conclusive proof that the erectors [of megalithic monuments, including Avebury] succeeded to a remarkable degree in getting a reliable calendar of this kind'.[5]

From the Hill's summit, the birth and death of light may be witnessed as a function of the Great Goddess's

body and, as might be expected, the critical shortest day is integrated with particular care into the divine water figure. The midwinter sunrise (129° azimuth) aligns with the moat (thigh/vulva) in the southeast quadrant, while midwinter sunset (at 229° azimuth), seen from the southwest edge of the summit, aligns with the tip of the breast (areola).

The midwinter sunset brings pink to the old mother's breast. Turn her the other way up and her lower lip runs with blood as she devours the last sun in the year. The suggestion is explicitly made that the goddess ate the midwinter sun every year as it set. Her lower jaw was appropriately dry as a bone as it champed out the light, for this event was aligned with the steep chalk bank fringing the causeway (mouth).

For a recently discovered Neolithic parallel, one may turn to the great tomb mound at New Grange, Co. Meath. In 1969 Professor H. C. O'Kelly established that the midwinter sunrise, and *only* the midwinter sunrise, penetrated to the central chamber through a specially contrived roof box, and says:

'It seems unlikely that this is due to chance, and confirms a local tradition that, at a certain time of the year, the sun lights up the 3-spiral figure in the end chamber.'[6]

The New Grange tomb goddess required to receive the hope of renewal. While the Silbury womb-head needed to swallow down the last rays of the old year, before starting work on the next.

The east-west axis

It takes a year to raise a crop, and Silbury showed her concern for the whole year in that her long axis was planned to coincide with the axis of the solar year – the due east–west line described by the spring and autumn equinoxes, March 21st and September 23rd. Referring to this line, Thom writes: 'Ideally the calendar is based on observations of the sun made at the equinoxes, when daily movement of the setting sun along the horizon is maximum and of the order of its own diameter.'[7]

On those days every year, and only on those days, night and day were of equal duration, and on those days both sun and full moon rose (were born) at her moat vulva, and set (died) as they crowned her moat head, bringing eye-light to the squatting goddess's head. Moreover, both birth and death occurred *at the same moment*, for when the sun was rising, the moon

was setting and, after a twelve-hour interval, the roles were reversed.

From Silbury, following Lockyer's refraction adjustment of 46 feet per mile, this western horizon falls within $\frac{1}{4}°$ of an ideal horizontal register, and may be regarded as highly satisfactory. The eastern horizon at $c.610$ feet, one mile distant, is only $\frac{1}{2}°$ from the ideal. Rising and setting are taken, according to G. Hawkins, as the moment when the disc stands tangent on the horizon. That this was the common Neolithic procedure is confirmed by C. A. Newham's work on the Stonehenge car park post alignments (1972). In the case of the moon, because of an 18.61 year cycle, moon set oscillates through a band running $5°$ $15'$ north and south of due west, and the same is true of moon rise in the east. Even taking this variation into account, it is true to say that all equinoctial sun and full moon sets, when not obscured by cloud, accurately define the position of the goddess's moat eye as their last act before setting. The Silbury east–west axis crosses the Winterbourne 1,100 feet from the Silbury centre, and it was here that, in 1966, the headless skeleton of a Romano-British male was found protruding from the east bank. The skeleton was aligned east–west, and was extended on its back.[8]

The fundamental optimism of the Neolithic vision – an optimism based on awareness of continuity and overlap, was thus literally reflected in the Silbury goddess. Whether searching for spring, or peering towards winter, Silbury, the great reclining Mother, gave assurance in her water body. She was, in T. S. Eliot's words, 'The still point of the turning world', providing in the celestial balance another demonstration of the life-death harvest theme:

> *Concentration*
> *Without elimination, both a new world*
> *And the old made explicit, understood*
> *In the completion of its partial ecstacy*
> *The resolution of its partial horror.*

The midsummer sunrise

The midsummer sun rose in the north east at $50.5°$, and drew a fiery serpentine reflection from the base of the goddess's spine towards the womb-head. Because Great Goddess worship predictably employed the snake in its repertoire,[9] and because the image features prominently in other Avebury parish monuments, the

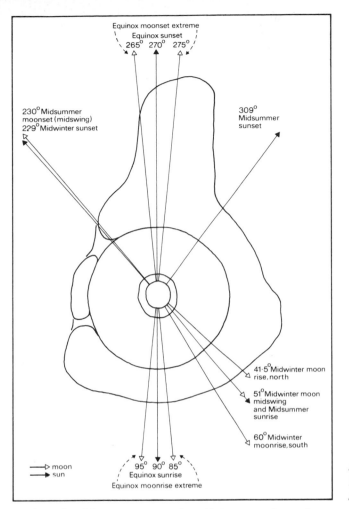

Equinox moonset extreme
Equinox sunset
265° 270° 275°

230° Midsummer
moonset (midswing)
229° Midwinter sunset

309°
Midsummer
sunset

41·5° Midwinter moon
rise, north

51° Midwinter moon
midswing
and Midsummer
sunrise

60° Midwinter
moonrise, south

→▷ moon
→▶ sun

95° 90° 85°
Equinox sunrise
Equinox moonrise extreme

Sun and moon at Silbury.
Equinoctial and solstitial rises
and sets.

snake of midsummer morning light may have been
welcomed as offering preparatory help towards the
eventual birth of the host of Merewether string snakes,
which (it is known) were plaited up approximately a
month later.

The birth moon

From the Old Stone Age to the seventeenth century of
our era, people in Britain and throughout the world
believed that the birth process was strongly influenced
by the moon, so if we want to watch the Neolithic
Silbury Mother give birth, we should go at night.

Concerning the importance of the moon to the British
Neolithic community, Thom writes, 'the existence of
lunar observations is beyond dispute. . . . An intense
interest [was] taken in the Moon's movements. . . .
Judging by those districts that have been closely

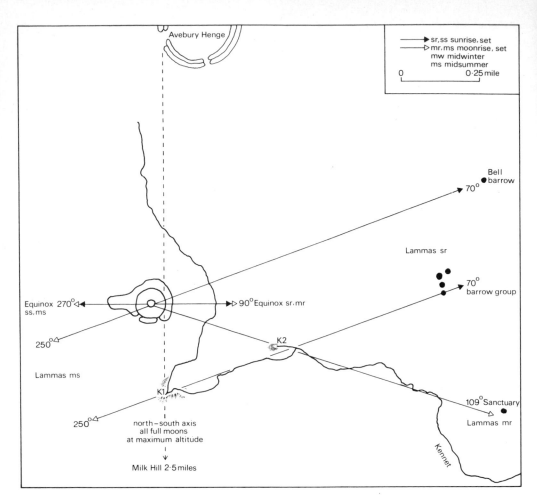

Avebury Henge

sr,ss sunrise, set
mr,ms moonrise, set
mw midwinter
ms midsummer

0 0·25 mile

Bell
barrow
70°

Lammas sr

70°
barrow group

Equinox 270°◁◀
ss,ms

▷ 90°Equinox sr,mr

K2

250°◁

Lammas ms

K1

250°◁

north–south axis
all full moons
at maximum altitude

Milk Hill 2·5 miles

109° Sanctuary

Lammas mr

Kennet

Lammas sun and moon and the Silbury landscape. The lower parallel line shows the alignment of the two confluences (K1 and K2) with Lammas moonset and sunrise. The upper line duplicates this in terms of monumental imagery from Silbury breast to Bell barrow. The diagram also shows the four quarters centred on the Silbury vulva, and the Lammas moonrise over Waden spring.

examined, it is probably safe to say that at least one lunar site was to be found in each part of the country where there are other Megalithic remains.'[10]

The pre-eminence of the moon in matters of parturition depends upon the spectacular rhythm of decay and growth displayed, for all to see, in the lunar body. As Eliade observes: 'It is not surprising that [in ancient belief] the moon governs all those spheres of nature that fall under the law of recurring cycles, waters, rain, plant life, fertility. . . . Becoming is the lunar order of things.'[11]

The synchronization between the moon and woman's menstrual flow served to strengthen the reliance upon the lunar symbol.

To understand how the Neolithic moon was made to fit into the Silbury body it is important, first, to recall that the moon and moonlight were regarded as possessed of life in the full organic sense, being part

of the intelligent cosmic organism. Even in the nineteenth century, Berkshire maidens addressed the new moon: 'New Moon, New Moon, I hail thee! By all the virtue in thy body.'[12] And 'in Herefordshire, the vulgar people at the prime of the moon say, "Tis a fine moon, God bless her".'[13] Both these greetings reflect the belief, prevailing in the classical world, that the moon was divine and female.

To the ancient Greeks the moon was the goddess Selene,[14] sister of the sun; she lit up the dark night with her golden crown, having previously bathed her body in the ocean, and who but the Roman moon goddess, Luna, should descend on Aquae Sulis, to be worshipped with the eye goddess, Sul? Luna's portrait was carved in low relief there, and placed over the façade of the Four Seasons.

Although in Roman times divinities proliferated and were ascribed specialized roles, a goddess like the Bath Luna, incorporating a moon disc in her hair, was often understood to correspond to the Great Goddess. In *The Golden Ass* of Apuleius (*c.* AD 130) Isis, crowned by a lunar disc, rises from the ocean at night to say: 'I am Nature, the Universal Mother . . . single manifestation of all gods and goddesses that are.' Therefore, in Romano-British terms, the Silbury birthright is very probably represented by a Sul-Luna fusion.

Moon over water

'The moon is chief over the waters', wrote Van Helmont,[15] fifteen years before John Aubrey made his first visit to Silbury, and in world folklore these waters included 'the humours which circulate throughout the human system'.[16] 'The moon was thought to control the amount of moisture in the human body, and the brain, as the moistest part, was believed to be particularly subject to its influence.'[17]

If this body and brain emphasis is reminiscent of the double-ended, two-way Silbury image, so also is the total interpenetration of moon with fluid. The moon does not merely deliver the baby and then depart. Rather its influence operates *inside* the child, through to adulthood.

The relationship of moon and water, as understood in the seventeenth century, and certainly in the Neolithic, challenges our rationalist concept of the separation of subject from object, and our insistence upon maintaining the distinction between cause and effect. At Silbury neither of these ideas is helpful because there,

The goddess Luna with crescent moon, on the Romano–British pediment of the Four Seasons, Bath. The Romans divided the functions of the Great Goddess between several deities, but gave Luna a place of honour over the hot spring.

in common with so many prelogical cosmologies, the moon *made* the birth on the water, and *was itself born from the water*. So Silbury put the moon in the sky, and the moon put the baby on Silbury's knee.

The nocturnal birth ceremonies come very close to us. They were still maintained at Lammas, the start of harvest, in seventeenth-century Scotland, when people gathered to watch the mountain give birth.

Nineteenth-century newspapermen claim to have devised the phrase 'the Silly Season' to describe a period of high summer bathos. Yet in Scotland the Silie Season celebrated the harvest birth, and in a mood far removed from ridicule or triviality:

In August 1656, the Minister of Rathven (Whitering) declared that there had been great confluences of people in the parish of Dipple beyond Spey, on three Saturdays before Lammas and three after, called the six Silie Saturdays, and *that the conventions were on the night and before daybreak*. The people came not only from Moray, but as far as Buchan [over 30 miles from Dipple].[18]

The Kirk was determined to disperse this great confluence, but as late as 1751 it was reported that 'multitudes even from the Western Isles do still resort to Dipple and nothing short of violence can restrain their superstitions'.[19]

For a seventeenth-century Scot to say 'he (or she) was born in August', was to imply high praise and

recognition of a 'well-skilled person'.[20] August, the month of the Lammas towers, the month when the Irish dancers moved around the female effigy,[21] was the right time for birth. *Then* the Lammas moon was at work, on behalf of new children, and the new harvest. 'After Lammas, corn ripens as much by night as by day,' was still a widespread saying in 1670, when recorded by John Ray.[22]

For Silbury to give a good birth, she had to begin labour at the Lammas quarter day, at night, in moonlight, and *when the moon was full.*

Even the rational Francis Bacon concluded that 'it may be that children and young cattle that are brought forth in the full of the moon are stronger and larger than those that are brought forth in the wane.'[23] In Cornwall the same belief was stated baldly: 'No moon, no man',[24] meaning that children born at the new or crescent moon were unlikely to reach adulthood.

Everywhere in the ancient world the full moon, so replete, so plainly ready, was the time in the month for births of all kinds. What is more, Thom has shown that in Neolithic Britain, the full moon was the object of particular scrutiny. Consequently, the Silbury nativity was likely to have been celebrated on the night of the full moon nearest to the fixed solar quarter day. (The need to incorporate a full moon explains why the Scottish Silie observance stretched over several weeks.)

Because the synodical or lunar month is not in phase with the solar calendar, the full moon coincides with solar Lammas Eve only 2 years out of 30, and it can fall as much as a fortnight away from the Lammas night. In addition, the lunar progression of the nodes (the 18.61 year cycle) means that even when solar Lammas and full moon did coincide, the moon did not rise and set in two fixed azimuthal positions. Instead, there was a fluctuation of several degrees on either side of two average lines, 180° from Lammas sunset and sunrise respectively.

Yet, for a society with a strong sense of rhythm, the difficulties outlined above were probably understood as a longer interval between repeats rather than a fall into confusion. The attention paid to the lunar extremes on the 18.61 year cycle in many of the stone circles, including Stonehenge, speaks strongly for this attitude. Thom has found 'conclusive proof' that the solar Lammas quarter day *was* marked in Neolithic Britain by monumental megaliths.

Silbury in labour

The Silbury birthnight

The Silbury designers had to satisfy an awe-inspiring list of demands. They had to build in the immediate vicinity of the sacred springs. They had to tap the underground water supply, and find the only strata of chalk capable of being cut into large blocks. They were asked to construct on an unprecedented scale, so that the Hill could be seen clearly from the other monuments in the ritual cycle. The mighty sculpture had to be modelled in an unmistakably figurative idiom – it had to look like the Mother of the Universe, combining supreme intelligence (eye) with her role as giver of physical life. To meet these needs involved engineering problems of an unprecedented order. The stipulation that solstitial and equinoctial events should be given their appropriate places was also honoured.

After all that, the primary reason for building Silbury has yet to be described, for if Silbury failed to give birth, the builders would have regarded the whole achievement as profoundly inadequate. At Lammas 2600 BC the mound-building was begun. At Lammas, every year since, the completed structure is put to the test.

So let us go to the Hill on Lammas Eve, August 7th, when a full moon coincides with the half-way stage between summer solstice and autumn equinox, to see if the harvest child will appear.

The sequence of events outlined below takes account of the Silbury latitude 51° 25′, and may be witnessed by moving round the periphery of the Neolithic summit terrace (a perambulation method used later at the Stonehenge trilithon sighters).

It presupposes that the ditch should be clear of silt though, in some years, such as 1971, the August water level may rise above the sediment accumulated since Neolithic times.

On the night of August 7th–8th, the goddess gave birth and gave birth *for all to see*. Nothing less than total theatre was required and provided. The theme was to be the same every year – namely the birth and nourishment of the harvest or first fruits child. The principal parts were all played by the goddess:

Moon	played by the goddess	(eye, child, and celestial mother)
Mound	played by the goddess	(spider's web, woven skirt, first rock and mighty eye)
Moat	played by the goddess	(hole, negative and liquid) (her squatting body)
Swallowhead & Waden spring	played by the goddess	(landscape, white chalk goddess with Cunnit)
Child	played by the goddess	(intercauseway moat, moon and human baby)
Sickle	played by the goddess	(moat and antler tine)
Grain	played by the goddess	(green corn and intercauseway moat)
Man and woman	played by the goddess	(man and woman and as woman-man) (hermaphrodite and individualized)
Chorus of worshippers	played by the goddess	(everything and everyone)

Heavy cloud could ruin the performance, but every effort was otherwise made to ensure that the action could be seen and understood by the audience participators. In this respect the scale of the Mother stage was crucial. It had to be broad enough to absorb all known variations of Lammas full moon behaviour, while avoiding the consequent danger that the actress with the most dynamic part (the goddess as Moon) would muddle up her moves.

Here is the script, which operates when the observer stands on the specially designed sub-summit terrace, which gives functional necessity to this feature.

TIME	EVENT	AZIMUTH	REFLECTED LIGHT
1935 hrs	Sunset	291°	Back of neck, with reflection of last light running like a plait of hair towards mound.[I]
2000 hrs	Moonrise over Waden spring	109°	Thigh, at vulva position.[II]
2100 hrs	Moon climbing	127½°	Vulva.
2205 hrs	Moon climbing	145°	Moon on Mother's knee.[III]
2250 hrs	Moon climbing	160°	Moon over east causeway and Winterbourne at K2.[IV]
2330 hrs	Moon directly over Swallow-head spring	171°	Lunar disc makes child head in the intercauseway ditch.
0010 hrs	Moon at maximum altitude	180° (due South)	Defines neck of baby-grain and the moment to cut both the umbilical cord and the first corn.[V]
0112 hrs	Moon sinking	197½°	Moon 'head' moves to west end. Child, born head first, is turned to face the mother's breast.
0215 hrs	Moon sinking	215°	Moon over western causeway
0317 hrs	Moon sinking	232½°	Moon touches tip of breast.
0400 hrs	Moon sinking	244°	Moon becomes milk in the moat breast.
0420 hrs	Moonset	250°	
0435 hrs	Sunrise	70°	Moat thigh.

I In Ancient Rome matrons ceremonially washed their hair at the August 13th festival of Diana. This act was performed at night. The following day was a holiday for slaves.

II Corresponding to the point at the mound base where a pierced 'whetstone' was found buried in 1869. (*Wilts Arch. Mag.*, XI, p. 115).

III The kneecap, perhaps partly because of its U-shape, was regarded as the seat of fecundity in prehistory. (See Onians, *Origins of European Thought*, 1954.)

IV The causeway axis (160°), not only joins Silbury centre to the river but also bisects the 180° angle between Lammas Eve moonset (250°) and Lammas sunrise (70°).

V 180° due south runs across the south horn of the circum-summit U-feature. Was this corn actually growing on the summit? Unlike the sub-summit terrace, the summit itself does not provide a view of the vital sections of the moat, which suggests a different purpose – namely to provide a sacred wheat field for the first fruits corn.

The Lammas Eve sun, going down in the northwest shortly after 7.30 p.m., aligns with a pronounced curve in the otherwise straight moat edge, perhaps corresponding to a plait of hair, to which the setting sun contributes an extra length, composed of an orange reflection, snaking towards the mound.

After this show has disappeared, there is a pause lasting about 30 minutes, during which the observers move to the southeast edge of the terrace to await moonrise. At 8 o'clock the moon's upper edge shows itself at 109° azimuth, appearing directly over the Waden Hill spring.

This conjunction must surely have been happily regarded and was probably planned. The moon is born from and on Waden and Silbury water *simultaneously*. The Waden spring, downstream of Swallowhead, may have been regarded as the daughter spring. The importance of the spring in relation to Lammas moon birth is emphasized by the placement on Overton Hill of the Neolithic Sanctuary – a circular building which stands within 2° of the same axis. Thus, seen from Silbury, the Lammas moon appears at the Silbury moat (in reflection), over Waden spring, and moving over the silhouetted Sanctuary temple. At 110° the full disc occupies the Silbury moat, its light falling across the thigh and indicating the vulva. (And the vulva lies precisely on a due north–south axis, joining the Avebury henge to Swallowhead.)

For the next four hours the moon climbs into the sky while travelling towards the south. Thus an observer standing at the western moat head would get his first sight at 9 p.m., when the moon eye-child would move from behind the eye-womb and appear on the western causeway rim of the foreshortened squatting goddess. By 10 p.m. the reflection has fallen on the Mother's big left knee, and when the last stain of twilight has given way to true darkness, at 10.45 p.m., the moon is hanging over the narrow gap between knee and child. The gap is the eastern causeway. The child, waiting to be defined, is the intercauseway moat.

When viewed from Silbury, the moon over the east causeway aligns with the exposed left knee of the squatting goddess, i.e. the point where the Winterbourne first abuts onto the exposed chalk cliff, before running the length of her thigh towards Swallowhead.

At 11.30 p.m. the infant's head appears as a full, round lunar reflection on the intercauseway moat. At the same moment it is seen suspended over the Swallowhead.

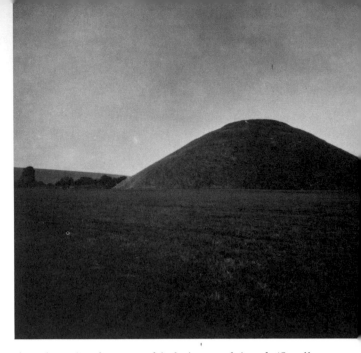

The moon over Silbury on Lammas Eve enacts the annual drama of the harvest birth night.

Another simultaneous birth is proclaimed (Swallowhead-Silbury), matching the first display combining Waden spring and Silbury. The birth genius is visibly the interaction of Mothers, revealed as one by the moon's dynamic eye.

Silbury Mother and river Mother are in harmony, and share the child-making, while affirming, in the intercauseway ditch-phallus, the bisexuality of the great creator. For in addition to being part of the goddess, the phallus also 'stands as son to feminine matter; bursting the shell of the egg, he discloses the mystery of phallic masculinity that has hitherto been hidden within; the phallic god springs from the darkness of the maternal womb.'[1]

Seen from the south rim of the terrace shortly after midnight, the moon is at its highest altitude, lying 180° due south, and aligning with a part of the mound base where the mother's navel might be found. This was the moment to cut the umbilical cord, to declare the birth achieved, and also to cut the first heads of green corn, severing them from the earth in which they had been rooted. (Perhaps wheat grew on the summit itself, to be ceremonially decapitated at the time of the southing moon, when the reflected disc defined the baby's navel.)

Here was the great moment, the classical demonstration of the goddess's power and generosity, where riverhead, lunar pulse, and temple image combined. We may hear the echo from Demeter's temple at Eleusis:

'At Eleusis, in the course of the night . . . the hierophant cries and shouts aloud saying: "Holy Brimo has

born a sacred child, Brimos;" that is, the mighty gave birth to the mighty one.'[2]

This moment was accompanied, according to Pindar, by 'the showing of that great and marvellous mystery of perfect revelation, in solemn silence: cut wheat.'[3]

No wonder the Wiltshire moonrakers looked into their ponds and streams and saw silver treasure, long after their behaviour had come to be regarded as the depths of rustic folly, for they had inherited a mighty tradition, and were in love with moonshine for good reason.

The corn child can still be seen by Lammas full moon light, swaying over Swallowhead-Cunnit. The very name Cunnit helps to bring to mind the *cununas*, the young girls who, in Transylvania, personified the harvest babies. They wore a spherical crown of wheat (*not* the last sheaf) giving them an exaggerated golliwog appearance, and sang:

> *Two girls have cut down*
> *Ripe wheat, high as a wall*
> *From where the cununa comes.*
>
> *The little cununa, glittering like gold*
> *Must slake its thirst*
> *With water from the mill*
> *With wine from the inn*
> *And with water from the stream.*[4]

The Silbury milk

The little *cununa* must drink, and so must the Silbury child. To do so, she had only to descend the specially made steps (rediscovered by Atkinson), into the moat. But babies prefer milk and, by 1 a.m. on the Silbury birth night, the child's moon head has moved to the west end of the intercauseway moat, and is demanding to be fed.

If the Neolithic child is not born to starve, where is the milk? None is to be had on the broad, dry, west causeway but, accompanied by the first signs of dawn, the moon indicates the nipple at 3.17 a.m. The anxious wait for milk is over once the moon has touched the tip of the breast. For the next hour, the breast swells with white light.

The reflected lunar disc falls to pieces, fragmented by the river Kennet's rippling water, yet there is some reason to believe that both the ancient Greeks and the ancient Britons saw the moon eye in three-dimensional, though miniature, form within such animated streams.

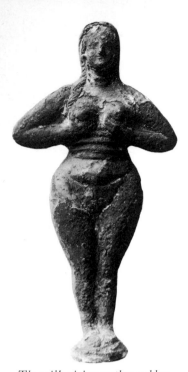

The milk-giving mother goddess. A clay figurine from Susa, 3rd millennium BC, *displays the breast symbolism of the Great Goddess.*

In ancient Greece and in Phrygia the rural divinities known as Sileni personified the genii of springs and rivers. Their name 'seems to mean water which bubbles as it flows'.[5] The significance of these air-bubbles may be revealed by the Gaelic word *suileag*, meaning a little eye or small bubble, with *suileag* being to Suil what the Sileni were to Selene.

Gradually, the scene merges into general daylight, with sunrise at 4.35 a.m., and the start of harvest. Setting moon and rising sun, it will be recalled, were separated by an angle of 180°, and this straight line also forms the longitudinal axis to the Silbury U-shaped terrace, which is the simulated Swallowhead.

A flight of Neolithic steps, each one foot high, was found by A. C. Pass, and led to the bottom of the twenty-foot-deep breast. At this place he discovered stags' horns, the Neolithic symbols for maternity.[6]

The Silbury goddess was so arranged in relation to the natural hillside from which she was dug that she ended the night by visually conveying yet another vital layer of meaning, concerned with the outward radiation of fertility. (A temple or religious centre is of value in proportion to its success in receiving *and* transmitting.)

As the Silbury Lammas night drew to a close, the reflected moonlight was removed from the moat breast by the growing shadow, cast by the high rock wall forming the outer edge of the breast lobe. When the moon had dropped to within 8° of the horizon, the water was left in darkness, while the outermost crest of the ditch, defining that part of her anatomy, continued to glisten with silver light and therefore became the centre of attention. This was now focused on the natural soil line, and the cornfields beyond, and so away to the southwestern horizon, where eventually the moon would set.

The genius of the Silbury designers is nowhere better demonstrated than in this use of moonlight and shadow to create an apparent outward flow of fecundity, where birth moved from the specific monumental Mother to the Mother in her extended form – the land awaiting the start of harvest.

Lunar variations

The programme outlined above is for solstitial quarter day eve, with full moon at mid-swing, and therefore illustrates the best possible adjustment. It must now be shown how the drama worked in less favoured

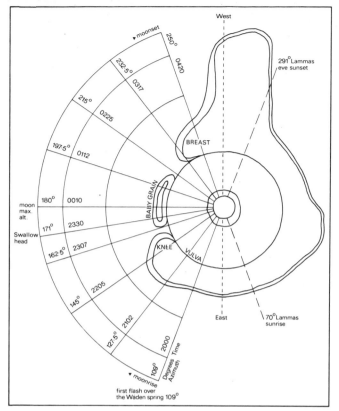

West

291° Lammas eve sunset

moonset
250°
0420
232·5°
0317
215°
0225
197·5°
0112
180°
0010
moon max. alt.
171°
2330
Swallow head
162·5°
2307
145°
2205
127·5°
2102
109°
2000
moonrise

BREAST

BABY GRAIN

KNEE

VULVA

Degrees Time
Degrees Azimuth

East

70° Lammas sunrise

first flash over the Waden spring 109°

Lammas Eve nativity: sequence of events and approximate times.

years. For example, in searching for a full moon, Lammas night might have to be shifted back or forward as much as fourteen days, bringing an appreciable variation in length of night.

Whereas a longer night would not impair the lunar imagery, difficulties might attend the shortest possible Lammas night, i.e. when the full moon occurred on July 24th.

The following table sets out the likely sequence:

July 24–25th

Sunset	True darkness begins	Length of true darkness	Twilight	Sunrise
2000 hrs	2200 hrs	4 hrs 12 min.	0212	0412

Even for this, the shortest Lammas night (when moonrise comes after sunset) true night has fallen before the moon has reached the moat knee. The moon journey along the intercauseway moat is conducted in true night, and although the breast event has to be shared

with a grey dawn, the sunrise does not occur till after moonset. The sequence of events is therefore maintained. When the northern moonset extreme combines with a July 24th full moon, sunrise does precede moonset, but since, by this time, the moon is well beyond 250° azimuth, the breast phenomenon has already been registered.

Silbury is also equal to accommodating the progression of the lunar modes without disruption. This is because the breast, viewed from the mound, embraces an angle of 30°, whose axis is the 250° azimuth moonset mean. All possible Lammas moonsets can be comfortably registered within this belt. Similarly, since the human vulva is a long fissure (particularly at childbirth) and Silbury, lying on her side, exhibits this generous arc in longitudinal view, all conceivable Lammas moonrises could be seen to come from this organ.

The food-child balance

Professor Campbell has shown that ancient Neolithic societies were committed to keeping population and food supply in balance. For them it followed naturally from worshipping a synthesizing deity rather than one which celebrated man's conquest of nature.[7] Similarly, Carr-Saunders's massive survey lists over 200 'primitive societies, where there was definite and detailed evidence of systematic and (until the arrival of civilized man) successful control of the human population. . . . Customs restrictive on increase have been so widespread, in the form either of abortion, infanticide, or prolonged abstention from intercourse as to have been practically universal.'[8]

As R. G. Wilkinson writes, 'Primitive societies limited their populations within their resources,' but he points out that this truth 'involves throwing out the whole popular (modern) idea of primitive societies as societies which exist in a perpetual state of hardship, scarcely able to scrape up a bare minimum of subsistence with large families, children suffering from malnutrition, and a low life expectancy. In so far as this *is* the situation in parts of the underdeveloped world today, it is a comparatively recent phenomenon.'[9]

The ancient Silbury goddess, who paid such obvious regard to the terrestrial and celestial environment, was built to help propagate and perpetuate *the totality*, with an understanding of the benefits of preserving due proportion between animal and vegetable fecundity.

The typical Neolithic practice of controlled fecundity, involving infanticide (for which there is evidence at the Neolithic site G.55, overlooking Silbury)[10] was philosophically based on what Campbell calls 'the glimpse of death in harvest'.

The Silbury birth, the Silbury treasure, is completed by death, the cutting of the umbilical lifeline between mother and child, the *execution* of crops. All authorities agree on the profound sense of apology which pervades the first acts of harvesting in coherent rural cultures. Indeed the honest recognition of death is one of the mainsprings of first fruits ceremonial.[11]

The land around Silbury, having reached the climax of the vegetable year, looked forward to dessication, while the water level in the Silbury Mother was to fall inexorably during the autumn months.

So Silbury Hill was a tomb, after all, from where the dead earth, coming to life, died as it was born, and was devoured once again. But when death was formed as a mother, deprivation was replaced by security at every stage, because everything was *both dead and alive*.

Therefore, with the confidence of true companions, the Neolithic worshippers in any particular year could combine a proper concern for the business of current birth with a greeting for those born long ago, including the first ancestress and her first child, and for those who would be born in the distant future.

Abramson found that the huge female figures in New Guinea were until recently regarded in just this manner: 'The motif stood for, or "was", the tribe and its culture, acting to extend both entities backwards and forwards in time.'[12]

The four quarters

The first Lammas moonlight, coming up over Waden spring, describes the Silbury vulva, where Hill meets thigh and where two more vital axes intersect:

1 The east–west Silbury long axis, which is also the equinoctial sun–moon line. All this east–west power is given to the vulva at a place where mound and water meet.

2 The due north–south line, running from Avebury henge (west entrance) through the Silbury vulva to Swallowhead spring (and on to Milk Hill, three miles south). The importance of this axis is confirmed by the fact that all full moons and all mid-day suns reach highest altitude on this line.

For primitives, the four cardinal points express 'the relation between every particular reality and the fundamental form of the universe'.[13] For the Silbury builders, 'geometry' and human image were two expressions of the same divine reality.

The Lammas sunrise
The solar pivot of the lunar Silly Season was, and is, the August quarter day, August 8th. From the Silbury summit the sun is seen to rise on that day, at 70° azimuth, directly over the sharp profile of a Bronze Age bell barrow on Avebury Down, described by Grinsell as one of the most magnificent specimens in the country.

If, instead of remaining at Silbury for the sunrise, we move through the grey dawn[14] to a position above Swallowhead, we are greeted with a sight both older and younger than the Neolithic, for the first harvest sun, rising at 70°, by a remarkable geographical coincidence links the two stream confluences in a single alignment. Seen from Swallowhead, the sun rises over K2 (the point where the Waden spring water debouches into the Kennet), *and* over K1, the junction of Swallowhead water with the river.[15] The birthplaces are united by the first gleam of harvest sunlight. Let the harvest begin! Open the Silbury treasure again!

> . . . *And the end of all our exploring*
> *Will be to arrive where we started*
> *And know the place for the first time.*
> *Through the unknown remembered gate*
> *When the last of earth left to discover*
> *Is that which was the beginning;*
> *At the source of the longest river*
> *The voice of the hidden waterfall*
> *And the children in the apple-tree*
> *Not known, because not looked for*
> *But heard, half-heard in the stillness*
> *Between two waves of the sea.*
> *Quick now, here, now, always-*
> *A condition of complete simplicity*
> *(Costing not less than everything)*
> *And all shall be well and*
> *All manner of thing shall be well*
> *When the tongues of flame are in-folded*
> *Into the crowned knot of fire*
> *And the fire and the rose are one.*

T. S. Eliot, Little Gidding

Silbury in the Roman period APPENDIX

Two thousand years after the Neolithic Age had ended, the Romans dug several wells in the field between Silbury and Swallowhead. Each was over twenty feet deep, and sunk through solid chalk. But because they do not appear to be associated with a villa or other contemporary shelter, it is difficult to ascribe to them a narrowly practical function.

The wells lie close to the 'Via Badonica', the Roman road from Cunetio to Bath, but since this highway crosses the river a few yards to the east of the wells, travellers could easily have refreshed themselves and their horses there, instead of digging twenty feet through a hill spur to arrive at the same level as the surface river.

H. E. Priestley offers an explanation: 'Worship was one of the principal activities of Roman and Briton alike, and hardly a single conscious act in human life was performed without a thought of the particular god whose influence could make it succeed.'[1]

Consider then the likely impulse of a Cunetio citizen, when the road approached the source of the sacred river after which his town was named, and passed within sight of the holy spring and around the biggest supernatural female in the whole Empire. Would he not feel the need to *contribute* to the pattern of worship? Nearly 2,000 years later, the local population was still drinking springwater on Silbury's summit. By placing *their* pattern of wells between the two sites, the Romans have indicated a similar double recognition, having for them a direct bearing on the prosperity of their town, six miles downstream.

The willingness of the Romano-British community to concern itself with monuments far older than Silbury is testified by Professor Piggott's discovery of six Roman coins in the forecourt area of the nearby West Kennet long barrow which, he says, 'seem to represent something more than casual losses by Roman visitors to the site'. He goes on: 'One is prompted to wonder what this Roman interest in prehistoric

monuments in the fourth century A D may mean, and whether it may be connected with the association between Roman cults and pre-existing native traditions, noted some years ago by Mr G. E. Stevens.'[2]

An examination of the contents of the Roman wells would appear to confirm their special ritual nature. Well A was found to contain at a depth of three feet 'a mass of sarsen stones of various sizes'. Beneath these there was one sarsen, standing vertically, 'which took the united strength of 7 men to raise'.[3] In seventeenth-century Scotland men were still raising their hats to vertical megaliths, and at Well A an intended fertility function is at least possible.

Beneath the big stone lay 33 Roman coins, the most ancient being a sestertius of Trajan (c. A D 110), found at 18 feet, and the most recent belonged to Valentinian I (A D 364–375), discovered at the base level of 26 feet. Also in the shaft were:

1 relics consisting of necks, bases, handles and pieces of pottery in a great variety of shapes and colours and sizes, including Samian ware.
2 Various bronze relics, square-headed iron nails, and an iron bucket handle clip.
3 Antler picks and bones of deer, dog, sheep, ox and pig, and oyster and snail shells.
4 A moulded freestone corbel and base of a column and 3 flint flakes.[4]

Perhaps the most unexpected discovery was a large quantity of clean sandy deposits from the stream, containing water-worn stones and pieces of pottery with rounded edges. Dropping stream deposits into a well might seem as pointless as emptying well water into a stream, but becomes comprehensible if the shaft performs as intermediary between holy river and divine female. (Silbury itself contains much riverine material in the primary mound.)

Well B was excavated in 1896 and at high speed – 13 feet in one day. 'Almost from the beginning there were finds of flint flakes and Romano-British pottery. At about 6 feet from the surface the well assumed somewhat of an oval form.'[5] A bronze finger ring, a steel yard, and a coin of Arcadius (A D 383–395) were also found.

Well D contained several surprises. Apart from 'a beautiful specimen of a red deer horn pick', 16 feet from the surface, there was 'a curious piece of antler, about 6 inches long, tapering to a point – one of the crown tines of a red deer which showed signs of having

been rubbed, pointed or polished'. Further down they discovered 'a sarsen stone with a round hole bored through it, having been worked from both sides'. 20 feet from the surface they found '3 immense sarsens weighing over half a ton each, and a piece of Bath Stone, apparently part of a pillar, measuring 9 inches diameter, and 12 inches high'. The very bottom of the shaft (26 feet) was filled with 'a flat stone, somewhat circular in shape and about 8 inches thick, with a hole in it, 4 inches diameter, lying on another large flat stone with a hole in its centre'.[7]

May we not see in this pair of circular pierced stones some reference to the great eye goddess, the subterranean eyes matching the two above ground, expressed so unforgettably at Silbury? The depth, 26 feet, also brings the twin sarsens into horizontal alignment with the great natural eye of Swallowhead. Surely the contents of Well D describe a very common form of Romano-British religious experience, where a phallic mast was securely fixed into the great hull of the Magna Mater.

When we know that the Romans, including Hadrian, worshipped the Greek Demeter, and that they identified with the Great Goddess, wherever they found her, and by whatever name she was locally known, the wells can safely be taken as evidence of a similar continuity of interest in Neolithic Silbury.

The Great Goddess rediscovered. Demeter, with serpents, holds up the severed corn.

Chapter References

Chapter 1
Silbury Hill and the king

[1] Aubrey, John, *The Topographical Collections, 1659–70*, edited by J. E. Jackson, 1862.

[2] Aubrey, John, *Monumenta Britannica*, vol. 2, 1695.

[3] Pepys, S., *Diary*, vol. 3, 1854 ed., p. 466.

[4] Stukeley, William, *Abury Described*, 1743, pp. 41–3.

[5] *Ibid.*, p. 41.

[6] *Ibid.*, pp. 41–2

[7] L. V. Grinsell compares it with the Viking bridle illustrated in R. E. M. Wheeler's *London and the Vikings*, 1927, p. 42, fig. 20. See also *Society of Antiquaries' Minute Book*, 1757–62, viii, 128.

[8] Douglas, J., *Nenia Britannica*, 1793, p. 161.

[9] Smith, A. C., *Wiltshire Archaeological Magazine*, vol. 7, 1862, p. 181. L. V. Grinsell reports this and an alternative twentieth-century variation, known in the locality, that the golden monarch lay in a golden coffin – see *Ancient Burial Mounds of England*, 1953.

[10] *Ibid.*, p. 181.

[11] *Ibid.*, p. 165–6.

[12] Grinsell, L. V., *op. cit.*, p. 179.

[13] Stone, J. F. S., *Wessex before the Celts*, 1958, p. 90.

[14] Fowler, P. J., *Regional Archaeology of Wessex*, 1968, p. 33.

[15] Thomas, Nicholas, *A guide to Prehistoric England*, 1960, p. 223.

[16] Dyer, James, *Discovering Regional Archaeology, Wessex*, 1971, p. 66.

[17] Atkinson, R. J. C., *Silbury Hill*, 1967.

[18] Wood, E. S., *Collins' Field Guide to Archaeology in Britain*, 1963, p. 161.

[19] *Ibid.*, p. 161.

[20] Grinsell, L. V., *The Archaeology of Wessex*, 1958.

[21] Atkinson, R. J. C., *Antiquity*, vol. 44, 1970, p. 313.

[22] Wood, E. S., *op. cit.*, p. 161.

[23] Atkinson, R. J. C., *Stonehenge and Avebury*, 1959, p. 52.

[24] Atkinson, R. J. C., *Antiquity*, vol. 44, 1970, p. 313.

[25] Atkinson, R. J. C., *Silbury Hill*, 1967.

[26] Thomas, N., *A guide to Prehistoric England*, 1960, p. 218–31.

[27] Wood, E. S., *Archaeology in Britain, a field guide*, 1963, pp. 159–60.

[28] Atkinson, R. J. C., *Stonehenge and Avebury*, 1959, p. 52.

[29] Ordnance Survey, *Field Archaeology Guide*, 1951, p. 26.

Chapter 2
The empty tomb

[1] Fleming J., *Robert Adam and his Circle*, 1962.

[2] MS Cottonian Coll., City Museum and Art Gallery, Plymouth.

[3] Quoted in Aubrey, J. (ed. J. E. Jackson), *Wiltshire Collections*, Devizes, 1862, p. 333.

[4] Douglas, J., *Nenia Britannica*, 1793 p. 161.

[5] Merewether, J., *Diary of a Dean*, 1851. Published posthumously. Merewether's family came from Devizes, Wilts. He had been chaplain to Queen Caroline, and had hoped to become a bishop.

[6] *Ibid.*, p. 11.

[7] *Ibid.*, pp. 13–14.

[8] *Ibid.*, p. 15.

[9] *Ibid.*, p. 16.

[10] Tucker, C., *Proceedings of the Archaeological Institute*, Salisbury, 1849, p. 303.

[11] *Ibid.*

[12] Smith, A. C., *Wilts Arch. Mag.*, vol. 7, 1862, pp. 145–191.

[13] *Ibid.*, p. 153.

[14] *Ibid.*, p. 155.

[15] Flinders-Petrie, W. M., *Wilts Arch. Mag.*, vol. 42, 1922, p. 217.

[16] Crawford, O. G. S., *Wessex from the Air*, 1928.

[17] Bray, W., and D. Trump, *A Dictionary of Archaeology*, 1970, p. 196.

[18] McKim, F. R., *Wilts Arch. Mag.*, vol. 57, 1959, p. 176.

[19] *Ibid.*, p. 178.

[20] *Ibid.*, p. 176.

[21] Atkinson, R. J. C., *Silbury Hill*, 1967.

[22] *Ibid.*, pp. 8–11.

[23] Atkinson, R. J. C., *Antiquity*, vol. 41, 1967, pp. 260–1.

[24] Blake, William, *Marriage of Heaven and Hell*, 1793.

[25] Johnstone, Paul, in *Silbury Hill*, 1967, p. 1.

[26] Atkinson, R. J. C., *Silbury Hill*, 1967, p. 13.

[27] *Ibid.*, p. 13.

[28] *Ibid.*, p. 5.

[29] Atkinson, R. J. C., *Stonehenge*, 1956, pp. 164–5.

[30] Atkinson, R. J. C., *Antiquity*, vol. 44, 1970, p. 313.

Chapter 3
Inside the treasure

[1] Merewether, J., *Diary of a Dean*, 1851, p. 14.

[2] *Ibid.*, p. 12.

[3] *Ibid.*

[4] *Ibid.*, p. 13.

[5] *Ibid.*, p. 150.

[6] Atkinson, R. J. C., *Antiquity*, vol. 42, 1968, p. 299.

[7] *Ibid.*

[8] Atkinson, R. J. C., *Antiquity*, vol. 44, 1970, p. 313.

[9] Atkinson, R. J. C., *Silbury Hill*, BBC Supplement, 1969, p. 2.

[10] *Ibid.*, p. 4.

[11] *Wilts Arch. Mag.*, vol. 42, 1922, p. 217.

[12] *Wilts Arch. Mag.*, vol. 58, 1962, p. 176.

[13] Avebury Museum Display, 1971. 6×17 ft = 102 ft (to base of ditch) = 130 ft.

[14] Atkinson, R. J. C., *Antiquity*, vol. 44, p. 314.

[15] *Ibid.*

[16] *Ibid.*

[17] *Wilts Arch. Mag.*, vol. 42, 1922, p. 217.

[18] Atkinson, R. J. C., *Silbury Hill*, BBC Supplement, 1969.

[19] *Antiquity*, vol. 42, 1968, p. 299.

[20] Atkinson, R. J. C., *Antiquity*, vol. 42, 1968, p. 299.

[21] Pass, A. C., *Wilts Arch. Mag.*, vol. 23, 1887, p. 246.

[22] *Ibid.*, p. 246

[23] Atkinson, R. J. C., *Antiquity*, vol. 43, 1969, p. 216. Radio carbon dating: a method first suggested in 1946 by F. W. Libby. Carbon 14 is a radioactive isotope of $C12$ produced from nitrogen 14 in the atmosphere by cosmic

radiation. Thereafter it acts exactly like C_{12}, being taken into organic compounds of all living matter. When organic matter dies, it ceases to exchange its carbon, as carbon dioxide, with the atmosphere, so its C_{14} dwindles by decay and is not replenished. Determination of the radioactivity of the carbon from a sample will reveal the proportion of C_{14} to C_{12}. This will in turn, through the known rate of decay of C_{14}, give the time elapsed since the death of the sample. (Bray, W. and D. Trump, *Dictionary of Archaeology*, 1970, p. 194.)

[24] Excavation of Windmill Hill began in 1925, directed by H. St George Gray F.S.A., and was continued by A. Keiller F.S.A.

[25] Piggott S., *Neolithic Cultures of the British Isles*, 1954. Stone, J. F. S., *Wessex Before the Celts*, 1958, pp. 22–6.

[26] Atkinson, R. J. C., *Antiquity*, vol. 44, 1970, p. 314.

[27] Case, H., *Antiquity*, vol. 43, 1969, pp. 176–86.

Chapter 4
The birth position

[1] Hawkes, J., *Dawn of the Gods*, 1968, p. 25.

[2] Neumann, E., *The Great Mother*, 1955, p. 135.

[3] Zimmer, H., *The King and the Corpse*, 1948, p. 249.

[4] James, E. O., *The Cult of the Mother Goddess*, 1959, p. 249.

[5] Guirand, F., in *New Larousse Encyclopedia of Mythology*, 1968, p. 85.

[6] Woolley, L., and J. Hawkes, *Prehistory and The Beginnings of Civilisation*, 1963, Part II, Section II, p. 337–8. For a full treatment of Great Goddess evidence see Robert Briffault's *The Mothers*, 1927, 3 volumes.

[7] See Mellaart, J., *Anatolian Studies*, vol. 11, 1961, p. 49.

[8] Hawkes, J., *Dawn of the Gods*, 1968, p. 26.

[9] Eliade, M., *Patterns in Comparative Religion*, 1958. 'This attitude is recognized by gynaecologists. The association of these figures with a stool is a most interesting

illustration of a passage from the Bible (Exodus I, 16): "And he said, when ye do the office of midwife to the Hebrew women, and see them upon the stools".' For modern use of a stool or basket at the time of childbirth see W. S. Blackman, *The Fellahin of Upper Egypt*, Ch. 4.

[10] Lommel, A., *Prehistoric and Primitive Man*, 1969.

[11] Mellaart, J., *Anatolian Studies*, vol. 13, 1963, pp. 93–4.

[12] Rainbird, Clarke R., *Grimes Graves*, 1963, p. 22.

[13] Pass, *op. cit.*, p. 253.

[14] Atkinson, R. J. C., *Antiquity*, vol. 44, 1970, p. 313.

[15] Pass, *op. cit.*, p. 249.

[16] Hawkins, Prof. H. L., *Marlborough College Nat. Hist. Soc.*, vol. 96, p. 39. This decline proceeds independently from factors such as climatic variation, and pumping station activity, due to the phenomenon of scarp foot spring seepage, increased by erosion of the clay vale beyond.

[17] Cunnington, M. E., *An introduction to the Archaeology of Wilts*, 1933, p. 58.

[18] Flinders-Petrie, W. M., *Wilts Arch. Mag.*, vol. 42, 1922, p. 217.

[19] Atkinson, R. J. C., *Antiquity*, vol. 44, 1970, p. 313. Thus confirming the work of A. C. Pass, *Wilts Arch. Mag.*, vol. 23, 1886, pp. 245–55.

[20] Atkinson, R. J. C., *Stonehenge*, 1956.

[21] Norberg-Schulz, C., *Intentions in Architecture*, 1963, p. 125. W. R. Lethaby and V. Scully elaborate upon this former commitment.

[22] Lethaby, W. R., *Architecture, Mysticism and Myth*, 1892, p. 5.

[23] Levy, G. R., *The Gates of Horn*, 1948.

[24] Zuntz, G., *Persephone*, 1972, p. 8.

[25] Scully, V., *The Earth, The Temple and The Gods*, 1964, p. 19.

[26] Evans, J. D., *Malta*, 1959, pp. 117 and 144.

[27] Calder, C. T. S., *The Northern Isles*, (ed. F. T. Wainwright), 1962, pp. 26–44.

[28] Rykwert, J., *Meaning in Architecture*, ed. Jencks and Baird, 1969, p. 239.

[29] Griaule, Marcel, *Conversations with Ogotemmeli*, 1965, pp. 94–5.

[30] *Ibid.*, p. 96.

[31] Van Eyck, Aldo, 'Basket-house village-Universe', in *Meaning in Architecture*, (ed. C. Jencks), 1969, p. 190.

[32] Griaule, M., *op. cit.*, p. 97.

[33] Auboyer, Jeannine, in *Byzantine and Medieval Art*, 1963.

[34] Giedion, S., *The Eternal Present*, 1962–4, p. 437. The sitting goddess, side view, is engraved at La Roche, (Dordogne), Pech-Merle, and Les Combarelles.

[35] Lethaby, *op. cit.*, p. 4.

Chapter 5 Cornucopia

[1] Woolley, L., and J. Hawkes, *Prehistory and the beginnings of civilisation*, 1963, p. 338.

[2] Mellaart, J., *Anatolian Studies*, vol. 11, 1961, p. 39–77.

[3] Crawford, O. G. S., *The Eye Goddess*, 1957, p. 27.

[4] Schmidt, H., in M. Oppenheim, *Tel Halaf*, 1931, p. 299.

[5] Van Buren, E., *Iraq*, vol. 12, 1950, pp. 141–2.

[6] O'Riordain, S., and G. Daniel, *New Grange*, 1964, p. 127.

[7] Plato, *Timaeus*, Part III, 91c, trans. F. M. Cornford, 1937.

[8] James, E. O., *The Cult of the Mother Goddess*, 1959, p. 249.

[9] Kramer, S. N., *History begins at Sumer*, 1958, pp. 133–4.

[10] Campbell, J., *Occidental Mythology*, 1965, p. 10.

[11] Quoted by Lethaby, *op. cit.*, p. 75.

[12] Neumann, E., *The Great Mother*, 1955, p. 98. He also remarked that rock and stone were regarded as the 'same' as mountain by virtue of the law of *pars pro toto* in participation mystique. Wherever an identity is established between persons and objects it applies also to their parts.

[13] *Ibid.*, p. 99.

[14] Hocart, A. M., *Kingship*, 1927, p. 92.

[15] Hawkes, J., *The First Great Civilisations*, 1973, p. 409.

16 James, E. O., *The Ancient Gods*, 1960, p. 78.

17 Lethaby, *Architecture, Mysticism and Myth*, 1892.

18 Wilkins, E., *The Rose Garden Game*, 1969, p. 96.

19 Neumann, *op. cit.*, p. 227.

20 Bachofen, J. J., *Myth, Religion, and Mother Right*, 1967 ed., p. 58.

21 Sandars, N. K., *Prehistoric Art in Europe*, 1968.

22 Harden, K., *The Phoenicians*, 1962, p. 88.

23 Mallowan, M. E. L., *Early Mesopotamia and Iraq*, 1965.

24 Exhibited in the British Museum.

25 Taylor Page, F. J., *Red Deer*, 1962, pp. 4–5 and 16–17.

26 *Ibid.*, p. 5.

27 Marshack, A., *The Roots of Civilisation*, 1973.

28 McKay, J. G., in *Folklore*, vol. 43, 1942, pp. 144–49.

29 Neumann, E., *Art and the Creative Unconscious*, 1959.

30 Ashe, G., *Camelot and the Vision of Albion*, 1971, p. 100.

31 Norberg-Schulz, *op. cit.*, p. 186.

32 P. Rawson, R. Briffault, M. Eliade, J. Campbell, J. E. Harrison, E. O. James, V. Scully, E. Cassirer, C. G. Jung.

33 Eliade, M., *Images and Symbols*, 1961, p. 9.

34 Eliade, M., *The Two and the One*, 1965, p.201.

35 *Ibid.*, p. 203.

36 Eliade, M., *The Structure of Symbols*, 1969, p. 440.

37 Keen, S., *Apology for Wonder*, 1969, p. 66.

Chapter 6 Big Sunday and the British goddess

1 Macneill, Maire, *The Festival of Lughnasa*, 1962, pp. 662–3.

2 *Ibid.*, p. 19.

3 *Ibid.*, p. 43–4.

4 M.S. 889, Portacloy, Co. Mayo, p. 407.

5 *Proc. Royal Irish Acad.*, Second series I., 1878, pp. 267–9.

6 M.S. 889, Kilchreest, Co. Galway, pp. 483–4.

7 Macneill, Maire, *op.cit.*, p. 60.

8 *Ibid.*, p. 68.

9 *Ibid.*, p. 68.

10 *Ibid.*, p. 69.

11 *Ibid.*, p. 222.

12 *Ibid.*, pp. 223–4. The old woman lived at Clooneen, near Eglis.

13 *Ibid.*, p. 223.

14 *Revue Celtique*, vol. 11, 1892, p. 454.

15 Ross, A., *Pagan Celtic Britain*, 1967, p. 205.

16 See Daniel and O'Riordain, *op. cit.*, p. 130.

17 See Page, Revd J., *Ireland, its evils traced to their source*, 1836, p. 77.

18 Macneill, *op. cit.*, p. 143.

19 *The Metrical Dindshenchas*, IV, ed. Edward Gwynn.

20 *Journal Royal Society Antiquaries of Ireland*, vol. 6, 1867, p. 7.

21 Anderson, J., *Soc. Antiquaries of Scotland*, 1792.

22 Gover, J. E. B., *Place Names of Wiltshire*, 1939.

23 Nicol, Revd. James, *Poems*, 1805, pp. 1–17.

24 Stukeley, *op. cit.*, p. 43.

25 *Ibid.*, p. 44.

26 Whistler, L., *The English Festivals*, 1947. p. 105.

27 See Wright, A. R. and T. E. Lones, *British Calendar Customs in England*, vol. I, 1936. Mothering Sunday cakes of a special star shape were baked at nearby Devizes.

28 *Wilts Arch. Mag.*, vol. 4, 1858, p. 340.

Chapter 7 The Swallowhead spring

1 Frankfort, Henri and H. A., *Before Philosophy*, 1949, p. 12.

2 Eliade, M., *Myths, Dreams and Mysteries*, 1960, pp. 157–8.

3 Scully, Vincent, *The Earth, the Temple and the Gods*, 1962.

4 Nuttgens, P., *The Landscape of Ideas*, p. 40.

5 Oeri, G., *Man and his Images*, 1968, p. 91.

6 Gover, J. E. B., *op. cit.*

7 O'Kelly, Claire, *New Grange*, 1967, p. 61.

8 Jones, F., *The Holy Wells of Wales*, 1954, p. 4.

9 Gifford, J. M., *Victoria County History of Wilts*, vol. 1, part 1, 1957.

10 Eliade, M., *Myths, Dreams and Mysteries*, 1960 ed., p. 169.

11 *Ibid.*

12 For English folklore attitudes to living pebbles and fossils, see Oakley K., 'Folklore of Fossils', *Antiquity*, vols. 38–9, 1964–5.

13 Osborne White, H. J., *op. cit.* p. 76.

14 HMSO, Geol. Survey, 1925, p. 75.

15 *Ibid.*, p. 75.

16 Sherlock, R. L., *Geological Survey, London and Thames Valley*, 1947, p. 22.

17 Hawkes, J., *Dawn of the Gods*, 1968.

18 Alcock, J. P., 'Celtic Water Cults in Roman Britain', in *Archaeological Journal*, 1965, p. 1.

19 Ekwall, E., *Concise Oxford Dictionary of Place Names*, 1947, p. 228.

20 Ekwall, E., *English River Names*, 1928, p. 228.

21 Nilsson, M. P., *op. cit.*, p. 10.

22 Cassirer, E., *Philosophy of Symbolic Forms*, vol. II, 1923–9, p. 107.

23 Campbell, J., *Primitive Mythology*, 1960, p. 64.

24 See Osborne White, *op. cit.*, p. 100. Stukeley, *op. cit.* vol. 2, p. 19.

25 Cassirer, *op. cit.*, p. 105.

26 Leland's *Journey Through Wilts* (VII, 85), 1540–2.

27 Stukeley, *op. cit.*, p. 19.

28 *Ibid.*, pp. 34–5.

29 See Stukeley, *Itinerarium Curiosum*, vol. I, 1723, p. 63.

30 Map of Roman Britain, Ordnance Survey, 3rd. ed.

31 Partridge, Eric, *Dictionary of Slang*, 4th ed., 1951. p. 198.

32 Farmer, J. S. and W. E. Henley, *Dictionary of Slang*, vol. 1, 1966, Introd. p. xxxi.

33 Stukeley, William, *Abury Described*, 1743.

34 Long, W., *Wilts Arch. Mag.*, vol. 4, 1858.

35 English proverb, current *c.*1600. See Middleton T., *The Changeling*, Act III, Scene III.

36 Macneill, Maire, *op. cit.*, p. 650.

37 Radford, E. and M. A., *Encyclopaedia of Superstitions*, 1961.

38 Munro, N. G., *Ainu Creed and Cult*, 1962, p. 135.

39 Hope, R. C., *Holy Wells*, 1893.

40 Onians, R. B., *Origins of European Thought*, 1954, p. 122.

41 *Ibid.*, p. 123.

[42] Aristotle, *Historia Animalium*, Bk VII, ch. 4.

Chapter 8
Landscape with figures
[1] Clark, K., *The Nude*, 1960, p. 33.
[2] See Aristotle, discussing Pythagoras, in *Metaphysica*, A.5.
[3] Cassirer E., *Philosophy of Symbolic Forms*, vol. 2, 1923–9, p. 141.
[4] Thom, A., *Megalithic Sites in Britain*, 1967, p. 34.
[5] Cassirer, *op. cit.*, p. 142.
[6] *Ibid.*, p. 142
[7] Lévi-Strauss, C., *The Savage Mind*, 1966, p. 17.
[8] *Ibid.*, p. 269.
[9] Cassirer, *op. cit.*, p. 142.
[10] Levy-Bruhl, Claude, *How Natives Think*, 1926.
[11] Woolley, Sir L., in *History of Mankind*, vol. I, 1963, pp. 669 and 673.
[12] Pareti, Luigi, in *History of Mankind*, vol. 2, pp. 145–6. See Taton, R., *Ancient and Medieval Science*, article by J. Vercoutter, on Egyptian concrete fractions, pp. 20–3.
[13] Piggott, S., *Excavation of West Kennet long barrow*, 1955–6.
[14] Osborne White, H., *Geology of country around Marlborough*, 1925, p. 3.
[15] Lévi-Strauss, *op. cit.*, p. 220.

Chapter 9 Neolithic harvest hills in England
[1] Burl, M. A. W., *Architectural Journal*, vol. 126, 1969.
[2] Piggott, S., in *Victoria County History of Wilts*, vol. 1, pt. 2, 1973.
[3] Field, N. H., *Proc. Dorset Nat. Hist. and Arch. Soc.*, vol. 84, 1962, pp. 117–24. The outer ditch was found to be flat-bottomed and 5.5 ft below the modern surface. See also Piggott S., *Antiquity*, vol. 13, 1939, p. 155.
[4] Tristram, E., *Journ. Derby. Arch. Soc.*, vol. 37, 1915, pp. 77–87.
[5] Bateman, T., *10 years' digging in Celtic and Saxon Grave Hills*, 1861, p. 17.
[6] Bateman, T., *Vestiges of the Antiquities of Derbyshire*, 1848, p. 31.
[7] *Ibid.*, p. 111.

[8] Bateman, T., *10 years' digging in Celtic and Saxon Grave Hills*, p. 18.
[9] A slit trench cut through the Dove Holes mound during the 1939–45 war revealed that it was composed partly of clay. (Alcock L., *Proc. Prehist. Soc.*, 1950, p. 81.)
[10] Bateman, *Vestiges*, p. 31.
[11] *Ibid.*
[12] The name Gib Hill is modern. In the eighteenth century it was called Llewing Low. (See *Journ. Derby Arch. Soc.*, vol. 30, 1908, p. 171, and vol. 33, 1911, p. 56.) N. Thomas found traces of a ditch surrounding the mound. See Thomas N. *op. cit.*
[13] *Soc. Ant. Minute Book.*, vol. 11, 1769, pp. 156–8.
[14] Hoare, R. C., *Ancient History of North Wilts*, vol. 2, 1821, p. 4.
[15] *Ibid.*, p. 7.
[16] Wainwright, G. J., *Ant. Journal*, vol. 51, 1971.
[17] Hoare, R. C., *op. cit.*, p. 6.
[18] *Ibid.*, p. 7.
[19] See Smith, E. Baldwin, *Architectural Symbolism of Imperial Rome*, 1956.
[20] Woodbridge, K., *Landscape and Antiquity*, 1974, p. 49.
[21] Hoare, R. C., *Ancient Wilts*, 1821, p. 15.
[22] Oliver, Edith, *Wiltshire*, 1951, p. 168.
[23] Brentnall, H. C., *Wilts Arch. Mag.*, vol. 48, p. 141. Twenty years earlier a similar find was made on the other side of the mound. In his scholarly official guide to Marlborough, of 1922, Brentnall continued to press for a Neolithic date, and regarded the Norman takeover, first mentioned in AD 1138, and leading to a shell keep construction, c. 1175, as a much later re-use of the site.
[24] *Ibid.* p. 141.
[25] Stukeley, W., *Itinerarium Curiosum*, vol. I, 1776.
[26] Evelyn, J., *Diary*, 1654.
[27] Worlidge, J., *Systema Horticulturae*, London, 1683, p. 41.
[28] Hulme, F. E., *Town, College and Neighbourhood of Marlborough*, 1921, p. 109.
[29] See Hyams, E., *History of Gardens and Gardening*, 1971,

p. 144. 'The mount is the last vestige of the prehistoric ziggurat.'
[30] Clifford, Derek, *History of Garden Design*, 1962, p. 20.
[31] More, Hannah, ed. Roberts, 'Conversation with Capability Brown' in *Memoires*, vol. 1, 1834, p. 267.
[32] Clifford, *op. cit.*, p. 159.
[33] *Art Forum*, Oct. 1971, p. 56.
[34] Hussey, C., *The Picturesque*, 1927.
[35] Curwen, E. C., *Antiquity*, vol. 4, 1930, pp. 38–40; *Wilts Arch. Mag.*, vol. 59, 1964, p. 185; and vol. 60, 1965, p. 127.
[36] Piggott, S., *Antiquity*, vol. 5, 1931, p. 40.
[37] *New Larousse Enc. Myth.*, 1968, p. 225.
[38] Atkinson, *op. cit.*, and *Antiquity*, vol. 42, 1968, p. 299.
[39] Woolley and Hawkes, *op. cit.*, vol. I, 1963, p. 242.
[40] Grinsell, L. V., *White Horse Hill*, 1939.
[41] Smith, I. F., *Windmill Hill and Avebury*, 1959, p. 13.

Chapter 10
Silbury, the name
[1] Swadesh, M., 'Linguistics as an Instrument of Prehistory' in *Southwestern Journal of Anthrop.*, vol. 15, 1959, pp. 20–5.
[2] Sapir, E., 'Conceptual Categories in Primitive Languages', 1929, quoted in Hymes, D., *Language in Culture and Society*, 1964, p. 209.
[3] Mathiot, M., in Hymes, D., *Language in Culture and Society*, 1964, p. 154.
[4] Gover, J. E. B., *English Place Name Society*, vol. 16, Wiltshire, 1939, p. 295.
[5] *Ibid.*, p. 295.
[6] Letter from Pope Gregory to Mellitus, AD 601, offering advice to Bishop Augustine in Kent.
[7] *Encyclopedia Britannica*, vol. 13, 1971.
[8] Phillpotts, B. S., *The Elder Edda*, 1920, p. 209.
[9] Speirs, J., *Medieval English Poetry*, p. 314.
[10] Smith, I. F., *Windmill Hill and Avebury, Short Account*, 1959, p. 21.

[11] Ellis Davidson, H. R., *Scandinavian Mythology*, 1969, p. 93.

[12] Pevsner, N., *Wiltshire*, 1963, p. 526.

[13] English folksong, from J. Pomery, Bridport, Dorset, 1906.

[14] Pitcairn, R., *Trials and other proceedings before the High Court of Justice in Scotland*, vol. 1, pt. iii, p. 245.

[15] Jamieson, *Dict. of Scottish Language*, 1910.

[16] Rees, A. and B., *Celtic Heritage*, p. 41.

[17] *Ibid.*, p. 41.

[18] Ceitein Oinich and Ceitein Oinnsich – see M. Macleod Banks, *British Calendar Customs*, vol. 2, 1939, p. 19.

[19] Quoted in H. M. Chadwick, *Origin of the English Nation*, 1907, p. 279.

[20] Hutchinson's *History of Northumberland*, vol. 2, 1778, p. 17. At Hawkie, nr. Cambridge, there was also a harvest queen.

[21] Gronbeck, V., *The Culture of the Teutons*, 1931.

[22] Lévi-Strauss, C., *op. cit.*, p. 26.

[23] *Oxford Dictionary of English Proverbs*, 3rd ed., 1970.

[24] Benwell, G., *The Sea Enchantress*, 1961, p. 17.

[25] See 'Legend of Marden Cleric's preaching bell, stolen by the Wye mermaid', Leather, E. M., *Folklore of Herefordshire*, 1912.

[26] *Victoria County History of Wilts.*, vol. 2, 1955, p. 222. 1872 was the year of local government reorganization.

[27] Gover, *op. cit.*, p. 291.

[28] Scarth, H. M., *Aquae Sulis*, 1864, pp. 44–64; and *Som. Arch. and Nat. Hist. Soc.*, vol. 6, 1885, p. 119.

[29] Cassirer, E., *Theory of Language and Myth*, (trans. S. K. Langer, 1953) p. 390.

[30] Thieme, P., 'The Comparative Method for Reconstruction in Linguistics', in Hymes, *op. cit.*, p. 587.

[31] Swadesh, M., 'Diffusional Cumulation and Archaic Residue', in Hymes, *op. cit.*, p. 630.

[32] Houghton, H. P., *An Introduction to the Basque Language*, 1961, p. 1.

[33] Baugh, A. C., *A History of the English Language*, 1959, p. 49.

[34] *Ibid.*, p. 49.

[35] Griera, A., *Vocabularia Vasco*, vol. 2, 1960.

Chapter 11
Silbury, sun and moon

[1] Newham, C. A., *The astronomical significance of Stonehenge*, 1972, p. 7.

[2] Cassirer, E., *op. cit.*, vol. 2, p. 90.

[3] *Ibid.*, p. 148.

[4] *Ibid.*, p. 149.

[5] Thom, A., *Megalithic sites in Britain*, 1967, pp. 108 and 114.

[6] O'Kelly, C., *New Grange*, 1971, pp. 94–5.

[7] Thom, A., *Megalithic Lunar Observatories*, 1971, p. 11.

[8] Evans, J. G., *Wilts Arch. Soc.*, 1966, p. 97.

[9] See Eliade, M., *Patterns in Comparative Religion*, 1958, pp. 166–71.

[10] Thom, A., *op. cit.*, pp. 113–14. See also G. S. Hawkins, *Stonehenge Decoded*, 1966: 'To a mean accuracy of $1\frac{1}{2}°$, 12 of the Stonehenge I alignments pointed to an extreme position of the moon' (p. 142).

[11] Eliade, M., *Patterns in Comparative Religion*, 1958, pp. 154, 177.

[12] Hone, W., *The Year Book of Daily Recreation and information*, 1838, p. 254.

[13] Harley, T., *Moonlore*, 1885, p. 215.

[14] Plato, (*Timaeus*, 40A) regarded all the celestial bodies as 'living beings divine, eternal'.

[15] Van Helmont, J. B., *Works*, 1644, p. 142.

[16] Harley, T., *op. cit.*

[17] Thomas, K., *Religion and the Decline of Magic*, 1971, p. 296.

[18] Cramond, W., *The Church and Churchyard of Rathven*, 1885.

[19] Shaw, L., *History of the Province of Moray*, vol. 3, 1751, p. 368.

[20] *Oxford Dictionary of English Proverbs*, 3rd ed., 1970. Quoting Fergusson, 1641.

[21] Macneill, *op. cit.*, p. 223.

[22] *Oxford Dictionary of English Proverbs*.

[23] Bacon, F., *Works of London*, 1740, vol. 3, p. 187.

[24] Harley, *op. cit.*, p. 190.

Chapter 12 Silbury in Labour

[1] Bachofen, J. J., *op. cit.*, p. 30.

[2] Hippolytus, *Philosophumena*, V, pp. 38–41.

[3] Pindar, *Fragment 102*, Oxford.

[4] *Folklore*, vol. 40, 1929. pp. 245–54.

[5] *New Larousse Encyclopedia of Mythology*, p. 161.

[6] Pass, *op. cit.*, p. 251.

[7] Campbell, J., *Masks of God*, vols. 1 and 2, 1960 and 1965.

[8] Carr-Saunders, Sir Alexander, *The Population Problem*, 1922.

[9] Wilkinson, R. G., *Poverty and Progress*, 1973, p. 32.

[10] Smith, I. F., *Wilts Arch. Mag.*, 1965, p. 30.

[11] James, E. O., *Sacrifices and Sacrament*, 1962, pp. 25–7 and 137–48.

[12] Abramson, J. A., *Art News*, Nov. 1970. p. 54.

[13] Cassirer, *op. cit.*, p. 145.

[14] 'Doing the rounds' from harvest hill to spring or nearby well remained a very important aspect of twentieth-century first fruits behaviour in Ireland.

[15] 'It is considered wholesome,' a Dorset tradition reminds us, 'to plunge a new-born infant in a cold spring, provided it is done at the right place and time.' At Cerne Abbas, the right spring apparently lay below the carved chalk Giant: 'There is a spring directly facing the rising sun, where the infant is "dipped" just at the time when it first begins to shine on the water.' (*Folklore Journal*, vol. 6, p. 118.)

Appendix: Silbury in the Roman World

[1] Priestley, H. E., *Britain under the Romans*, 1967, p. 107.

[2] Piggott, S., *Excavation of West Kennet long barrow*, 1955–6, pp. 55–6.

[3] Brooke, J. W., *Wilts Arch. Mag.*, vol. 36, 1908, pp. 373–5.

[4] *Ibid.*, pp. 373–5.

[5] Brooke, J. W., and B. M. Cunnington, M. E., *Wilts Arch. Mag.*, vol. 29, pp. 166–7.

[6] Brooke, J. W., and B. M. Cunnington, M. E., *Wilts Arch. Mag.*, vol. 24, p. 167.

[7] *Ibid.*, p. 168.

Bibliography

Abbreviations: *Antiquity – Ant.; Wiltshire Archaeological Magazine – Wilts Arch. Mag.; Victoria County History, Wiltshire – V.C.H.W.; South Western Journal of Anthropology – S.W.J.A.*

ALCOCK, J. P. 'Celtic water cults in Roman Britain' (*Archaeological Journal*, 1955)

ASHE, G. *Camelot and the vision of Albion* (London, 1971; New York, 1972)

ATKINSON, R. J. C. *Silbury Hill* (London, 1967)
——'Silbury Hill' (*Ant.*, 1967, *Ant.*, 1968, *Ant.*, 1969, *Ant.*, 1970)
——*Stonehenge and Avebury* (London, 1959)
——*Stonehenge* (London, 1956)

AUBREY, J. *The Topographical Collections, 1659–70* (London, 1862)

BACHOFEN, J. J. *Myth, Religion and Mother Right* (London and Princeton, N.J., 1967)

BARFIELD, O. *Poetic diction* (London, 1928; New York, 1964)

BATEMAN, T. *Ten years' digging in Celtic and Saxon grave hills* (London and Derby, 1861)
——*Vestiges of the antiquities of Derbyshire* (London, 1848)

BAUGH, A. C. *A History of the English Language* (New York, 1957; London, 1959)

BENWELL, G. *The Sea Enchantress* (London, 1961)

BRAY, W., AND D. TRUMP *A Dictionary of Archaeology* (London, 1970)

BRENTNALL, H. C. 'Marlborough Mount' (*Wilts Arch. Mag.*, vol. 48)

BRIFFAULT, R. *The Mothers* (London, 1927; New York, 1969)

BURL, H. A. W. 'Henges' (*Archaeological Journal*, vol. 126, 1969)

CAMPBELL, J. *Creative Mythology* (London, 1968; Princeton, N.J., 1970)
——*Occidental Mythology* (Princeton, N.J., 1964; London, 1965)
——*Primitive Mythology* (New York, 1959; London, 1960)

CARR-SAUNDERS, A. *The Population Problem* (Oxford, 1922; New York, 1974)

CASE, H. 'Neolithic Explanations' (*Ant.*, 1969)

CASSIRER, E. *Philosophy of Symbolic Forms*, (New Haven, Conn., 1953–7; London, 1965)
——*Theory of Language and Myth* (New York and London, 1946)

CHEVIOT, A. *Proverbs of Scotland* (Paisley and London, 1896)

CLIFFORD, D. *History of Garden Design* (London, 1962; Detroit, Mich., 1969)

CRAMOND, W. *The Church and Churchyard of Rathven* (Banff, 1885)

CRAWFORD, O. G. S. *The Eye Goddess* (London, 1957)
——*Wessex from the Air*, (Oxford, 1928)

CUNNINGTON, M. E. *An Introduction to the archaeology of Wiltshire* (Devizes, 1933)

CURWEN, E. C. 'Neolithic Camps' (*Ant.*, vol. 4, 1930)

DANIEL, G. *A hundred years of archaeology* (London, 1950)

DOUGLAS, J. *Nenia Britannica* (London, 1793)

DYER, J., AND L. V. GRINSELL *Wessex* (London, 1971)

EKWALL, E. *Concise Oxford dictionary of place names* (Oxford, 1947)
——*English river names* (Oxford, 1928)

ELIADE, M. *Images and symbols* (London, 1961; New York, 1969)
——*Myths, dreams and mysteries* (London, 1960; New York, 1969)
——*Patterns in comparative religion* (London and New York, 1958)
——*The two and the one* (London, 1965; New York, 1969)

EVANS, J. D. *Malta* (London, 1959; Atlantic Highlands, N.J., 1971)

FARMER, J. S., AND W. E. HENLEY *Dictionary of slang* (new edition, London, 1966)

FAWCETT, I. *The Symbolic Language of Religion* (London, 1970)

FLEMING, J. *Robert Adam and his circle* (London, 1962; Los Angeles, Calif., 1964)

FOWLER, P. J. *Regional Archaeology of Wessex* (London, 1968)

FRANKFORT, H. *Before philosophy* (Harmondsworth, 1949)
——*Kingship and the gods* (Chicago, 1948)

GIEDION, S. *The Eternal Present* (London, 1962–4; Princeton, N.J., 1964)

GIFFORD, J. M. 'The physique of Wiltshire' in *V.C.H.W.* pt. 1 (London, 1957)

GILPIN, W. *Three essays* (London, 1792)

GOVER, J. E. B. *The Place Names of Wiltshire* (Cambridge, 1939)

GRAVES, R. *The White Goddess* (London, 1948; New York, 1966)

GRAY, H. ST GEORGE 'Arbor Low' (*Archaeologia*, vol. 58, 1903)

GRIAULE, M. *Conversations with Ogotemmeli* (London, 1965)

GRIERA, A. *Vocabularia Vasco* (Abbadia de San Cugat des Vallés, Spain, 1960)

GRINSELL, L. V. *Ancient Burial Mounds of England* (new edition, London, 1953)
——*The Archaeology of Wessex* (London, 1958)
——*White Horse Hill* (London, 1939)
——'Wiltshire gazetteer of monuments' in *V.C.H.W.* pt. 1 (London, 1957)

HARLEY, I. *Moon Lore* (London, 1885; Detroit, Mich., 1969)

HARTLAND, E. *Folklore of Gloucestershire* (London, 1899)

HAWKES, J. *Dawn of the Gods* (London, 1968)

HAWKINS, G. S. *Stonehenge decoded* (London and New York, 1966)

HOARE, SIR R. C. *Ancient History of North Wilts* (London, 1821)
——*Journal* (London, 1802)

HOCART, A. M. *Kingship* (London, 1927)

HOUGHTON, H. P. *An introduction to the Basque language* (Leiden, 1961)

HYMES, D. (ed.) *Language in culture and society* (New York, 1964)

JAMES, E. O. *The Ancient Gods* (London, 1960)

——*The Cult of the Mother Goddess* (London, 1959)

——*Sacrifice and Sacrament* (London, 1962)

JENCKS, C. (ed.) *Meaning in architecture* (London, 1969; New York, 1970)

JONES, F. *The holy wells of Wales* (Cardiff, 1954)

KEEN, S. *Apology for wonder* (New York, 1969)

KRAMER, S. N. *History begins at Sumer* (London, 1958)

LEACH, E. R. 'Primitive time reckoning' in Singer, *History of Technology*, vol. I (Oxford, 1954)

LELAND, J. *Journey through Wiltshire, 1540–42* (Devizes, 1875)

LETHABY, W. R. *Architecture, Mysticism and Myth* (London, 1892)

LÉVI-STRAUSS, C. *The savage mind* (London, 1966)

——*The raw and the cooked* (London, 1970)

LEVY, G. R. *The gates of horn* (London, 1948)

LOCKYER, N. *Stonehenge and other monuments* (London, 1906)

LOMMEL, A. *Prehistoric and Primitive Man* (New York, 1966; London, 1967)

LONG, W. 'Abury' (*Wilts Arch. Mag.*, vol. 4, 1858)

MACNEIL, M. *The Festival of Lughnasa* (Oxford, 1962)

MALLOWAN, M. E. L. *Early Mesopotamia and Iran* (London, 1965)

MARSHACK, A. *The roots of civilisation* (New York, 1971; London, 1972)

MCKIM, F. W. 'Resistivity survey of Silbury Hill' (*Wilts Arch. Mag.*, 1959)

MELLAART, J. *Catal Hüyük* (London, 1967)

MEREWETHER, J. *Diary of a Dean* (London, 1851)

NEUMANN, E. *Art and the Creative Unconscious* (London, 1959)

——*The Great Mother* (London and New York, 1955)

NEWHAM, C. A. *The astronomical significance of Stonehenge* (Leeds, 1972)

NORBERG-SCHULZ, C. *Intentions in architecture* (Oslo, 1963)

NUTTGENS, P. *The Landscape of Ideas* (London, 1972)

OAKLEY, K. 'Folklore of fossils' (*Ant.*, vol. 39, 1965)

OERI, G. *Man and his images* (London, 1968)

O'KELLY, C. *New Grange* (London, 1967)

OSBORNE WHITE, H. J. *Geology of the country around Marlborough* (London, 1925)

PARTRIDGE, E. *Dictionary of slang* (4th edition, London, 1951)

PASS, A. C. 'Recent explorations at Silbury Hill' (*Wilts Arch. Mag.*, vol. 23, 1887)

PASSMORE, A. D. 'Unpublished field notebooks 1910–1930' (Devizes Museum)

PEPYS, S. *Diary*, vol. 3, 1688 (London, 1904)

PETRIE, FLINDERS W. M. 'Diggings in Silbury, 1922' (*Wilts Arch. Mag.*, vol. 42, 1922)

PEVSNER, N. *Wiltshire* (Harmondsworth, 1963)

PHILLPOTTS, B. S. *The Elder Edda* (Cambridge, 1920)

PIGGOTT, S. *Neolithic Cultures of the British Isles* (London, 1954)

——'The first agricultural communities in Wiltshire, c. 3000–1500 BC' in *V.C.H.W.*, pt. 2, vol. I (London, 1973)

RADFORD, E. AND M. A. *Encyclopaedia of Superstitions* (London, 1961)

RAINBIRD CLARKE, R. *Grimes Graves* (London, 1963)

RAWSON, P. *Primitive erotic art* (London, 1974)

REDFIELD, R. *The primitive world and its transformations* (New York, 1953; Harmondsworth, 1968)

REES, A. AND B. *Celtic Heritage* (London, 1961)

ROSS, A. *Pagan Celtic Britain* (London and New York, 1967)

SANDARS, N. K. *Prehistoric art in Europe* (Harmondsworth, 1968)

SCULLY, V. *The Earth, the Temple and the Gods* (New Haven, Conn., 1962; London, 1964)

SHERLOCK, R. L. *Geological Survey, London and Thames Valley* (London, 1947)

SMITH, A. C. 'Silbury' (*Wilts Arch. Mag.*, vol. 7, 1862)

——'Wiltshire superstitions' (*Wilts Arch. Mag.*, vol. 14, 1874)

SMITH, I. F. *Windmill Hill and Avebury, short account* (London, 1959)

——*Windmill Hill and Avebury* (London, 1965)

SPEIRS, J. *Medieval English poetry* (London, 1957)

STONE, J. F. S. *Wessex before the Celts* (London, 1958)

STUKELEY, W. *Abury described* (London, 1743)

——*Itinerarium Curiosum*, vol. I (London, 1724)

SWADESH, M. 'Diffusional cumulation and archaic residue' in Hymes, *Language in culture and society* (New York, 1964)

——'Linguistics as an instrument of prehistory' (*S.W.J.A.*, vol. 15, 1959)

TAYLOR PAGE, F. J. *Red deer* (London, 1962)

THOM, A. *Megalithic lunar observatories* (Oxford, 1971)

——*Megalithic sites in Britain* (Oxford, 1967)

THOMAS, K. *Religion and the decline of magic* (London, 1971)

THOMAS, N. *A guide to Prehistoric England* (London, 1960)

TRISTRAM, E. 'The Bull Ring' (*Journ. Derby. Arch. Soc.*, vol. 37, 1915)

TURNER, V. W. *The ritual process* (London, 1969)

WAINWRIGHT, F. T. (ed.) *The Northern Isles* (Edinburgh, 1962)

WALL, D. R. 'Church architecture, symbols and meanings' (*New Catholic Encyclopaedia*, vol. 3, 1966)

WHISTLER, L. *The English Festivals* (London, 1947)

WILKINS, E. *The Rose Garden game* (London, 1969)

WILKINSON, E. 'Diggings made in Silbury Hill, 1867' (*Wilts Arch. Mag.*, vol. 11, 1869)

WILKINSON, R. G. *Poverty and progress* (London, 1973)

WOOD, E. S. *Collins Field Guide to Archaeology in Britain* (London, 1963)

WOODBRIDGE, K. *Landscape and antiquity* (Oxford, 1974)

WOOLLEY, L., AND J. HAWKES *Prehistory and the Beginnings of Civilization* (London, 1963)

WRIGHT, A. R., ed. T. E. JONES *British Calendar Customs, England* (London, 1936)

ZIMMER, H. *The King and the Corpse* (London, 1948: New York, 1956)

ZUNTZ, G. *Persephone* (Oxford, 1971)

List of illustrations

I should like to thank many people who have helped me write this book. Dr I. F. Smith, while not accepting the interpretation, generously agreed to read the manuscript at an early stage, and offered valuable advice. Mr J. Michell offered much useful criticism. Members of archaeological societies at Leicester University and South Wessex engaged me in stimulating discussion. Dr G. T. Warwick made helpful suggestions. Students at Swindon College, 1969, collaborated in the field work.

The members of my family, especially my wife, have contributed both directly and indirectly to the work. Mr and Mrs M. W. Hawes and Mr P. K. Hawes have read and commented upon the manuscript.

Library staff at Birmingham University, the City of Birmingham Central Reference Library and in Devizes, have been extremely helpful, as have the staff at the British Museum, the Warburg Institute, the Ashmolean and Avebury Museums.

For the photographs in the text I am also indebted to Fay Godwin, Aerofilms, the *National Monuments Record, Wiltshire Gazette*, and Wiltshire newspapers.

I am very grateful to Mrs E. McCarthy who typed the manuscript.

Finally I would like to thank Mr P. Rawson, Professor J. Campbell and Professor V. Scully for their encouragement and direct help, given when I needed it most.

Index